Successful Photography

Successful Photography

Revised Edition

by Andreas Feininger

Prentice-Hall, Inc., Englewood Cliffs, N.J.

Successful Photography, Revised Edition by Andreas Feininger

Copyright © 1954, 1975 by Andreas Feininger

Printed in the United States of America

Prentice-Hall International, Inc., London
Prentice-Hall of Australia, Pty. Ltd., Sydney
Prentice-Hall of Canada, Ltd., Toronto
Prentice-Hall of India Private Ltd., New Delhi
Prentice-Hall of Japan, Inc., Tokyo

10 9 8 7 6 5 4 3 2 1

Library of Congress Cataloging in Publication Data

Feininger, Andreas
 Successful photography.
 Includes index.
 1. Photography—Handbooks, manuals, etc. I. Title.
TR146.F43 1975 770 74-23537
ISBN 0-13-864603-1

Contents

6

9

PURPOSE, SCOPE, AND ORGANIZATION OF THIS BOOK

This book was written to teach you "photography." I tried to make it a thoroughly practical guide that starts with essentials and then goes on from there to tell you what to do and how to do it until you become a competent and confident photographer.

Teaching implies learning. Even if photography is merely your hobby, if you want to make it successful and rewarding, a certain effort on your part is necessary. A few rules and technical terms must be memorized. However, do not worry; what at first may seem strange and difficult because it is new will soon become familiar to you.

As you leaf through the following pages, it may occur to you that this is a rather *complete* book. You may even think: What use do I have for a blue filter or infrared film? All this is much too complicated for me . . .

Right now you may not need these things—in which case you simply skip such items for the time being. However, as your knowledge increases and your ambitions grow, you will find that some of these less commonly used devices can account for the difference between a mediocre picture and an impressive photograph. *Then* you will be glad to have the necessary information handy. This book is organized in such a way that skipping the things you do not need at the moment neither interrupts the continuity of the whole nor makes the rest less easy to understand.

Part 1 tells you what it is all about. A short "indoctrination course" familiarizes you with the different steps in the making of a photograph. Operations to be discussed in detail later are here shown in their proper relationship to one another. This overall view of photo technique, with particular emphasis on "control," forms the background for all our later discussions.

Part 2 introduces you to your tools and materials. Accurate, precise, thorough, yet free from nonessential technicalities, it tells you all you have to know about your camera, lens, film, lights, and those small but practical accessories that greatly facilitate picture taking.

Part 3 shows you how to take a picture. Subdivided into six sections, it contains meticulously detailed information on how to produce photographs that are sharp, have depth, contain the right degree of contrast, "freeze" or suggest motion, and are correctly exposed. It also tells you how to use artificial light—photofloods, flash, and speedlights.

Part 4 teaches you how to develop your films and print and enlarge your negatives. You can learn how to improvise an inexpensive darkroom —any time and place. The mysteries of developing and printing are explained in such simple terms that, by the time you finish this chapter, you will agree with the author that film processing is "as easy as boiling a couple of eggs."

However, if, for the present, you want to let a commercial photo finisher do your darkroom work, simply skip this chapter, and save it for the day when you feel ready to attend to this fascinating phase of picture making yourself.

Part 5 helps you to develop your critical faculties. Numerous instructive pictures show you most of the things that can go wrong—complete with information on diagnosis, and correction, as well as advice on how to avoid such mistakes.

Part 6 teaches you how to work with chemicals. Mixing your own solutions from basic compounds makes it possible to reduce the cost of your hobby or work. It furthermore enables you to use special solutions that, because of their instability, are not commercially available in prepared form—a bonus for the more advanced worker.

Part 7 shows you how to expand the scope of your work. Having acquired a sound foundation of basic photo technique, you are now ready to explore, through tests and experiments, those subtle variations of approach that will enable you to do original work. You learn how to evaluate critically different types of cameras and lenses and how to select

those best suited to *your* specific needs. Furthermore, you will learn with the aid of numerous photographs and diagrams how basic operations can be varied to an almost limitless degree in accordance with the demands of the subject of your picture.

Part 8 tells you how to use your "technique" to best advantage. Photography is picture language, and photo technique is but a means to an end: a picture with purpose and meaning. How to produce such pictures is the theme of this section, which, in many ways, is the most important chapter in this book—and also the most interesting. It is hoped that the ideas discussed here will prove to be the turning point in your career or hobby, the spark that liberates your latent creative faculties.

You will notice that certain features are discussed several times, in different connections. Such apparent repetitions are necessary to better clarify the subject. In the making of a photograph, almost every step is the combined result of a number of operations so intimately connected that a change in one almost invariably demands corresponding changes in one or several of the others if the final result is to be satisfactory. Recognition of this interdependence of the various factors that determine the outcome of a picture is one of the "secrets" that lead to consistently good photographs. "Wasting" a few lines on repetitions seemed to me the best way of making sure that this is fully understood by the reader.

This book is not a novel. Rarely, if ever, will anyone read through it in a single session. But you will refer to it again and again for advice on specific questions. To be sure that you find accurate and complete answers to your photographic problems was my foremost consideration.

Andreas Feininger

1

General Principles

Imaginary and real difficulties

Here, at the very beginning, I shall give the reader a pleasant surprise by exploding an old myth that has been carefully kept alive by certain writers and photo-magazine editors who seem to believe that their livelihoods depend upon its preservation: the idea that "photo technique is difficult."

This is definitely not true. Years ago, in the days of wet plates, large cameras, slow lenses, and slower films, photography was a craft that demanded the highest technical skill and years of experience before one could expect to master it. But today, in our streamlined era of automated and electronically controlled cameras, super-fast lenses and films, standardized developing processes, and reliable controls for every operation, photo technique has become so simple that anyone who can spare the time to read instructions can also produce "technically perfect photographs."

I know this sounds like heresy, but it is not. In order to produce a "technically perfect photograph," a "technically perfect negative" is needed. A technically perfect negative is sharp, and it has the right kind of contrast and the right degree of density. In other words, it is a negative that is neither fuzzy (because of faulty focusing) nor blurred (because of subject or camera motion), neither too "contrasty" nor too contrastless, and neither too black (dense) nor too transparent (thin). Sharpness or fuzziness is the result of proper or improper *focusing* and of holding or not holding the camera still while making the exposure. Contrast range and degree of

15

density are controlled by *exposure* and *development*. Today, a technically perfect negative can be made by anyone who knows how to use the following control instruments: *microprism grid* or *rangefinder* for focusing, *exposure meter* for exposing, and *thermometer* and *timer* for developing. Basically, that's all there is to it.

A shortcut to technical perfection

Most people who want to learn a trade or master a craft realize that, before they can successfully execute their ideas in any medium, they must learn the basic elements of "technique." They also realize that there is no better aid to success than practical experience. And that experience is the result of experimentation and hard work.

For example, the first thing that an apprentice cabinetmaker learns is how to use a saw and a plane: He learns not by studying the finished work of master cabinetmakers but by taking these tools into his own hands and finding out from his own experience how they work. To begin with, he learns how to make a straight cut with a saw and how to smooth a rough board with a plane. He does *not* immediately try to construct an entire cabinet or a chair; instead, he starts at the beginning. He learns through trial and error, practicing to gain experience. He methodically experiments, searches, and learns as he works. Later he will be taught the different kinds of saws, the different types of planes, and which is best suited to specific types of work. But not until he has acquired a considerable degree of skill will he be allowed to attempt a "real" job—to make a simple, salable piece of furniture.

This is the time-honored, sound, and practical method by which any apprentice learns his trade. Yet the amateur photographer, who may be likened to an apprentice, insists on producing "finished pictures" right from the start. Having spent a lot of money on his equipment, he apparently expects to get the skill to handle his tools as part of the deal. And, strangely enough, to a certain degree he is right. Modern photo equipment has been perfected to such a degree that, figuratively speaking, quite a lot of "skill" is built into a camera, exposure meter, and so on; if a photographer follows the manufacturer's instructions implicitly, he can never go wrong. On the

other hand, his work will be little better than average. *Only if he explores the possibilities and limitations of his tools through laborious practice and experiment will he be able to make the fullest use of the inherent potentialities of the photographic medium, and only then will his pictures differ from those produced by the faithful instruction followers.*

CONCLUSIONS

If a shortcut to success in photography exists, it is through experiment. I know that the experiments recommended in Part 8 will involve what seems like extra work at first. Actually, however, they will save time and much work later. By trying to make "finished pictures" right from the start, a photographer can spend years in time-consuming trial and error. He also wastes material that, because of lack of specific knowledge, is converted into mediocre pictures instead of interesting photographs. In comparison to this constant frustration, the time, money, and effort spent on essential experiments are inconsequential, whereas the practical gain is enormous. By *doing* these experiments instead of merely reading about them, a photographer accumulates more useful knowledge in a few weeks than he otherwise could gain through years of planless fumbling. Besides, nothing creates more confidence in one's ability and the potentialities of the medium in which one works than a solid background of experience based upon personally performed experiments and tests.

Useful and useless knowledge

An ambitious photographer is constantly concerned with improving his work. To facilitate this he relies mainly on books and magazine articles on photo technique, being guided by more advanced photographers and writers on photographic subjects. This is basically a sound approach. However, it has its pitfalls, for unless the student's goal has been established, he may be inadvertently led into a morass of completely useless "knowledge."

An enormous number of books, booklets, and magazine articles have been written for amateur consumption on subjects that in no practical way help the amateur to improve the quality of his pictures. There are books upon books dealing with optics, chemistry, sensitometry, the history of photography—yes, even entire books devoted to such apparently simple matters as how to expose a negative! Complete with higher mathematics and logarithms, too! Believe it or not—before the average amateur could read, much less understand, some of these books he would first have to take a course in mathematics. And, after he had finally waded through this complicated material, he would still not know anything of practical value that his exposure meter would not have made apparent at a glance.

CONCLUSIONS

Superficially seen, photography may appear to become more intricate each year, but actually the opposite is true. All the complicated devices of modern photo technology—electronically controlled shutters, photoelectric and diaphragm-coupled exposure meters, lens-coupled rangefinders, automatic and self-quenching speedlights, cameras with built-in this and built-in that, etc.—actually are designed to make work simpler for the photographer by eliminating guesswork and providing in meter settings and dial readings facts that previously he could learn only through practical experience. And just as one can operate a transistor radio or a television set without knowledge of electronics, or drive a car without being familiar with the theory of the internal-combustion engine, so anyone can use a modern camera, exposure meter, ready-mixed developer, and so on without studying optics, electronics, or chemistry.

THIS IS WHAT HAPPENS
WHEN YOU MAKE A PHOTOGRAPH

Light emitted by a natural or artificial source of illumination strikes the subject, is reflected by it, and thus makes it visible to the eye, as well as to the lens of the camera.

The lens of the camera refracts the rays of light reflected into it by the subject, forms an image of this subject, and, if properly focused, projects this image onto the sensitized emulsion of the film.

The film responds (within certain limits) to the light that strikes it in direct proportion to the amount of exposure. A *latent*, or invisible, image is formed by the chemical interaction of the light quanta with the crystals of the light-sensitized emulsion.

Development transforms the latent image into a visible one, the parts that **p. 155** received more light being correspondingly darker than those that received less light. The result is a *negative* image of the subject—the values of light and dark are reversed. To make such a negative impervious to further exposure to light, it must be *fixed* in a chemical solution (the *fixer* or *hypo*). To make it permanent, it must be cleansed of all extraneous chemicals by washing before it is ready to be dried and printed.

Printing again reverses the tone values of the image, resulting in the final **p. 184** *positive* picture on paper. Printing, whether directly *by contact* or indirectly *by projection* through an enlarger, is basically nothing but a repetition of the processes of exposing and developing a negative. Now the image contained in the negative is projected onto the light-sensitized emulsion of the paper, where interaction between light and emulsion once more produces a latent image, which, after being developed, fixed, and washed, becomes the final photograph.

The "technically perfect negative"

The starting point for any technically perfect photograph is a technically perfect negative. Such a negative combines sharpness of rendition with the right degree of *density* (neither too dense nor too thin) and the proper contrast or *gradation* (neither too "contrasty" or *hard* nor too contrastless or *soft*). And, of course, a technically perfect negative is absolutely clean, free from spots, streaks, smears, dust, scratches, and fingermarks.

Negatives that are not sharp produce fuzzy, unclear pictures.

Negatives that are too dense are difficult to print and often excessively *grainy*.

Negatives that are too thin produce prints that lack shadow detail.

Negatives that are too contrasty produce prints deficient in intermediate shades of gray.

Negatives that are too contrastless produce prints deficient in black and white.

Negatives that are not clean produce spotty and dirty prints.

Three vital functions

The three operations that determine whether or not a negative will be technically perfect are

focusing
exposing
developing

Of these vital functions, *focusing* controls the *sharpness of rendition;* *exposing* (which is a function of the combined effects of *diaphragm stop*—a device to reduce the effective diameter of the lens—and *shutter speed*), in conjunction with *developing*, determines *density* and *contrast* of the negative. How these functions and the results that they produce are interconnected is shown in the following diagram.

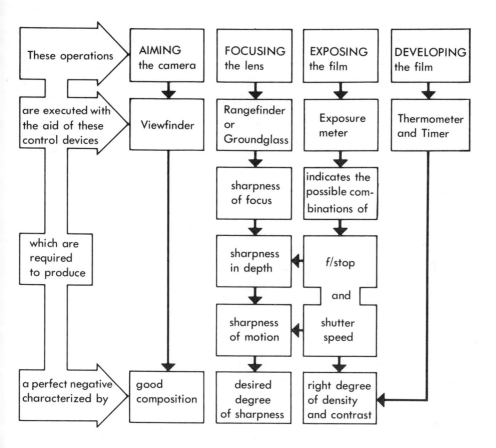

These operations	AIMING the camera	FOCUSING the lens	EXPOSING the film	DEVELOPING the film
are executed with the aid of these control devices	Viewfinder	Rangefinder or Groundglass	Exposure meter	Thermometer and Timer
		sharpness of focus	indicates the possible combinations of	
which are required to produce		sharpness in depth	f/stop	
			and	
		sharpness of motion	shutter speed	
a perfect negative characterized by	good composition	desired degree of sharpness	right degree of density and contrast	

Footnote on "sharpness"

The attentive reader has doubtless noticed that three different kinds of sharpness are distinguished in the previous diagram. Basically, *sharpness* or *unsharpness* is controlled by *focusing*, but there are additional factors that, under certain circumstances, can also produce the effect of unsharpness.

Unsharpness due to faulty focusing. This is the most common type of unsharpness. Unless the lens is correctly focused on the subject, the picture will become more or less unsharp, the degree of unsharpness depending on the extent to which the image is *out of focus*.

Unsharpness due to faulty diaphragm adjustment. A lens can be focused only on a certain *plane* at a certain distance from the lens. If the camera is correctly focused on a subject that has no depth (like a painting or a wall in frontal view), a sharp picture will result. However, when confronted with a subject of greater extension in depth (like a person, a room, a landscape), the photographer can still focus only on a certain plane at a certain distance from the lens. As a result, *theoretically*, everything in front of and behind the plane of focus should appear increasingly unsharp the farther it is from the plane of focus. *Practically*, this kind of unsharpness is overcome with the aid of the *diaphragm*. The more the diaphragm opening is reduced (an operation known as *stopping down the lens*), the greater the depth of the sharply rendered zone.

Unsharpness due to faulty shutter-speed adjustment. If stationary subjects are photographed, the shutter speed theoretically has no influence on the sharpness of the picture. When we are photographing subjects in motion, however, the image of the subject moves across the surface of the exposing film with the result that it will be rendered more or less blurred unless the photographer uses a shutter speed fast enough to "freeze" the image on the film.

Unsharpness due to motion of the camera. Practically, it makes no difference whether the subject moves while the camera is stationary or the camera moves while the subject is stationary; in both cases, the result will be a blurred negative. To avoid this very common fault, a photographer must learn to *hold his camera perfectly still while making an exposure*. He should brace himself, hold his breath, and gently "squeeze" the shutter-release button as carefully as a sharpshooter "squeezes" the trigger of his rifle in order not to spoil his aim. Furthermore, he should remember that, normally, *only* shutter speeds shorter than $1/60$ sec. can be hand-held without danger of moving the camera during the exposure. If possible, exposures longer than $1/60$ sec. should be made with the camera firmly supported by either a tripod or other suitable means. Unsharpness due to accidental camera movement is one of the most common mistakes made by the beginner—and one that can be most easily avoided.

Controls for Focusing, Exposing, and Developing

The tremendous advances in photography during the last decade or two have made it possible to mechanize fully the technical side of producing a photograph. Instead of relying on his eyes, his sense of time, and previous experience, today's photographer relies on mechanical, optical, and electronic devices and instruments, dial settings, and meter readings—and produces photographs that are "technically" superior to any produced before. To "estimate" the subject-to-camera distance, to "guess" the time of exposure, or to develop "by inspection" in the red glow of a darkroom lamp is now as obsolete as riding around in a horse and buggy.

FOCUSING CONTROLS

Focusing means adjusting the lens-to-film distance in accordance with the lens-to-subject distance in order to produce a sharp image. The device for accomplishing this is either a *groundglass* (a negative-size piece of frosted glass onto which the image can be projected) or a *lens-coupled rangefinder*.

Groundglass. The main advantage of groundglass focusing is that a groundglass produces an image in the same size as the negative. Furthermore, it clearly indicates the degree to which sharpness extends in depth. *

Its disadvantage is that, as the diaphragm is stopped down to increase sharpness in depth, the image darkens accordingly. However, this disad-

*Exception: all twin-lens reflex cameras, in which the groundless image is produced not by the lens that takes the picture but by a separate viewfinder lens.

vantage is nowadays overcome in one of two ways (exception: all view cameras): First, by means of an *automatic diaphragm*, which permits focusing with the lens wide open but closes down automatically to a preset stop when the shutter is released; second, by having the groundglass image produced by a *separate finder lens* (all twin-lens reflex cameras).

Lens-coupled rangefinder. The outstanding features of the lens-coupled rangefinder are compactness, speed of operation, and complete focusing control at all times—before, during, and after the exposure. In other words, the viewfinder image is always brightly visible and neither darkens nor disappears at the moment of exposure. Disadvantages of the rangefinder are the relative smallness of its viewfinder image (photographers who wear glasses sometimes have difficulty in working with a rangefinder) and the fact that it is not very accurate at very short and very long subject distances, as a result of which rangefinders cannot be used either in close-up photography or in telephotography (except in conjunction with telephoto lenses of rather moderate focal lengths). And, finally, rangefinders do not show the degree to which sharpness extends in depth.

EXPOSURE CONTROLS

The right amount of light must be admitted to the film in order to produce a correctly exposed negative.

Too much light results in overexposed negatives that are too dense (too black). Highlights (the darkest parts of the negative) are frequently surrounded by "haloes." These spill over into adjacent parts of the image, where they cause a certain degree of unsharpness through diffusion of light within the emulsion. Negative grain* is more pronounced than in correctly exposed negatives made on the same type of film. Overall contrast is usually too low.

* Any photographic emulsion contains minute particles of metallic silver that may cluster together and manifest themselves as "grain."

Too little light results in underexposed negatives that are too thin (too transparent). The darkest parts of the subject (the thinnest parts of the negative, the so-called *shadows*) are often as clear as glass and devoid of any detail. Overall contrast is usually too high.

The two controls by means of which the exposure is regulated are the diaphragm (or f-stop) and the shutter-speed setting, each of which has a double function:

The diaphragm regulates

1. the amount of light admitted to the film
2. the extension of sharpness in depth

The shutter regulates

1. the amount of light admitted to the film
2. the degree of sharpness of subjects in motion

Diaphragm and shutter speed. By selecting a larger or smaller diaphragm opening, we admit a wider or narrower beam of light; by selecting a slower or higher shutter speed, we permit this beam of light to affect the film for a longer or shorter time. This means that we can produce a correct exposure in many different ways: The effect of a large diaphragm opening in conjunction with a high shutter speed is essentially (although not in its ramifications, as we shall see soon) the same as a small diaphragm opening in conjunction with a slow shutter speed.

To use an analogy: Let us assume that we have to fill a vessel with a specific amount of water, for example, one gallon. If we draw the water from a pipe with a large diameter (corresponding to a large diaphragm opening) we keep the faucet open for a shorter time (corresponding to a high shutter speed) than if we had to draw the same amount of water from a pipe with a smaller diameter (corresponding to a smaller diaphragm opening). In the

latter case, in order to compensate for the slower flow, we must keep the faucet open for a longer time (corresponding to a slower shutter speed). In either case, by correlating the diameter of the pipe (or diaphragm opening) and the duration of the flow (the time the faucet or the shutter is open), we achieve the identical result: to draw exactly one gallon of water (or to admit identical amounts of light to the film).

CONCLUSIONS

The secret of correct exposure is the *selection of the most suitable combination* of diaphragm opening and shutter speed. The basis for any such selection should be the data provided by a photoelectric exposure meter, either built into the camera or in the form of a separate instrument. Many beginners using simple cameras that lack built-in exposure meters feel that they don't need or cannot afford separate exposure meters, that they are too "professional," difficult to understand and use. This is a fallacy. In my opinion, an exposure meter is almost as important as the camera itself for the production of technically perfect photographs. There are several reasons, the most important one being that the eye is a very unreliable instrument for gauging differences or changes in the brightness of the incident light; it readily adapts to light and thereby gets fooled. Few things are more disappointing to a photographer who takes his hobby seriously than discovering that an important picture turned out poorly because of incorrect exposure. Not to mention the fact that film costs money. But with the aid of an exposure meter each shot can be made to yield a "technically perfect negative," and waste due to poor exposure can be eliminated. As a result, possession and constant use of an exposure meter not only pay off in the form of better pictures and increased enjoyment of photography, but, in the long run, the instrument also pays for itself, even if it should save only one bad exposure out of every three shots—a conservative estimate.

An exposure meter built into the camera may show in the viewfinder but doesn't correlate the different possible f-stops and shutter speeds; in contrast, separate hand-held instruments display on their properly

adjusted dials *simultaneously* all the possible combinations of f-stop and shutter speed that will yield a correctly exposed negative. Which of these combinations a photographer should use depends on the following factors.

Extension in depth of the subject. If the depth of the subject is considerable, to render it sharply, the photographer must use a relatively small diaphragm stop (how small the diaphragm stop should be will be discussed later). And, as previously explained, a relatively *small* diaphragm opening must be compensated for by a relatively *slow* shutter speed if underexposure is to be avoided.

p. 93

Motion and speed of the subject. If the subject is not stationary but in motion, a relatively high shutter speed must be used to "freeze" the motion and produce a sharp picture. The higher the speed of the subject or the faster the action, the higher the shutter speed must be (how high the shutter speed should be will be discussed later). And, as previously explained, a relatively *high* shutter speed must be compensated for by a relatively *large* diaphragm opening if underexposure is to be avoided.

p. 113

Hand-held or tripod exposure. To avoid unsharpness due to accidental camera movement, only exposures faster than $1/60$ sec. should normally be hand-held. Longer exposures should be made with the camera firmly supported by a tripod or steadied by other suitable means. Consequently, if the shot has to be made hand-held, a shutter speed not slower than $1/60$ sec.—and preferably somewhat faster—should be selected when computing the exposure. The corresponding diaphragm opening can then easily be found by consulting the exposure meter.

All this may sound complicated but is actually very simple. A practical example should make this clear: Let us assume that the speed of your film is 125 ASA and that your correspondingly preset exposure meter indicates a brightness reading of 25. Under these conditions you would have a choice of the combinations of diaphragm opening (f-stop numbers) and shutter speeds listed in the following table. This table also shows the effects of the different combinations, as far as accuracy of focusing, extension of sharpness in depth, and ability to "freeze" motion are concerned.

Diaphragm (f-stop numbers)	1.4	2	2.8	4	5.6	8	11	16	22	32
Corresponding shutter speeds	$1/1000$	$1/500$	$1/250$	$1/125$	$1/60$	$1/30$	$1/15$	$1/8$	$1/4$	$1/2$

Focusing	Decreasing sharpness in depth demands increasingly accurate focusing	Increasing sharpness in depth compensates for less accurate focusing

Extension of sharpness in depth — Very limited—limited—medium—increasingly extensive

Rendition of objects in motion — Very sharp—sharp—slightly blurred—increasingly blurred

Conclusions	The faster the motion of the subject or the action, the higher the shutter speeds that are necessary to produce sharp pictures.	The greater the depth of the subject, the smaller the diaphragm stops that must be used to produce sufficient sharpness in depth.
	Exposure short enough to be hand-held	Tripod should be used

CONCLUSIONS

It is of the highest importance that the beginner realize how closely the functions of the three controls—focus, diaphragm stop, and shutter speed—are related. Change of one almost invariably necessitates readjustment of one or both of the others if the result is to be a technically perfect negative. In practice, ideal solutions of this problem are rare. In most cases the best one can do is to find *the most advantageous compromise* between the conflicting effects resulting from the double functions of the diaphragm and shutter.

In order to achieve the best possible results, the following often contrary demands must be considered and, what is more, fulfilled as far as practically feasible.

If the lens is focused accurately, the selection of diaphragm stop and shutter speed can be made exactly as already outlined.

If, however, the lens is focused more or less at random, either because the camera is not equipped with a groundglass or a rangefinder or because a "grabshot" must be taken quickly (leaving no time for accurate focusing), then the danger of producing an out-of-focus image must be counteracted as far as possible by using a relatively small diaphragm aperture, which automatically produces a correspondingly larger *safety zone* of sharpness in depth (extended *depth of focus*). However, as previously explained, a relatively small diaphragm aperture must be compensated for by a relatively slow shutter speed to avoid the danger of underexposure.

Diaphragm aperture should be as small as possible to produce the greatest extension of sharpness in depth, but not so small as to cause underexposure.

Diaphragm aperture should be as large as possible to permit the use of the highest practical shutter speed to prevent unsharpness due to subject motion or accidental movement of the camera.

Shutter speed should be as high as possible to "freeze" the motion of the subject and to prevent unsharpness due to accidental movement of the hand-held camera, but not so short as to cause underexposure.

Shutter speed should be as slow as possible to permit the use of the smallest possible diaphragm aperture in order to produce the greatest extension of sharpness in depth.

Summing up the advantages and the less desirable effects of different settings of focus, diaphragm, and shutter, we arrive at the following conclusions.

	Advantages	Disadvantages
Focusing accurate	Guarantees the highest degree of sharpness of rendition.	The time required for focusing accurately may cause the photographer to miss a shot or the peak of action.
Focusing random	Takes practically no time, is often the only way of making *grabshots* when one has to act fast.	Danger of out-of-focus pictures necessitates use of small diaphragm apertures to increase the zone of sharpness in depth. This calls for slower shutter speeds to avoid underexposure and can become the cause of unsharpness due to motion of subject or camera.
Diaphragm aperture small	Increases extension of zone of sharpness in depth; reduces the danger of overexposure in very bright light.	The relatively small amount of light admitted to the film creates danger of underexposure; to prevent underexposure, slower shutter speeds must be used, increasing danger of unsharpness due to motion of subject or camera.
Diaphragm aperture large	Admits plenty of light, making underexposure less likely. Permits use of high shutter speeds that aid in avoiding unsharpness due to subject or camera motion.	Extension of sharpness in depth is limited. Focusing has to be especially careful. Danger of overexposure exists.
Shutter speed high	Prevents danger of unsharpness due to motion of subject or camera. Reduces danger of overexposure in very bright light.	Necessitates use of larger diaphragm apertures to counteract danger of underexposure due to the fact that the higher the shutter speed, the less light admitted to the film.
Shutter speed low	Allows use of smaller diaphragm apertures resulting in greater extension of the zone of sharpness in depth. Reduces danger of underexposure.	Increases danger of unsharpness due to motion of subject or camera. Increases danger of overexposure in very bright light.

Recognition of the interdependence of the three controls, focus, diaphragm, and shutter—and their effects upon the negative—should make it clear that they must never be considered separately; instead, they must be treated as a unit. The following diagram shows in graphic form all the factors that determine the outcome of an exposure.

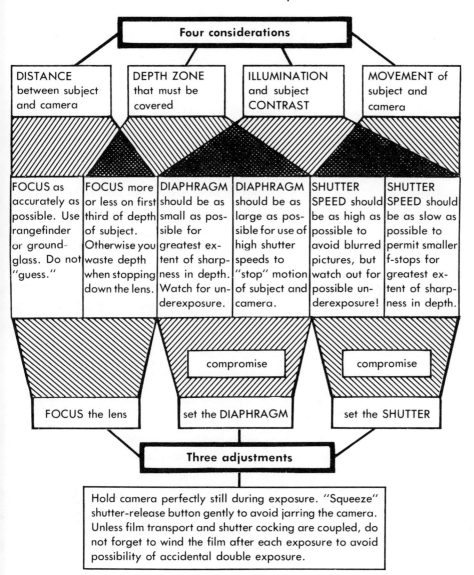

Four considerations

DISTANCE between subject and camera	DEPTH ZONE that must be covered	ILLUMINATION and subject CONTRAST	MOVEMENT of subject and camera

FOCUS as accurately as possible. Use rangefinder or ground-glass. Do not "guess."	FOCUS more or less on first third of depth of subject. Otherwise you waste depth when stopping down the lens.	DIAPHRAGM should be as small as possible for greatest extent of sharpness in depth. Watch for underexposure.	DIAPHRAGM should be as large as possible for use of high shutter speeds to "stop" motion of subject and camera.	SHUTTER SPEED should be as high as possible to avoid blurred pictures, but watch out for possible underexposure!	SHUTTER SPEED should be as slow as possible to permit smaller f-stops for greatest extent of sharpness in depth.

compromise

compromise

FOCUS the lens | set the DIAPHRAGM | set the SHUTTER

Three adjustments

Hold camera perfectly still during exposure. "Squeeze" shutter-release button gently to avoid jarring the camera. Unless film transport and shutter cocking are coupled, do not forget to wind the film after each exposure to avoid possibility of accidental double exposure.

In the days of large-size glass plates and individual sheets of cut film, developing each negative individually and, if necessary, in a specially prepared developer made sense. Then, best results could most consistently be produced by adapting the developing process to the particular requirements of each exposure, in accordance with the type of illumination, the contrast range of the subject, the inherent qualities of the negative material, and, most important, the desired qualities of the finished negative in regard to contrast range and density.

Today, however, the most commonly used type of negative material is roll film. On roll film, subjects extremely different in character are often recorded side by side. Amateurs, in particular, frequently shoot subjects as diverse as landscapes, portraits, interiors, backlighted scenes, close-ups, and still lifes on the same roll—many of them more or less wrongly exposed. Because individual development of each *frame* (the individual negative on a film strip) is impossible for technical reasons, the only method by which such films can be developed successfully is standardization of the whole process in accordance with the requirements of what might be called "the average negative" and performing the necessary operations in a strictly mechanical manner. This way of developing is called the *time-and-temperature method*.

The time-and-temperature method of film development is based upon two factors, which govern the process of negative development, regardless of the type of developer or film.

The temperature of the developer determines the rate of development—warmer solutions develop a negative faster than colder solutions. However, the usable temperature range is rather restricted —from 65° to 78° F. with 68° F. as the norm. Colder developers develop erratically or not at all; warmer solutions produce overall *fog* (a more or less uniform veil of gray over the image) and can cause the emulsion to melt and run off its base.

The time of development determines the density and contrast range of the negative. The longer the development, the denser (blacker) the negative becomes, and the higher its contrast (the greater the difference between its thinnest and densest areas); and vice versa. This fact is of great practical value in controlling the contrast range of negatives and will be discussed in more detail later. **p. 175**

The standard time of development at the standard temperature of 68° F. varies with the type of developer and the type of film. For specific cases consult the instruction sheet that always accompanies the film.

The beauty of the time-and-temperature method is that it simplifies film development to such a degree that even a rank beginner can produce consistently good results right from the start. All he has to do is to use the developer that is recommended by the film manufacturer and consult the instruction sheet that comes with his film to find the correct time of development at any developer temperature between 65° and 78° F. The only control instruments he needs are a *thermometer* and a *timer*. With their aid (and the manufacturer's instruction sheet, which correlates the temperature of the developer and the time of the development), film development today is no more difficult than boiling a couple of eggs.

POINTERS FOR BEGINNERS

The three control instruments, *exposure meter, thermometer,* and *timer,* are just as important for ultimate success as camera and film. Train yourself to use them constantly. There is no excuse for guesswork.

The "secret" of the technically perfect negative is revealed in the foregoing diagram. Memorize the four considerations of *distance, depth, illumination, motion* and the three adjustments of *focus, diaphragm aperture,* and *shutter speed.* **p. 31**

In black-and-white photography, always expose for the shadows; the highlights will then take care of themselves. When in doubt, overexposure is preferable to underexposure.

To avoid blurred negatives, train yourself to hold the camera perfectly still when making an exposure; "squeeze" the shutter-release button gently. Wind or change the film after each exposure.

Study the instructions that come with your camera, film, and developer; they contain in concentrated form everything you need to know to use them to best advantage.

Learn to evaluate your subject in terms of black and white and shades of gray and to disregard color. Unless, of course, your camera is loaded with color film.

Pay attention to the background. Branches appearing to grow out of people's heads are amusing but not particularly beautiful, and fuzzy bright spots of no particular shape in the background of a picture are most distracting. A neutral background is never wrong, and the open sky is the best background for portraits and pictures of people.

Close-ups invariably make more interesting pictures than shots that are taken from afar—especially shots of people. Distant views, beautiful as they may appear to the eye, notoriously produce some of the most disappointing photographs.

Photography is as simple or as complex as you wish to make it. Prize-winning pictures have been taken with box cameras loaded with a "nameless" brand of film. On the other hand, possession of a thousand dollars' worth of equipment is still no guarantee of outstanding work. All of which only helps to prove the generally known but commonly ignored fact that it is the photographer who "makes" the picture, not his camera, lens, or film.

2

Tools and Materials

THE COMPONENTS OF A CAMERA
AND THEIR FUNCTIONS

Any camera, regardless of how costly or cheap, how simple or how complex, is basically nothing but a light-tight box, or sleeve, connecting two vital parts:

the lens that produces the image
the film that retains it

All other parts are auxiliary devices, whose purpose is to facilitate the three operations by which the negative is produced:

aiming
focusing
exposing

Aiming a camera is as important as aiming a gun. To aim, a photographer needs a *finder* (viewfinder). He has the choice of two basically different types:

Eye-level finders through which he looks with the camera held against his eye; all cameras equipped with a rangefinder and all pentaprism-equipped single-lens reflex cameras employ this type of finder. Pictures taken with cameras equipped with eye-level finders show more or less the same perspective as that which we see. This is never really wrong but occasionally somewhat dull. And, when working very close to the ground, an eye-level finder is inconvenient because it forces the photographer to work in an uncomfortable position. However, addition of an auxiliary right-angle finder permits conversion of many eye-level finder cameras to waist-level finder operation, should this become desirable.

Waist-level finders make it necessary to hold the camera at chest or waist level (or lower), for the photographer looks into them from above. All nonprism single-lens reflex cameras, all twin-lens reflex cameras, and many box-type cameras feature this kind of finder. Pictures taken with cameras equipped with waist-level finders usually have a more or less "worm's-eye view" perspective, which can be very effective. Many such cameras can be converted to eye-level operations through the addition of an auxiliary prism device that fits on top of the regular finder.

CONTROLS FOR FOCUSING

Focusing means adjusting the lens-to-film distance in accordance with the lens-to-subject distance, in order to produce an image that is sharp. To do so, two devices are needed.

A mechanical control—a helical lens mount or a rack-and-pinion drive operated by a focusing knob—by which the photographer can adjust the distance between lens and film until an optical control device shows him that the image projected by the lens onto the film is *in focus*.

36

An optical control—a groundglass or a rangefinder—by means of which the photographer can visually check whether or not the image is in focus. In this respect, he has the choice of three different designs, each with its own advantages and drawbacks.

Groundglass panel. The simplest and most direct of all focusing devices, the groundglass panel is used today only on view cameras and some press cameras. It is the only focusing control that permits the use of "swings"—individual adjustability of the front and back of a camera indispensable for the control of perspective and, in certain cases, for extending the zone of sharpness in depth to an almost unlimited degree. However, a groundglass panel has the disadvantage that the lens-projected image disappears the moment a film holder is inserted into the camera. Consequently, a camera equipped with a groundglass panel is unsurpassed in cases in which the subject is stationary, the photographer has time, and the camera can be mounted on a tripod. In all other instances, this type of camera is useless, unless, of course, it is equipped with a second optical control—a rangefinder or a 45° mirror as, for example, the Speed-Graphic—the typical "press camera"—or the Graflex, a large-format single-lens reflex camera, is.

Reflex type finder. The image produced by the lens is projected, via a 45° mirror, upon a *horizontal* groundglass panel in the size of the negative. This has the advantage that the so equipped camera can be used for making hand-held exposures, for, in this case, the film cannot block the passage of light between lens and finder. Distinguish among three different versions of the reflex-finder principle.

"Plain" reflex cameras utilize the reflex principle in the form of a waist-level finder. Perhaps the best known representatives of this type are the now obsolete Graflex and the modern Hasselblad.

Pentaprism-equipped single-lens reflex cameras utilize the reflex principle in the form of an eye-level finder. Well-known representatives are the Leicaflex, the Nikon, and the Pentax.

Twin-lens reflex cameras avoid two minor shortcomings of both the "plain" and the pentaprism-equipped single-lens reflex camera design: image

blackout at the instance of exposure and the possibility of "mirror shock"—the accidental blurring of the picture due to the "bang" of the up-swinging mirror. On the other hand, they are larger and heavier than single-lens reflex cameras of the same film format and preclude the possibility of visually checking the extent of the sharply covered zone in depth. Perhaps the best-known representatives of this type are the Rolleiflex and the Mamiyaflex.

Lens-coupled rangefinder. The principle: The image of the subject, which in this case is produced by a separate finder lens (that is, not by the lens that takes the picture), is split into two parts, one stationary, the other movable and connected via a rotating mirror or prism and a cam coupling to the focusing device of the lens that takes the picture. Focusing the lens moves this part of the image relative to the stationary one; when the two match, the lens is correctly focused. The advantages of rangefinder focusing are speed and accuracy and the fact that this device takes less space than a reflex system, is quiet, and precludes the possibility of mirror shock.

But there are drawbacks, too, the reason why this type of camera is gradually losing in popularity: The finder image is rather small, making it difficult or impossible to see details of composition clearly. Furthermore, rangefinders cannot be used at subject distances shorter than approximately three feet, in conjunction with telephoto lenses of more than moderate focal lengths, or when the subject does not have sharply defined edges or lines. They do not show the extent of the sharply covered zone in depth. And, finally, they may get out of synchronization with the lens without the photographer's noticing this in time, resulting in unsharp negatives.

CONTROLS FOR EXPOSING

Exposing means admitting the right amount of light to the film to produce a negative of desired density and contrast. This is accomplished with the aid of two controls.

The diaphragm, which regulates the "effective" diameter of the lens, thereby admitting more or less light to the film.

The shutter, which regulates the length of time that light is admitted to the film. Distinguish between two basically different types of shutters:

between-the-lens shutters, which are built into the lens

focal-plane shutters, which are built into the camera

The first type is generally more reliable and permits speed-light synchronization at any shutter speed. The second type permits higher shutter speeds but requires the use of special focal-plane-type flashbulbs and can be synchronized for speed-light operation only at relatively slow speeds. Most single-lens reflex and 35 mm. rangefinder cameras are equipped with focal-plane shutters; all twin-lens reflex and view cameras have between-the-lens shutters. Some press cameras are equipped with both types of shutters, each of which can be used separately as the occasion may require.

The following diagram shows the relationship between the different camera controls and their effects.

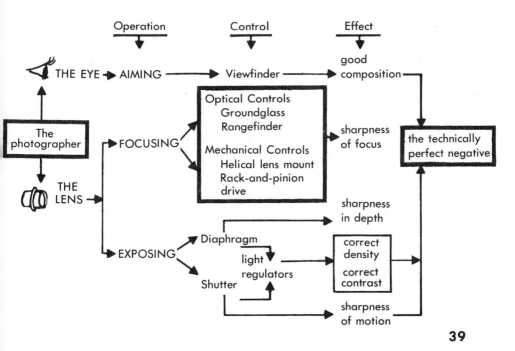

The Lens

There are more different types and sizes of lenses than there are breeds of dogs. However, *all* lenses, whether simple or complex, have certain fundamental qualities in common and are subject to the same optical laws. As stated previously: You do *not* have to know *how* a lens produces an image; you do *not* have to know the laws of optics; you do *not* have to know what refraction is, or astigmatism, spherical aberration, curvature of field, coma, or nodal points, in order to be able to select *your* lens intelligently and to use it to best advantage. All you have to learn is the meaning of three terms:

focal length
relative aperture
covering power

THE FOCAL LENGTH OF A LENS

The focal length of a lens determines the scale of the image on the film: the longer the focal length, the larger the image. Focal length and image size are directly proportional: A lens with twice the focal length of another lens produces an image twice as large as that produced by the "shorter" lens. Consequently, if a photographer wants to increase the scale of rendition, one way to do so is to use a lens with a longer focal length.

The focal length of a lens is the distance from lens center (approximately)* to film at which the lens produces a sharp image of an object that is infinitely far away, for example, the sun. To estimate roughly the focal length of an "ordinary" lens (one that is neither a telephoto nor a retrofocus wide-angle lens, each of which works according to a different principle), hold it up to the sun and measure the distance at which it produces the smallest, sharpest and hottest image. However, if you project the image onto the palm of your hand, be careful not to get burned. A photographic lens is basically nothing but a burning glass, and on a sunny day you can light a cigarette with it.

* More accurately, the *node of emission,* which in telephoto and retrofocus wide-angle lenses may lie outside the lens.

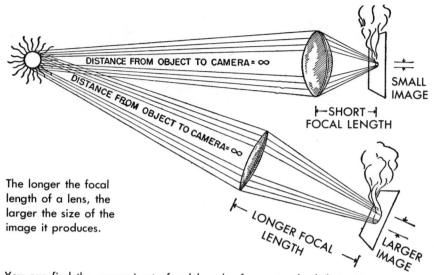

DISTANCE FROM OBJECT TO CAMERA = ∞

SMALL IMAGE

├─ SHORT ─┤
FOCAL LENGTH

DISTANCE FROM OBJECT TO CAMERA = ∞

LONGER FOCAL LENGTH

LARGER IMAGE

The longer the focal length of a lens, the larger the size of the image it produces.

You can find the approximate focal length of any standard (but not telephoto, retrofocus wide-angle, or zoom) lens by holding it up to the sun and measuring the distance (from its center) at which it burns a hole into a piece of paper.

The focal length of a lens is measured either in millimeters, centimeters, or inches and is normally engraved on the lens mount. The focal length is the shortest distance between the node of emission and film at which the lens will still produce a sharp image. In this position, the lens is said to be focused "at infinity." If sharp images of closer subjects are to be produced, the distance from lens to film must be increased in accordance with the lens-to-subject distance—the lens must be "focused." For example, to produce an image that is the same size as the subject (rendition in natural size, or 1:1), the distance from approximately lens center (more precisely, node of emission) to film must be twice the focal length of the lens; and, in order to produce an image in twice the natural size (of an extremely close, tiny subject like an insect), distance from lens center to film must be three times the focal length of the lens; and so on. The shortest subject-to-lens distance at which a lens can still produce a sharp image is equal to the focal length of the lens. In such a strictly hypothetical case, however, distance between lens and film would have to be infinitely great.

41

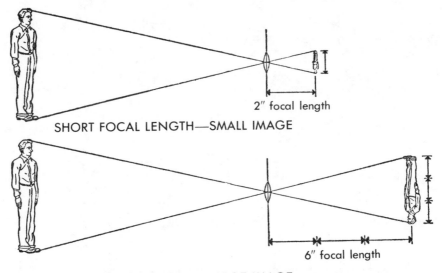

SHORT FOCAL LENGTH—SMALL IMAGE

LONG FOCAL LENGTH—LARGE IMAGE

According to their focal lengths, lenses are frequently referred to as "standard", "short focus," and "long focus" lenses. Such a classification, however, is not absolute. The same lens that has a relatively short focal length when used to cover a large negative has a relatively long focal length when used to cover a negative of small size. For example, a *wide-angle lens* for an 8 × 10-inch camera may have a focal length of 6 inches. This same lens, however, if used on a 4 × 5-inch camera, would act as a *standard lens* because the "normal" focal length for a 4 × 5-inch negative is 6 inches. And if used on a 35 mm. single-lens reflex camera, this same lens, which originally was a wide-angle lens, would now act as a *telephoto lens,* for the "standard" focal length of a 35 mm. camera is somewhere around two inches.

The normal or standard focal length for any camera is roughly equal to the length of the diagonal of the respective negative. Any lens with a focal length *greater* than the diagonal of the negative is a *long-focus* lens; if its focal length is *shorter* than the diagonal of the negative, it must be considered a *short-focus* lens.

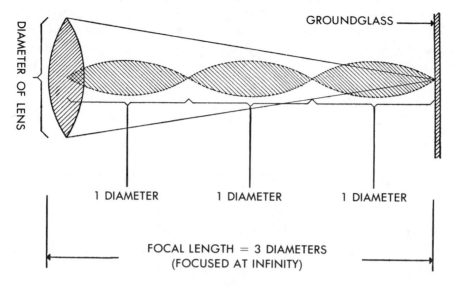

THE RELATIVE APERTURE OF THIS LENS IS f/3

GROUNDGLASS

DIAMETER OF LENS

1 DIAMETER 1 DIAMETER 1 DIAMETER

FOCAL LENGTH = 3 DIAMETERS
(FOCUSED AT INFINITY)

THE RELATIVE APERTURE OF A LENS

The relative aperture of a lens is the measure of the light transmission of the respective lens. The larger the diameter of a lens in proportion to its focal length, the larger its relative aperture, the more light it admits to the film, and the higher its "speed."

The relative aperture of a lens cannot be measured directly as can the focal length, for it is a function of two factors: lens diameter and focal length. It is expressed in the form of a ratio: *relative aperture equals focal length divided by the diameter of the front surface of the lens.** It is expressed in *f-numbers*. If, for example, the diameter of a lens is 40 mm. and its focal length is 56 mm., all you have to do to determine roughly its relative aperture is to divide 56 by 40; you get as a result an f-number of 1.4. This f-number can be written in several ways: either as f.1.4, or as f/1.4, or as 1:1.4.

* Strictly speaking, this is not quite correct. Actually, to determine its relative aperture, the *effective diameter* of a lens must be used; it is usually a fraction larger than the diameter of the front surface of the lens.

To understand better the importance of the relationship between lens diameter and focal length, let us consider an analogy: Imagine a circular window with a three-foot diameter. This window illuminates a small room, and the distance between the window and the opposite wall is nine feet. Then imagine a second room, illuminated by a circular window with a three-foot diameter. But this room is twice as deep: The distance between window and wall is eighteen feet.

Obviously, despite the fact that both windows are of equal size, the second wall must receive less light than the wall in the first room, for it is farther away from the window. Actually, because the wall in the second room is twice as far away from the window as the wall in the first room and because light intensity is inversely proportional to the square of the distance between the light source and the illuminated object, the wall in the eighteen-foot room receives only one-quarter of the illumination of that in the nine-foot room, even though it is only twice as far from the window.

This example should make it clear why the formula for the "speed" of a lens must include *two* factors: diameter and focal length. By itself, the diameter tells us nothing about the speed of a lens. Only if we know the distance between the lens (the window) and the film (the wall) can we compute the amount of light that will reach the film (the wall) and determine the exposure. The simplest way to express the values of *both* lens diameter and focal length in *one* formula is in the form of a ratio: *focal length divided by lens diameter*. According to this formula, the f-number of the three-foot window in the nine-foot room is 9:3 or f/3, whereas the f-number of the three-foot window in the eighteen-foot room is considerably lower—to be exact, 18:3 or f/6.

A fact that seems to cause the beginner considerable trouble is that, *the higher the speed* of a lens, *the lower its f-number*. An f/1.4 lens is considerably faster than an f/2.8 lens which in turn is much faster than an f/5.6 lens, and so on. Why this is so was explained by the analogy above—lens speeds are expressed *in the form of a ratio*: focal length divided by effective lens diameter.

44

The relative aperture is equivalent to the largest diaphragm opening of a lens. This diaphragm opening indicates its highest possible "speed." However, shooting pictures with the lens "wide open" is not always desirable for two reasons.

1. The larger the diaphragm opening, the smaller the extension of the zone of sharpness in depth (the *depth of field*).

2. The larger the diaphragm opening, the greater the danger of overexposure. When the light is extremely bright (at the beach, in snow scenes, and the like), the shutters of most cameras do not provide speeds that are fast enough to avoid overexposure if the picture is taken with the lens wide open.

The diaphragm is the means for reducing the relative aperture of a lens—for "slowing it down," for "reducing its speed." It is built into the lens and calibrated in *f-numbers*, which are computed by dividing the focal length by the diameter of the respective diaphragm opening. Diaphragm openings, or *f-stops* as they are commonly called, are *calibrated in such a way that each consecutive f-stop number requires twice the exposure of the preceding larger diaphragm opening—the smaller f-stop number.* In other words, *as the diaphragm aperture is reduced from one f-number to the next, the exposure must be doubled.* The following table shows the relationship among f-numbers, comparative exposure factors, sharpness in depth, and brightness of the groundglass image.

f-stop numbers	1	1.4	2	2.8	4	5.6	8	11	16	22
comparative exposure factors	1	2	4	8	16	32	64	128	256	512

diaphragm openings get larger
f-stop numbers get smaller
sharpness in depth decreases
exposure times decrease
groundglass image brightens

diaphragm openings get smaller
f-stop numbers get larger
sharpness in depth increases
exposure times increase
groundglass image darkens

The ratio between exposures at different f-numbers is equivalent to the ratio of the f-numbers multiplied by themselves.

For example: The ratio of f/2 to f/8 is equal to $(2 \times 2) : (8 \times 8)$, which is equivalent to 4:64 or 1:16. If we had to expose $^1/_{125}$ sec. at f/2 but wanted to stop down to f/8, we should therefore have to expose $^1/_{125} \times 16 = {}^{16}/_{125}$ or approximately $^1/_8$ sec. in order to get a negative with the same density.

F-numbers indicate the brightness of the image on the groundglass or at the film plane. For example, an f-number of 5.6 always indicates the same degree of brightness of the image—and requires the same exposure (shutter speed)—regardless of whether it represents the relative aperture (the highest possible "speed") of an f/5.6 lens or the diaphragm stop of an f/1.4 lens stopped down to 5.6. And it makes no difference whether the lens is a giant telephoto lens for a 4 × 5-inch camera or a tiny wide-angle lens for a 35-mm. camera—as long as each has a relative aperture of f/5.6 or is stopped down to f/5.6, there is no difference as far as image brightness and exposure are concerned.

Lens speed and close-up

The speed of a lens is not absolute but depends on the lens-to-subject distance. Remember that the "speed" of a lens is a function of both focal length and lens diameter. "Focal length," however, is merely a shorter term for "distance between lens and film when the lens is focused at infinity." When the lens is *not* focused at infinity but on a closer subject, distance between lens and film increases—the closer the subject, the greater the distance between lens and film. And, as "distance from lens to film" is part of the formula for the "speed" of a lens, any change in this distance must, of course, affect this formula.

Minor increases in lens-to-film distance above the focal length can safely be disregarded. The resulting loss in lens speed is so slight that the ability of the film to absorb a certain amount of underexposure (its *exposure latitude*) will compensate for it. However, *focusing on a very near subject* increases distance between lens and film to such an extent that the resulting loss of lens speed would cause serious underexposure unless compensated for by a

46

proportional increase in exposure. To refer to the analogy of the window and the two rooms: If the nine-foot distance from window to wall corresponds to the "focal length of the window," we arrive, by the computations shown, at a "speed" of f/3. But, if the same window lens were used to make a close-up with the image in natural size, the window-to-wall distance would have to be increased to twice the "focal length of the window lens" for the subject to be in focus. This would require a window-to-wall distance of eighteen feet—the same as the window-to-wall distance of the second room. However, as we have explained, the "effective" speed of the window lens would then be f/6, only one quarter of what it was when focused at "infinity."

Such a serious loss of lens speed affects, of course, the exposure. As the intensity of an illumination is inversely proportional to the square of the distance between light source (in this case, the lens) and illuminated object (in this case, the film),* focusing a lens on a close subject for rendition in natural size (requiring a lens-to-film distance equal to twice the focal length of the lens) increases the exposure 2^2 times relative to the exposure indicated by an exposure meter; and 2^2 equals 4! In other words, provided that the brightness of the illumination is identical to, for example, that of outdoors in direct sunlight, *close-ups in natural size must be exposed four times as long as shots focused at infinity*.

The necessary increase in exposure for any lens-to-film distance greater than the focal length of the lens can be computed with the aid of the following formula:

$$\frac{\text{lens-to-film distance} \times \text{lens-to-film distance}}{\text{focal length of lens} \times \text{focal length of lens}}$$

For example, we want to take a close-up of a flower, using a lens with a focal length of two inches. The distance between lens center and film after focusing should measure three inches. To find the exposure factor for this particular setup we use the following equation:

* Strictly speaking, this is true only if the light source is a point. If it is an area (like the diaphragm aperture of a lens), matters are slightly different—but not so much that they seriously affect this formula, which remains accurate enough for average photographic purposes.

$$\frac{3 \times 3}{2 \times 2} = \frac{9}{4} = 2\frac{1}{4}$$

This means that we must expose our flower 2¼ times as long as the exposure meter indicates. For example, if the meter indicates an exposure of 2 seconds at f/32, we now have to expose 2 × 2¼ or 4½ seconds at f/32 in order to get a correctly exposed negative. Or do we?

Actually, in this case, even an exposure time of 4½ seconds would be inadequate because, with such a long exposure, another factor must be considered: *reciprocity failure*. What this means will be discussed later. Here it must suffice to say that the exposure must be doubled once more: *not by increasing the exposure time but by increasing the diaphragm aperture by one full stop*, from 32 to 22, which would give us a final, correct exposure of 4½ seconds at f/22 (instead of 2 sec. at f/32, as indicated by the exposure meter). The following table shows the ratio between close-up and corresponding increase of exposure.

p. 126

	Subject-to-lens distance in multiples of focal lengths						Lens-to-film distance in multiples of focal lengths							
	∞	100	20	10	5	3	2	2	2½	3	4	5	6	7
Image magnification	0	.01	.05	.11	.25	.50	1 Natural size		1½	2	3	4	5	6
Exposure factor	1	1.02	1.11	1.23	1.56	2.25	4		6	9	16	25	36	49

For practical purposes, increases in exposure are necessary only if the subject-to-lens-center distance is shorter than approximately five times the focal length of the lens (see the arrow in the table). From that point on, however, the shorter the subject-to-lens distance (or the greater the distance from lens to film), the higher the exposure factor. For such close-ups, exposure times as indicated by the exposure meter must be multiplied by the applicable factor if the result is to be a "technically perfect negative," but with one exception: *If the exposure is determined with the aid of an exposure*

meter built into the camera, which measures the subject brightness through the lens, then these considerations do not apply because the close-up factor is already included automatically, and the exposure indicated on the meter is correct.

The Effective Aperture Kodaguide made by Kodak is an ingenious little device for immediate determination of the exposure factor for close-ups. It consists of a card with attached dial, which, after proper setting, shows both the exposure factor and the corresponding degree of magnification.

THE COVERING POWER OF A LENS

The covering power determines whether or not a lens can be used in conjunction with a certain negative size. The greater the covering power of a lens, the larger the negative size that it will "cover" (relative to the focal length of the lens).

Covering power has nothing to do with focal length. A lens with a long focal length may have very little covering power or vice versa. The 3-inch telephoto lens of a movie camera, for example, has just enough covering power to cover the tiny rectangle of the cinefilm; the 3-inch standard lens of a Rolleiflex covers the much larger negative size of 2¼ × 2¼ inches; and the three-inch Zeiss Dagor f/9 wide-angle lens covers the comparatively huge negative size of 4 × 5 inches.

Any lens produces a circular image. However, the quality of this image is not uniform. It is always sharpest near the center, gradually becoming less sharp toward the rim of the circle. For photographic purposes, only the inner, sharply rendered part of the image is of use. The outer zones are valueless. For this reason, the negative size must always fit within the inner useful circle, the diameter of which consequently must never be smaller than the diagonal of the negative.

We can imagine this useful inner circle to be the base of a cone with its apex at the center of the lens when the lens is focused at infinity. The height of the cone would then be equal to the focal length of the lens. The angle formed by the sides of this cone is the measure of the covering power of a lens. Standard lenses cover angles of approximately 45 to 55 degrees; telephoto

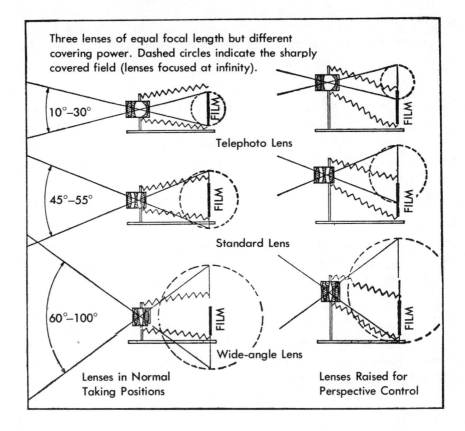

Three lenses of equal focal length but different covering power. Dashed circles indicate the sharply covered field (lenses focused at infinity).

10°–30°

FILM

Telephoto Lens

45°–55°

FILM

Standard Lens

60°–100°

FILM

Wide-angle Lens

Lenses in Normal
Taking Positions

Lenses Raised for
Perspective Control

lenses cover narrower angles, whereas wide-angle lenses cover angles of 60 to 130 degrees. A few super wide-angle lenses—the so-called *fish-eye lenses*, which yield pictures in spherical perspective—cover angles up to 220 degrees, which means that such lenses can literally "shoot backwards."

The covering power of most standard lenses is just about sufficient to cover sharply the negative sizes for which they are intended. This is satisfactory as long as such lenses are used in cameras without "swings" * or facilities for raising or lowering the lens. *Lenses intended for use on swing-equipped cameras must have greater than "standard" covering power.* Otherwise, use

* A provision for independent adjustment of camera front and back, a requirement for perspective control; see the accompanying drawing.

of the "swings" or raising and lowering the lens would cause part of the picture to fall outside the sharply covered circle; as a result only part of the image would be sharp. For this reason, it is advisable to use the wide-angle lens of a 5 × 7-inch camera as a standard lens on a 4 × 5-inch swing-equipped view camera. Its focal length would be identical to that of a standard lens for 4 × 5 inches—say, 6 inches—but the covering power of the wide-angle lens would be considerably greater than that of the standard lens. With this additional covering power, perspective can be controlled and sharpness still maintained even though full use of the "swings" is made.

The covering power of most lenses increases as the diaphragm is stopped down. In some cases, this increase is so considerable that the stopped-down lens will cover a negative one size larger than the negative it covers at full aperture (for example, the Goerz Dagor lenses for 4 × 5-inch and larger cameras). Whenever it is desirable that the entire negative be perfectly sharp, the lens should be stopped down to the smallest practicable f-stop to utilize its full inherent covering power.

The covering power of every lens increases as the lens-to-subject distance decreases. This phenomenon is especially useful for making close-up photographs in natural and more than natural size. When the bellows or extension tubes of a camera are too short to yield the lens-to-film distance required for such close-ups, the problem can often be solved by substituting a lens of shorter focal length for the standard lens. Lenses with focal lengths of 1 to 3 inches are especially suitable for close-up photography with 4 × 5-inch cameras. For example, a lens with a focal length of 1 inch, originally designed to cover nothing larger than a 16-mm. movie-camera frame, will cover a 4 × 5-inch negative perfectly at a distance of 10 inches from the film, where it will produce an image nine times magnified.

BASIC QUALITIES

Modern films are available in a great variety of different types, each especially well suited to certain specific purposes. To ask a clerk in a photo store for "a roll of film" without further specification would be as foolish as to ask him for "a camera" without specifying the type and size. A certain amount of theoretical knowledge is required to select and use the proper film, as it is required to select a camera or lens. But, just as in the case of a camera or lens, all the different types of film (negative material) can be classified by variations of a few basic qualities. Once a photographer is familiar with these fundamental properties of negative material, he will be able to evaluate any type of film and to determine which film each type of work requires.

Films vary in the following six major qualities:

> **type**
> **size**
> **color sensitivity**
> **speed**
> **graininess**
> **gradation**

Apart from these differences and the resulting differences in exposure time and method of development, all negative material must be treated according to the following rules as far as handling and storing are concerned.

TEN DOS AND DON'TS

1. Don't touch the film emulsion with your fingers—indelible spots caused by the always present acid moisture of the skin may result.

2. When handling negatives, hold them by the edges only, for the reason stated in rule 1.

3. Negative material should be stored in a cool dry place. Dampness and heat slowly destroy unexposed film and slowly but inevitably deteriorate finished negatives. In summer, for instance, the glove compartment of a car is much too hot a place for keeping film.

4. Always load your camera in the shade. No "daylight-loading" film is so thoroughly protected against light that if can stand direct exposure to the sun without fogging along the edges. If there is no shade, turn away from the light and use the shadow cast by your body.

5. When buying film, look at the expiration date stamped on the wrapping—it is your guarantee of freshness. Old film may have lost some of its speed, may be less contrasty and partially or wholly fogged.

6. Make sure that roll film is always wound tightly. Don't let it loosen when loading the camera, or your negatives may become light-struck. Thread the endpaper carefully into the slot of the take-up spool. Fold it over sharply so that it does not make a bulge, or the film may become light-struck.

7. Film packs are very delicate. Hold them by the edges only. Don't squeeze them by pressing on their flat sides, or light may penetrate and fog the film.

8. On cold and dry days, wind 35 mm. and roll film s-l-o-w-l-y. Otherwise, friction may generate static electricity, which causes *discharge marks*. Similar considerations apply to film pack, the tabs of which must likewise be pulled slowly in addition to being pulled straight and all the way out until a straight line shows; otherwise, all the following exposures will be partly cut off by the end of the incompletely pulled film.

9. When loading sheet-film holders, make sure that the emulsion side faces the slide. All sheet film has identification notches, which differ for each make and emulsion type. The emulsion side faces you if the film is held vertically and the notch appears in the upper right-hand corner.

10. When shooting pictures in very bright light, don't leave the camera uncovered longer than necessary, to avoid the possibility of light-struck film. If you use film pack or sheet film, cover the slot of the holder with the slide or the focusing cloth as long as the slide is pulled.

THE TYPES OF FILM

Distinguish among four types of negative material with the following characteristics.

Roll film. Long strips of film wound on a spool containing material for 8 to 72 (half-frame 35 mm. film) consecutive exposures, depending on the size of the film and the individual *frame* (negative). Roll film is available in a number of different emulsions and sizes, from subminiature (8 mm. movie film) to film 10 inches wide by 100 feet long for large aerial cameras.

Roll film is the most compact form of negative material. It is easily loaded in daylight and easier to use and process than any other type. Its disadvantages in comparison to other types: Individual shots cannot be processed individually, and it is impossible to change from one emulsion type to another (for example, from black and white to color) without sacrificing the remaining unexposed portion of the roll (unless the camera provides for the use of interchangeable roll-film magazines, which make it possible to change from one roll of film to another without losing a single frame).

Sheet film. Individual sheets of film with a relatively heavy base. Sheet film must be loaded individually into separate holders. It is available in a great variety of different emulsions and in sizes from $2\frac{1}{4} \times 3\frac{1}{4}$ inches to 8×10 inches and larger.

Advantages: Sheet film is cheaper than film pack and usually stays flatter in the holder than film-pack sheets, which are much thinner. Individual shots can be processed individually without waste of film. Switching from one emulsion type to another is possible at any time without loss of film.

Disadvantages: Loading must be done in the darkroom. Each holder takes only two sheets of film, one on either side. In weight and bulk, material for only half a dozen shots takes as much space as the camera itself.

Film pack. Sixteen individual sheets of film are packed flat in a container called a cassette. It is available in only two sizes: 3¼ × 4¼ inches and 4 × 5 inches. Film pack combines the ease of handling of roll film, with the advantage that individual shots can be processed individually and exposed sheets taken from the pack without sacrificing the rest. It can be loaded and unloaded in daylight; as each film pack is in a separate adapter, changing to sheet film or color is possible at any time without sacrificing unexposed film.

Disadvantages: Film pack is the most expensive form of black-and-white negative material. Humid atmospheric conditions may cause the thin sheets to buckle out of the plane of focus, resulting in unsharp negatives.

Glass plates are nowadays used only for making slides for projection, color-separation negatives, photoengraving, and certain scientific purposes, particularly in astronomy, where flatness is a vital prerequisite.

THE SIZES OF FILM

Different sizes of negative material offer different advantages and disadvantages. For those photographers who haven't quite decided yet whether to buy large, medium, or small cameras, the following considerations may be of aid in making a choice.

Large negatives (4 × 5 inches) have the following advantages over smaller sizes.

Sharper pictures. Large negatives require proportionally less magnification during enlarging than small negatives. Rendition of texture is better, as are detail and definition, particularly in shots of distant subjects.

Smoother tone values and richer gradation. Because the degree of enlargement is usually low, tone values are not "torn apart" until the film grain becomes apparent and breaks up the smoothness of the gray shades.

Less danger of unwanted "grain." Large film sizes require less negative magnification to yield effective enlargements than do smaller sizes; they also permit the use of standard developers, which are faster, cheaper, and **p. 164** simpler to use than special fine-grain developers.

p. 164

Higher effective film speed. Virtual elimination of the danger of "grain" permits the use of standard developers. Unlike many fine-grain developers, these developers do not require increases in exposure; on the contrary, they enable a photographer to "push" or "force" his negatives during development for additional gains in film speed.

Compositional advantages. As very high degrees of magnification are usually not necessary, relatively small sections of the negative can be enlarged to become effective pictures—a simple substitute for a moderate telephoto lens. Cutting off superfluous subject matter strengthens the composition and increases the impact of the picture.

Film processing is easier, for specks of dust and lint, minute scratches, and other blemishes do not show half as much as in enlargements made from smaller negatives, where magnification is much higher.

Against these advantages, the following shortcomings must be weighed.

Considerably higher cost per exposure.

Bulk and weight of the negative material—two sheets of 4 × 5-inch film in a holder take more space than material for 300 shots on 35 mm. film.

Larger, heavier cameras are, of course, needed for handling large negatives; this means slower and more conspicuous operation, which in turn restricts the photographer in the choice of his subjects. Less extension of sharpness in depth exists at any given f-stop because lenses with longer focal lengths are required. If depth is necessary, smaller diaphragm stops and correspondingly slower exposure times must be used.

Small negatives (35 mm.) have the following advantages over larger sizes.

Considerably cheaper per exposure.

More pictures can be taken of each subject, for film cost is relatively low. This ensures more complete coverage and reduces the danger of missing the dramatic climax, the peak of action, or the most expressive gesture.

Equipment is compact and light and thereby permits rapid and inconspicuous shooting. Capacious film magazines contain material enough for entire

56

picture series, and rapid-winding mechanisms permit shooting of pictures at a rate of several frames per second.

High-speed, fish-eye, and zoom lenses are available only for 35 mm. cameras. In the longer focal lengths necessary to cover larger negative sizes, such lenses would be prohibitively heavy and costly.

Superior sharpness in depth exists at any f-stop due to the shorter focal lengths of the lenses, permitting the use of generally higher shutter speeds.

Negative material for 200 exposures takes less space than a package of cigarettes.

Against these advantages, the following shortcomings must be weighed.

Inferior sharpness of the picture, especially noticeable in big enlargements.

Danger of film grain is always present. To minimize film grain, slower fine-grain films and speed-reducing fine-grain developers may be required.

Inferior gradation because of the need for higher negative magnification during enlarging, which tends to "tear apart" the tone values.

Loss of "effective" film speed for reasons explained under "danger of film grain."

More exacting processing because higher degrees of enlargement bring out specks of dust and lint, scratches, and other blemishes. And ultimately, in spite of all precautions, the photographer still ends up with prints that are technically inferior to those made from larger negatives, for reasons already stated.

CONCLUSIONS

Large film sizes are recommended for the photographer who specializes in inanimate subjects, the slow and deliberate worker, the man with a calm temperament, the perfectionist who insists on highest technical quality, who enjoys texture, sharpness, and superfine defini-tion.

Small film sizes are recommended for the documentary photog-

rapher who looks for "life" rather than "texture," the fast and impulsive worker, the man with the quick temperament and the itchy trigger finger, the traveler who wishes to travel light.

Medium film sizes (2¼ × 2¼ inches and 2¼ × 2¾ inches) are recommended for the average amateur.

<div align="right">

THE COLOR SENSITIVITY OF FILMS

</div>

In black-and-white photography, subject colors are translated into shades of gray. In order to obtain pictures that look as natural as possible, the brightness values of these must correspond as nearly as possible to the brightness values of the colors that they represent. For example, yellow, a light color, should be translated into a lighter shade of gray than blue, which to the eye appears darker. To accomplish such translation of color into corresponding shades of gray, black-and-white film is "color-sensitized." Unfortunately, no black-and-white film exists as yet that permits the *simultaneous* translation of *all* colors into *precisely* corresponding shades of gray. And, because for different purposes differently color-sensitized black-and-white films are needed, we must distinguish among the following types of negative emulsion.

Blue-sensitized films are sensitive only to ultraviolet radiation, violet, and blue and "blind" to all other colors. As a result, they render blue as white; red, orange, yellow, and green are rendered as black. Today, such emulsions are used only for certain special purposes (astronomy, photoengraving, and the like) for which this lack of general color sensitivity is a virtue, not a fault. For ordinary photographic purposes these films are, of course, completely unsuitable.

Orthochromatic films are more or less sensitive to all colors, with the exception of red, which they render as black. They are, however, over sensitive to blue, which they render too light. Whenever necessary, this oversensitivity to blue can be corrected by using a yellow filter.

p. 104

The use of orthochromatic films is indicated whenever it is desirable to render reddish and pink tones darker than their actual brightness value. In

portraiture, for example, this insensitivity of orthofilms sometimes improves the rendition of skin tones. Aside from such special purposes, orthochromatic films are used mostly by beginners because they can be developed by red light (one can see what one is doing) or simply because they are less expensive than the all-color-sensitized panchromatic films compared to which they are inferior in color rendition and smoothness of gray shades.

Panchromatic films are more or less sensitive to all the colors of the spectrum. They are, however, over sensitive to blue and red, which they render somewhat lighter than they appear to the eye; they are also somewhat insensitive to green, which they render too dark. These shortcomings can be corrected by means of special *correction filters*.

pp. 71, 104

Because of their sensitivity to all colors, panchromatic films must be developed in total darkness by the *time-and-temperature method*. Particularly for the development of roll film, however, this method is unquestionably the best for producing consistently good results since, for technical reasons, individual treatment of single frames is impossible. Consequently, because development in total darkness is no disadvantage and sensitivity to all colors is definitely most desirable, panchromatic films must be considered the best general-purpose negative material available today.

p. 176

Infrared films have panchromatic emulsions whose sensitivity to red has been extended beyond the visible spectrum into the invisible infrared. Infrared radiation is heat radiation, and consequently it is possible, for example, to photograph a hot flatiron in total darkness on infrared film. As infrared radiation has extraordinary haze-penetration power, infrared-sensitized films are particularly well suited to telephotography and aerial photography when atmospheric mist and haze are too dense to permit the use of other negative material. Even though a distant view may be completely invisible to the naked eye, it may still register with perfect clarity on infrared film.

For everyday purposes, infrared material is not suitable because of the unnatural way in which certain colors are rendered. Blue water and sky, for example, are black in infrared pictures, and green foliage and meadows appear snow white. This strange rendition, however, has nothing to do with

the actual colors of the subject; it depends entirely on whether or not and to what a degree an object reflects or absorbs infrared radiation. As such radiation is invisible, there is no way to predict how light or dark a certain color will appear when photographed on infrared film. Blue water and sky appear black in infrared pictures, *not* because they are blue, but because they absorb infrared radiation. And foliage and meadows appear white, *not* because they are green, but because chlorophyll strongly reflects infrared radiation.

As infrared emulsions are also sensitive to ordinary light, it is necessary to use special filters in order to get the typical infrared effect. For most purposes the Kodak Wratten Filters 15, 25, and 29 are perfectly adequate, even though they transmit some visible light. If a photograph must be taken entirely by infrared radiation, a special *black* filter like the Kodak Wratten Filter 87 or 89B must be used. For best results, follow the recommendations on the instruction sheet that accompanies the film.

Ultraviolet. All photographic emulsions are highly sensitive to invisible ultraviolet radiation. Normally, this is of no consequence, for, under ordinary conditions, the ultraviolet content of daylight is negligible. At high altitudes (aerial and mountain photography), however, ultraviolet can become so strong as to amount to a photographic nuisance. Ordinary lenses are not corrected for ultraviolet radiation, which they focus in a plane different from that of visible light. As a result, an unsharp UV image is superimposed upon the sharp image made by visible light. As long as the UV image is weak, it remains "invisible." But if the UV radiation becomes too strong, the out-of-focus image created by its action causes "mysterious" unsharpness of the negative. To avoid this, a special ultraviolet-absorbing filter (like the Kodak Wratten Filter No. 2-B), which prevents the ultraviolet from reaching the film, must be used.

THE SPEED OF FILMS

To make accurate exposure calculations possible, specific *speed numbers* have been assigned to all films; they provide the basis for setting the dials of an exposure meter. These numbers express a film's sensitivity to light: The

higher the number, the more sensitive, or *faster*, the film, the shorter the exposure, and the smaller the diaphragm stop that can be used to extend sharpness in depth. Fast films produce well-exposed negatives under conditions in which slower emulsions must fail—when light is poor, when the highest shutter speeds must be used to "freeze" fast-moving subjects, or when the smallest diaphragm stops are needed to create maximum sharpness in depth.

For these reasons it may seem that fast films are *better* than slow ones. But actually the opposite is true. Most high-speed films have two undesirable qualities that become more pronounced as film speed increases: coarser grain and softer gradation. Consequently, *the best film is usually the slowest film that is still fast enough to do a perfect job*.

Unfortunately, no single universally accepted film-speed system exists as yet. Instead, three systems are in use simultaneously: the system of the United States of America Standards Institute (formerly American Standard Association, or ASA), the English B.S. system (British Standard), and the German DIN system (Deutsche Industrie Normen). Since a number of foreign films are available in this country and travelers in foreign countries may want to use their films, I give in the following table equivalent speed ratings for the three different systems.

American ASA and English B.S. film speed numbers																
800	640	500	400	320	250	200	160	125	100	80	64	50	40	32	25	20
30°	29°	28°	27°	26°	25°	24°	23°	22°	21°	20°	19°	18°	17°	16°	15°	14°
Equivalent German DIN film speed numbers																

NOTE: Different systems use different methods of measuring the speed of a film, as a result of which it seems doubtful that any reliable conversion table can be compiled. Therefore, the values given here must be considered only as approximations that have to be confirmed or corrected by individual tests.

The "effective" film speed

Film-speed ratings are not absolute. They are intended primarily as guides that may have to be modified to suit the individual needs of a photographer. As a result, the *effective* speed of a film may be different from the

speed assigned to it by its manufacturer. In this respect, the following should be considered.

"Pushing" or "forcing." By increasing the time of development, the rated speed of any film can be increased by 50 or 100 percent or more, the actual factor depending on the amount of increase in developing time. However, the price for this gain may be considerable: Compared to films that have been exposed and developed in accordance with the standard for the respective film, "pushed" or "forced" negatives are always more contrasty and grainy. The first effect, of course, may actually be an advantage when subject contrast is abnormally low and strengthening it in the negative becomes desirable, as, for example, in telephotographs taken over vast distances, in which contrast is usually very low due to the effect of intervening atmospheric haze. Forcing the negatives of contrasty subjects, however, usually ends in hopelessly blocked and unprintable highlights, a result well known to any photographer who has ever tried to "push" the speed of films exposed outdoors at night.

p. 164 **Type of developer.** Some fine-grain developers require certain increases in exposure (consult the manufacturer's instructions for use), the equivalent to decreases in the rated speed of the respective film. On the other hand, a few developers actually boost the effective film speed.

p. 59 **Type of light.** Not long ago, panchromatic films had two different speed numbers, one for daylight and one for tungsten (incandescent light) illumination. However, experience has shown that the response of photoelectric exposure meters to these two types of light is, as a rule, so similar to the response of panchromatic films that the same speed number can safely be
p. 58 used for both types of light. With blue-sensitized and orthochromatic films it is, of course, still necessary to use lower speed ratings for tungsten illumination than for daylight because these films are predominantly sensitive to blue, and tungsten light contains less blue than daylight.

Classification of films according to their speed

For practical purposes, films can be classified in three speed groups.

Slow thin-emulsion films with speeds ranging from 16 to 64 ASA are

62

characterized by extremely fine grain and comparatively contrasty gradation. These films are ideal for the photographer who uses a 35 mm. camera, for they enable him to make enlargements up to 16 × 20 inches that are virtually grainless—provided, of course, that the speed is not too slow for his particular type of work.

Medium-fast general purpose films with speeds ranging from 80 to 400 ASA are characterized by relatively fine grain and normal gradation. These are the typical all-round films, which in most cases produce the best results.

High-speed films with speeds ranging from 500 to 1600 ASA are characterized by coarse grain and relatively soft (low contrast) gradation. Films belonging to this group should be used only when light conditions are marginal, and their enormous speed is really needed to get any picture at all. They are totally unfit for photography in bright light, when even the fastest available shutter speed in conjunction with the smallest diaphragm stop might not be enough to prevent overexposure, which, with high-speed films, is tantamount to photographic disaster.

THE GRAIN OF FILMS

The light-sensitive component of photographic emulsions consists of innumerable tiny particles of silver salts. Development transforms the exposed silver salts into minute grains of metallic silver, which form the negative: The denser the layer of silver grains, the darker that part of the image. The individual grains are so small that they can be seen only under the microscope. However, under certain conditions, they clump together and accumulate to such a degree that they become visible in the enlargement. When this happens, the picture appears *grainy*. Graininess is always most prominent in the medium-gray shades, which lose their smoothness and appear as a sandpaper-like texture. Graininess, furthermore, destroys sharpness by making contours ragged.

Graininess is basically an inherent film quality. As a rule, the faster the film, the coarser the grain. However, in addition, the degree of graininess is subject to the following factors.

Exposure. Overexposed negatives are always more grainy than correctly exposed and developed films of the same type.

p. 164 **Developer.** Fine-grain developers produce negatives with a somewhat finer grain than standard developers. However, this advantage is sometimes connected with a certain loss of film speed; that is, films that are going to be developed in certain types of fine-grain developers must be exposed longer than films of the same type that will be developed in a standard developer.

Development. The size of the negative grain increases with prolonged development. On the other hand, shorter-than-normal development produces negatives with finer-than-normal grain.

Enlargement. The greater the enlargement, the more apparent the grain. This fact explains the comparatively high degree of graininess of most enlargements made from 35 mm. negatives.

Paper. The more contrasty the gradation of the sensitized paper, the more pronounced the film grain and vice versa. Consequently, gains achieved through shorter than normal development (which produces negatives of relatively low contrast) are valueless if they result in negatives so lacking in contrast that they must be printed on paper of hard (contrasty) gradation.

THE GRADATION OF FILMS

The gradation of a photographic emulsion is the quality that determines the manner in which it reproduces contrast. In this respect, we must distinguish the following three types of film:

Films with hard (contrasty) gradation produce negatives in which contrast between the light and the dark parts of the images appears higher than it appeared in the subjects. Please note that the term "appears" is used deliberately. Almost without exception, subject contrast in nature is higher than the image contrast of a negative. High-contrast, process, graphic-arts, and microfile films have extremely hard gradation suitable for the production of pictures in pure black and white without any intermediate shades of gray; slow thin-emulsion films have moderately hard gradation.

Films with medium (standard) gradation produce negatives in which contrast between the light and the dark parts of the image appears to the eye more or less as it appeared in the subject. These are the typical all-purpose films of medium-high speed, which in the majority of cases yield the best results.

Films with soft (low-contrast) gradation produce negatives in which contrast between the light and the dark parts of the images seems lower than it appeared in the subject. Most high-speed films belong to this group. Such films are particularly sensitive to overexposure, to which they react by producing hopelessly "flat", that is, contrastless, gray, and fogged, negatives.

As a rule, the higher the speed of an emulsion (both films and sensitized papers), the softer its gradation and vice versa. However, gradation is not an unalterable factor. Regardless of the group to which a film belongs, the gradation of the negative is always subject to the following factors:

Subject contrast. High-contrast subjects obviously produce more contrasty negatives than do subjects in which contrast is low. Subject contrast, therefore, is an important factor in deciding which type of film a photographer should use.

Illumination. Contrasty illumination with brilliant highlights and deep black shadows always produces negatives of higher contrast than does soft and diffused illumination. Controlling the contrast range of the illumination is therefore one of the most effective means of controlling the contrast range of the negative.

Exposure. Overexposure produces negatives of lower contrast than correctly exposed negatives; underexposure yields negatives of higher contrast.

Developer. Rapid developers increase, and fine-grain developers decrease negative contrast in comparison to negatives developed in a standard developer at comparable developing times. p. 164

Development. Prolonged development increases and shortened development reduces negative contrast in comparison to standard development.

For average needs, a film with a medium gradation is normally most suitable. Such films combine adequate speed with sufficiently fine grain. For special purposes, however, a film of softer or harder gradation may be preferable. If a very contrasty subject must be photographed, a film with a softer gradation will give better results because it permits the photographer to reduce natural contrast to a degree where it no longer exceeds the contrast range of the photographic paper. On the other hand, if a subject that is very low in contrast must be photographed, a film with a harder gradation may give better results because it enables the photographer to strengthen the weak subject and render it in a graphically more effective form.

CONCLUSIONS

The type of negative material. Roll film is the most compact form of negative material. It can be loaded in daylight and is easier to use and process than any other type.

Color sensitivity. Panchromatic films are the only films that are sensitive to all the colors of the spectrum. Why limit yourself voluntarily by using orthofilms, which are blind to one of the most important colors: red?

Speed. The "best" film is always the slowest film that is still fast enough to do a perfect job.

Film grain. The slower the film, the finer the grain. However, many additional factors influence the size of the grain. Wrongly treated, even fine-grain films can yield astonishingly grainy prints. On the other hand, properly processed, virtually grainless prints can be made from relatively fast films.

Gradation. For the average photographer, films with medium gradation offer the best compromise solution, combining sufficient speed with sufficiently fine grain. However, many other factors influence the gradation of a negative, and, treated correctly, any type of film can be made "harder" or "softer" (more or less contrasty) in accordance with the demands of the subject.

Accessories

The number of photographic gadgets and accessories available today is truly overwhelming. For example, the manufacturer of the Honeywell Pentax 35 mm. single-lens reflex camera alone offers more than 250 matched accessories designed for use with one single camera—the Pentax—from which the interested photographer can choose. And in photo magazines, about twice as many pages are devoted to advertisements of cameras, gadgets, and accessories as to editorial material. No wonder so many amateurs collect gadgets the way philatelists collect stamps—they are not satisfied until they own the whole line.

The serious amateur, however—the working photographer whose interest is in pictures and not in hardware—needs no more accessories than he can count on the fingers of one hand. Everything else may increase his fun in photography, but it certainly is not necessary for increasing the quality of his pictures. Apart from lighting and darkroom equipment, which will be discussed later, this is what he should have:

Exposure meter
Filters
Lens shade
Cable release
Tripod

EXPOSURE METER

The starting point of every "technically perfect negative" is correct exposure. To trust the outcome of the exposure to guesswork or experience is the sign *not* of a seasoned photographer but of foolishness. The human eye is a very poor instrument when it comes to measuring light intensities. It adapts itself so quickly to changes of brightness that they usually pass unnoticed. Most professional photographers are aware of this fact and, in spite of their experience, do not trust their eyes; they trust their exposure

meters. Being professionals, they cannot afford to miss on an exposure. Amateurs can do no better than to follow their example. Unless the camera features a built-in exposure meter, one of the soundest investments a photographer can make is a good exposure meter.

Exposure tables don't measure light intensities. They interpret light conditions in terms of everyday experience. They are reliable only within the limits of their applicability. But, because of their simplicity, they often prove more useful to the beginner than genuine exposure meters, which are much more accurate but also more difficult to use. Simple but adequate exposure tables are included in the instructions that accompany any package of roll film.

Extinction-type exposure meters, which are gradually becoming obsolete, can be used to measure any kind of illumination, but their accuracy depends to a considerable degree on the skill and experience of the user. With the meter aimed at the subject, the photographer looks through an eyepiece and, rotating a graded wedge, tries to determine the exact moment at which a number (or the scene as viewed through the aperture) becomes extinct. A calculator then indicates the correct data for diaphragm stop and shutter-speed setting. Such meters are relatively inexpensive.

Photoelectric exposure meters are fully automatic, giving the same results in the hands of an amateur and a seasoned "pro." When the meter is pointed at the subject (or at the camera, if incident light is measured), reflected light (or direct illumination) strikes a photoelectric cell, which generates an electric current in proportion to the intensity of the light. This current acts upon a measuring unit, which indicates light values in the form of numbers. Transferred to a calculator, these numbers are automatically translated into f-stops and shutter speeds. There are two types of photoelectric exposure meters.

Meters for measuring reflected light; they must be pointed from the camera position at the subject.

Meters for measuring incident light; they must be pointed from the subject position at the camera.

68

Meters of the first type are equally well suited to photographic work indoors and outdoors. Meters of the second type are excellent for indoor and studio work where several light sources are involved but, in my opinion, less suited to outdoor work, except at fairly close subject-to-camera distances. Most photoelectric exposure meters for reflected light can be transformed into meters for measuring incident light by means of an adapter. How to use an p. 119 exposure meter correctly will be explained later.

FILTERS

Filters change the response of a photographic emulsion to light of a certain color. They are used to render this color either lighter or darker in the print than it would have been rendered without a filter. For example, a fashion shot of a girl in a green dress trimmed with red must be made. The particular attraction of the dress is the vivid contrast between the green and the red. Photographed without a filter, both green and red would probably appear as gray shades of more or less equal value, and the effect of the dress would be lost. Even though such a rendition might be "true," as far as translation of the colors into shades of gray is concerned, in effect it would be an unsuccessful photograph—a flop.

Contrast filters

Unsatisfactory color rendition can be improved through the use of *contrast filters*. Photographed through a red filter, for example, the red of the trim would be rendered lighter and the green of the dress darker than would have been the case if no filter had been used. Thus, *color contrast* would be translated into *graphic contrast* of light and dark, and the effect of the garment could be retained in black and white.

Another example is the rendition of a blue sky with white clouds. In an unfiltered photograph, the cloud effect is usually more or less lost, owing to the oversensitivity of all films to blue, which they render too light. However, with the aid of a yellow filter, most of the sky blue can be prevented from

reaching the film, with the result that the sky is rendered in a dark shade of gray against which the white clouds can stand out effectively.

These examples contain the whole "secret" of filtering: In the first case, *red* was rendered *lighter* through the use of a *red* filter—a filter in the *same color* as the color that had to be rendered *lighter*. In the second case, *blue* was rendered *darker* through use of a *yellow* filter—a filter of a color that is *complementary* to the color that had to be rendered *darker*.

To *render a color lighter*, use a filter of the same color.
To *render a color darker*, use a filter of the complementary color.

Complementary color pairs are

red and blue-green
orange and blue
yellow and purple-blue
green-yellow and purple
green and red-purple

For selection of the correct type of *contrast filter*, consult the following table, which lists the most often used Kodak filters for color separation. Wherever several filters are listed in one box, the first will make the least and the last will make the greatest change in color rendition.

Color of subject	Kodak filter that will render color lighter	Kodak filter that will render color darker
red	G, A, F	C5, B
orange	G, A	C5
yellow	K2, G, A	80, C5
green	X1, X2, B	C5, A
blue	C5	K2, G, A, F
purple	C5	B

Correction filters

Although the contrast filters described intentionally falsify the color rendition of films, another type, the *correction filters*, are used for just the opposite purpose: to improve the accuracy of color rendition in black and white. As mentioned in discussion of the color sensitivity of films, no p. 58 black-and-white film as yet exists that permits simultaneous translation of all colors into precisely corresponding shades of gray. This deficiency can be overcome with the aid of *color-correction filters*, which partially absorb those colors to which the respective emulsion is oversensitive and thus restore the color balance. The following table lists the Kodak filters for use in color correction and the factors by which they prolong the exposure that must be used in conjunction with panchromatic Kodak films if a "true" or *monochromatic* color rendition is desired.

Kodak filters for monochromatic color rendition		
Illumination	Kodak filter	Filter factor
daylight	K2	2
photoflood	X1	3

Filter factors

It is the purpose of a filter to absorb part of the light that otherwise would be available for the exposure. Consequently, to compensate for this loss of light and to prevent underexposure of the negative, a corresponding increase in exposure becomes necessary when a filter is used. The amount of increase, the *filter factor* by which exposure must be multiplied, depends on three factors: the type of filter, the type of film, and the color of the illumination (daylight or incandescent light, predominantly bluish or reddish light). The following table lists the filter factors and applicable increases in diaphragm aperture for the most often used Kodak filters in conjunction with panchromatic film. For other filters, consult the respective manufacturer's instructions that accompany the filter.

Color of filter	Filter number	Daylight		Photolamps	
		Filter factor	Open lens by f-stops	Filter factor	Open lens by f-stops
light yellow	6 (K1)	1.5	$2/3$	1.5	$2/3$
yellow	8 (K2)	2	1	1.5	$2/3$
deep yellow	15 (G)	2.5	$1\frac{1}{3}$	1.5	$2/3$
yellow-green	11 (X1)	4	2	4	2
light red	23A	6	$2\frac{2}{3}$	3	$1\frac{2}{3}$
red	25 (A)	8	3	5	$2\frac{1}{3}$
green	58 (B)	6	$2\frac{2}{3}$	6	$2\frac{2}{3}$
blue	47 (C5)	6	$2\frac{2}{3}$	12	$3\frac{2}{3}$
deep red	29 (F)	16	4	8	3
polarizer (gray)		2.5	$1\frac{1}{3}$	2.5	$1\frac{1}{3}$

The following table shows the relationship between filter factor and f-stop. The figure below each factor indicates the number of f-stops the diaphragm must be opened when a filter with this factor is used, if underexposure is to be avoided.

Filter factor	1.2	1.5	1.7	2	2.5	3	4	5	6	8	12	16
Open diaphragm by the following number of f-stops	$1/3$	$2/3$	$2/3$	1	$1\frac{1}{3}$	$1\frac{2}{3}$	2	$2\frac{1}{3}$	$2\frac{2}{3}$	3	$3\frac{2}{3}$	4

If the filter factor is very high, it is often advisable to divide the required exposure increase between the f-stop and the shutter-speed setting. For example, if the required exposure *without* a filter is, say, $1/100$ sec. at f/16 and the filter has a factor of 8, instead of opening the diaphragm 3 stops and exposing $1/100$ sec. at f/5.6 (which might make the zone of sharpness in depth unacceptably shallow) or shooting $1/12$ sec. at f/16 (which might cause unsharpness due to movement of the subject or the camera), the photographer can "split the difference" and expose $1/50$ sec. at f/8 (or,

alternatively, $^1/_{25}$ sec. at f/11). The simplest way to find the best equivalent combination of f-stop and shutter speed is with the aid of the exposure meter: If the meter-indicated dial setting is reduced by the respective number of f-stops (in our present example, three), any indicated combination of f-stop and shutter speed will automatically take the filter factor into consideration and yield a correctly exposed negative.

Polarizers and glare control

Polarizers are special filters that filter not color but *glare*. Most people are familiar with Polaroid sunglasses and the way they reduce glare on a highway. Polarizers work in the same way. They are used in front of the lens like ordinary filters. Through their use, unwanted glare and reflections can be partly or completely eliminated in a photograph, the degree of reduction depending on the angle of the reflected light. At angles of approximately 30°, glare reduction is more or less complete; at 90°, glare is not affected at all; in between, glare is more or less eliminated. However, only glare consisting of already polarized light is affected by a polarizer. Most surfaces polarize light as they reflect it—water, glass, paint, varnish, polished wood, glossy paper, to name only a few. Metallic surfaces, however, do not polarize light as they reflect it, and consequently highlights, reflections, and glare from metallic surfaces are not affected by polarizers.

Since polarizers and color filters work on principles that do not interfere with each other, they can be used together, which makes it possible to control color rendition and reflections simultaneously—and very often one control will aid the other. Thus elimination of glare will often bring out colors that were obscured by reflections, whereas the color filter will translate them into gray shades of the desired brightness.

To produce the desired effect, polarizing filters must be used in specific positions. Hold the polarizer up to your eye, look through it at the subject, then slowly rotate the filter and watch the effect on highlights, glare, and reflections. When the desired degree of extinction is reached, place the filter in front of the lens *in exactly the same position as you held it*; don't accidentally rotate the polarizer while transferring it from eye to lens, or

you will lose part of the effect. If you use a single-lens reflex camera, of course, rotate the polarizer in front of the lens and you can observe its effect directly on the groundglass of the viewfinder.

It is neither necessary nor advisable always to use a polarizer in its position of maximum efficiency. Sometimes, reducing glare to a printable level is better than complete extinction, which often results in dull and lifeless effects.

The filter factor for most polarizers is 2.5. If a polarizer is used together with a color filter, the factor of one must be *multiplied by* (*not* added to) the factor of the other to determine their combined factor. The combined factor in turn must be multiplied by the exposure indicated on the exposure meter.

LENS SHADE

Theoretically, only light reflected by the subject or emitted by sources within the field of view of the camera should fall upon the lens. All other light is potentially dangerous insofar as it might become the cause of lens flares and halation and should therefore be kept away from the lens by means of an effective lens shade.

Though insignificant in appearance and inexpensive, a lens shade is extremely important in the production of crisp, sharp, halation-free pictures. To be effective, it must be long enough really to shield the lens from unwanted light without cutting off part of the picture (*vignetting*). To be practical, it must permit the simultaneous use of a color filter. Without an adequate lens shade, a lens is incomplete. Some lenses, especially the more expensive telephoto lenses, have built-in lens shades. But usually it is up to the photographer to equip his lens with this indispensable accessory which protects it not only from undesirable light but also from raindrops and snowflakes, beside saving it from many accidental fingerprints.

CABLE RELEASE

Movement of the camera during the exposure is one of the most common causes of unsharp pictures. To avoid such accidental movement, exposures

longer than $^1/_{60}$ sec. should be made with the camera firmly supported. However, even if the camera is mounted on a tripod, unsharp pictures can result if it is accidentally jarred when the "button" is pressed.

Such accidental jarrings can be avoided if a cable release is used to trip the shutter. Its flexibility absorbs any accidental motion and prevents it from being transferred to the camera. A camera is incomplete without a cable release. It is another one of those "insignificant" accessories that lack the flashy appeal of more expensive gadgets but whose importance for the production of "technically perfect negatives" can hardly be exaggerated.

TRIPOD

Possession of a tripod enables a photographer to increase greatly the scope of his work: time exposures at night; close-up work in which fractions of an inch make the difference between sharp and unsharp pictures; interior shots made with wide-angle lenses and small diaphragm stops; architectural photographs in which perspective is controlled by "swings"; telephotography, with lenses of more than ordinary focal lengths; pictures at home with photo floods; copying and reproductions; table-top photography; and any kind of photographic work involving exposure times slower than $^1/_{60}$ sec. that must turn out critically sharp—all these fascinating fields are open to the possessor of a tripod, and only to him.

The best tripod is the strongest tripod. It is also the heaviest and the most expensive. It is always possible and even advantageous to mount a light camera on a heavy tripod, but it is *not* recommended to put a heavy camera on a light and flimsy support. Consequently, in choosing a tripod, be sure it is strong enough to support your camera safely; otherwise your money will have been wasted.

A tripod with a built-in "elevator" is particularly useful. An elevator is a center post that can be raised or lowered either by hand or with the aid of a crank, a convenience that is especially appreciated in close-up work in which fine adjustment in height can be made by a simple turn of a crank instead of the more complicated and time-consuming readjustment of three legs. In addition, a center post extends a tripod's useful height. However,

75

care should be taken not to raise the "elevator" unnecessarily high because, by promoting instability, that would negate the purpose of a tripod. Time and again one sees photographers who are too lazy to extend the three tripod legs at all and instead mount their camera on the fully extended center post, where it sways like a top-heavy flower at the end of a long, thin stalk.

A serious shortcoming of most tripods is their lack of a lateral leveling device; instead, leveling the camera laterally must be done by adjusting the tripod legs accordingly. For leveling a 35 mm. camera, a heavy-duty universal joint mounted on the tripod is sufficient. But for larger cameras only a special leveling adjustment, which is part of the tripod, will do, for example, the lateral tilt of the *Tilt-all* tripod.

A versatile and often adequate support for cameras up to 2¼ × 2¼ inches is a substantial table-top tripod (Leitz makes what is probably the best one) equipped with a ball-and-socket universal joint. It can be used on any hard surface no matter whether level, tilted, or vertical; one places it on or presses it hard against this surface—a wall, pole or post, tree trunk, rock . . . It can also be held against the chest, making hand-held exposures with relatively slow shutter speeds or more extreme telephoto lenses more likely to succeed without dangerously moving the camera.

Lighting Equipment

Knowledge of the different types of photo lamps and their characteristics is one of the first requisites for arranging an effective illumination. A man who knows his lights can do more interesting things with two lamps than one who does not can do with five. As a matter of fact, more pictures are spoiled artistically by too much light and too many lights than by lack of light. Overlighting destroys form, roundness, and delicate shades of gray. Multiple lights wrongly handled cast multiple criss-crossing shadows, one of the most serious faults of any photo illumination.

Most subjects can be lighted adequately with two lamps—a *main light* that

76

sets the key for the illumination and a *fill-in light,* which slightly lightens the shadows cast by the main light—not too much, just enough so that the shadows will not print too black. If an additional lamp—an *accent light* for highlights and sparkle—is available, anyone with a feeling for light should be able to arrange a thoroughly professional illumination. More about this later.

pp. 147–
150

As photographers, we must distinguish among four basically different types of light sources.

Photo floods (tungsten lamps) are incandescent bulbs of 250 and 500 watts, respectively, which give considerably more light than ordinary household bulbs, though their life span is only a few hours. "Ordinary" photo floods should be used in correctly designed large aluminum reflectors; "reflector" floods have their own reflectors built into the bulbs and need no separate reflectors. Both give a bright but soft and even light and are equally suitable as *main lights* or as *fill-in lights.* If used with a *diffuser*—made of transparent drafting paper or spun glass—their light is practically shadowless; this is particularly desirable for fill-in purposes to avoid criss-crossing shadows.

Spotlights concentrate the light by means of an optical system consisting of a parabolic mirror behind and a condenser lens in front of the bulb. All better spotlights can be focused; that is, the diameter of the field of illumination can be made wider and less intense or narrower and more intense by adjusting the position of the bulb in relation to the reflecting mirror.

Compared to photo floods, spotlights give a much sharper, harsher, more confined, and more intense illumination and cast blacker and more precisely defined shadows. They are well suited to be main lights or accent lights but totally useless as fill-in lights. They come in all sizes, from tiny "baby spots" of 150 watts to the giant "sun spots" used in commercial studios.

Flashbulbs deliver a wallop of light within a fraction of a second, then burn out. This characteristic makes flash the most expensive type of light per exposure. On the other hand, it offers the invaluable advantage of instan-

77

taneous exposures of shortest action-stopping duration through synchronizing the firing of the bulb and the action of the camera's shutter by means of a flash gun.

Flashbulbs come in two basically different types: bulbs to be used for synchronization with *between-the-lens shutters*, which are characterized by a *short peak*, that is, high intensity of very short duration, and bulbs intended for synchronization with *focal-plane shutters*, which are characterized by a *long peak,* that is, somewhat lower intensity of relatively long duration (necessary to ensure uniform exposure over the entire negative while the opening of the shutter curtain passes across the film). *It is imperative for correct flash exposure (and synchronization) that the type of flashbulb be used which the respective shutter requires.*

Speed lights are a kind of electronic super flash, which have the following advantages over the conventional type of flashbulb: repeating flash tube good for a thousand and more flashes before it must be replaced; extremely short flash duration which, depending on the type of speedlight, ranges from approximately $^1/_{500}$ to $^1/_{10,000}$ sec.; and a flash that, because of this extremely short duration, is almost invisible and, in portraiture, much easier on the eyes of the model. Disadvantages are comparatively low light output of the smaller, most popular units (equal approximately to that of a flashcube); potentially dangerous (this applies only to the larger studio outfits, which operate on voltages of several thousand volts) and, except for the smallest units, quite expensive.

The light output of a speed light is nowadays usually given in the form of guide numbers relating to Kodachrome II film; the higher the guide number, the more powerful the flash, the farther its reach, the smaller the f-stop that can be used with corresponding increases in the sharply covered zone in depth, and the bigger, heavier, and more expensive the speed light. The

p. 152 use of guide numbers as a means for determining the exposure will be explained later.

Recycling time—the length of time required for the batteries to charge the capacitor fully—varies from 2 to 15 and more seconds, depending on

78

model type and size. When full power is restored, a neon *ready lamp* lights up, and not until this moment is the unit ready for the next flash. A short recycling time is, of course, preferable to a longer one. Unfortunately, some ready lights are, shall we say, "overoptimistic"? The time from the moment of the last flash to the moment the ready light goes on is not always identical with the *true* recycling time because, in some models, the ready light goes on shortly *before* the capacitor is *fully* charged. As a result, flashing the speed light the instant the ready light indicates full power and flashing it a few seconds later may produce differently exposed negatives as the result of flashes of different intensity. Therefore, unless tests have shown that the ready indicator is reliable, it is advisable to give the unit a few additional seconds of charging time before firing it again.

Some speed lights have special features like automatic exposure control through feedback: A sensor unit built into the reflector housing "reads" the amount of light reflected by the flash-illuminated subject and, within microseconds, feeds the result via integration and amplification circuits into a switch that automatically quenches the flash when the amount of light required for a perfect exposure has been delivered. Others offer as accessories separate lamp heads for multiple-flash installations or *slave units*—self-contained, separate speed lights equipped with their own batteries and a photocell that triggers the unit to fire the instant that the cell is energized by the light emanating from the "master flash" of the principal speed light. This method has the advantage that no connecting wires are needed over which people might trip or that might accidentally show up in the picture. Then there are accessory flash tubes in the form of *ring lights*, which encircle the lens and provide completely shadowless illumination, making them particularly suitable as fill-in lights and for close-up photography.

Power is usually supplied by batteries of various types, some of them rechargeable with the aid of special rechargers built into the unit itself; or the unit can alternatingly be operated on standard 60 cycle A.C. house current. For satisfactory synchronization, the respective camera or shutter must be equipped with adjustable synchronizer contacts providing for "X" or "zero delay" synchronization.

Balanced lighting equipment is absolutely essential for the creation of balanced light effects. A spotlight that is too weak or too powerful in comparison to the photo floods with which it is used is practically valueless. An excellent combination consists of two photo-flood lamps of 500 watts each and one 250- or 500-watt spotlight. Spotlights of less than 250 watts are of little practical value except in conjunction with small table-top setups. To "balance" the light of the two photo floods, place the one acting as the *main light* relatively close to the subject and slightly to one side; place the *fill-in light* about twice as far from the subject, as close as possible to the lens axis and slightly higher than the camera. Finally, use the spotlight as a *backlight* for adding sparkling highlights.

Reflectors. To be able to choose from the great variety of different shapes and sizes the reflector that is most suitable to a specific purpose, a photographer must know the following:

The smaller a reflector, the harsher and more concentrated the light. The larger a reflector, the softer and more diffused the light. Narrow reflectors produce something of a spotlight effect with more sharply defined shadows and are more suitable for use in conjunction with the main light. Wide reflectors disperse the light more evenly, produce softer shadows with softer outlines, and are more suitable for use in conjunction with the fill-in light. Parabolic and hyperbolic reflectors produce a more concentrated beam of light than spherical reflectors, which produce a more evenly diffused illumination. Reflectors with pressed-in ridges produce a somewhat softer, more diffused light than smooth reflectors. Clamp reflectors can be attached to any projecting object and may eliminate the necessity for special light stands. Reflectors that "stack" take considerably less space in storage (and in the luggage of the traveling photographer) than reflectors that don't. Reflector floods completely eliminate the need for reflectors.

Light stands should be strong and light; aluminum is best. An invaluable asset on most jobs is a *boom light*—a counterbalanced crossbar that fits on top of a regular light stand, swivels, tilts, turns, and gets the light into any possible (and seemingly impossible) position like, for example, pure over-head light, without either lamp or light stand appearing in the picture.

POINTERS FOR PHOTO FRESHMEN

Practice with your camera. Learn how to focus lightning fast. Be ready when your opportunity arrives.

Next to the camera, the most important piece of equipment is a photoelectric exposure meter.

The surest way to improve the quality of most black-and-white outdoor pictures is through use of a yellow filter. The difference is enormous, the cost negligible.

A tripod is the "secret weapon" of the man who consistently produces tack-sharp pictures, crisp texture rendition, and negatives that can be enlarged successfully to photo-mural size.

Lenses with longer than standard focal lengths automatically produce more concentrated pictures, exclude superfluous subject matter, improve space rendition by minimizing perspective distortion, and strengthen the impact of any photograph. Ideal for portraits, too.

A good way to remember the type of film that a camera is loaded with is to tear the square top off the end of the roll-film cardboard box and tape it to the camera. But don't forget to change this tag when loading a different type of film.

Make sure 35 mm. film is advancing properly in the camera by watching the rewind knob: If it turns as you wind the film, everything is all right; if it doesn't, the film is not moving, and something is wrong.

When using flash in conjunction with a variable synchronizer, do not forget to set the delay dial in accordance with the type of flash you use.

Soft-focus effects are dangerous and tricky—not for the expert who knows what he is doing but for the tyro who steps where angels fear to tread. Best for backlight and soft blonde hair.

Too much light and too many lights spoil any indoor photograph.

3

How to Take a Picture

Mastery of "technique" is the first requirement for taking good photographs. Without the means for expression, creative work in any field is impossible. No matter how talented or industrious, the painter who has not learned how to mix and apply pigments, the sculptor who has not learned how to use chisel and mallet, the writer who has not learned how to construct sentences and write dialogue will never be able to produce a work of art, simply because he will not be able to present his ideas in a form that makes it possible to convey them effectively to other people. This also applies to photographers. Without a period of apprenticeship—dedicated to searching, experimenting, and learning from mistakes—no one becomes a master. But, whereas a master, a highly skilled craftsman, does not necessarily have to be an artist, every artist must be a master—a master of the techniques for expression in his chosen field.

A photographer may have the artistic genius of a Michelangelo—but, unless he also has manual dexterity, his talent will never take form. He may be highly sensitive to beauty; he may perceive a truth that others fail to see; he may suffer with the oppressed or be privileged to witness great events—but his gifts and experiences will be of no avail unless he knows how to express them in color or black and white on film and sensitized paper. In photography, the base and the sublime are inseparably connected, and the potentially most stirring picture may never materialize because of lack of technique.

Most amateurs make the mistake of expecting too much too soon. They don't want to practice; they want results immediately. Perhaps they remember too well a period in their lives that required hard work and entailed frustration. If photography is their hobby, they want nothing of that sort in it. A hobby, they think, should be fun and relaxation. But it is neither amusing nor relaxing when things don't go the way they should and pictures turn out disappointingly because of poor technique. And there is only one way to avoid this: to start with fundamentals and systematically to learn the elements of the craft. These elements are presented on the following pages.

How to Get Sharp Pictures

One of the basic requirements of a good negative is sharpness unless, of course, unsharpness is used deliberately to create a special effect. However, sharpness in photography is a rather vague concept. Most negatives are partly sharp and partly unsharp. Where actually does sharpness end and unsharpness begin?

DEFINITION OF SHARPNESS

Theoretically, sharpness exists when a point source of light (for example, a star) is rendered on the negative in the form of a point. Practically, of course, this is an impossibility, because the image of even the farthest star is never rendered in the form of a point (which has a diameter of zero) but as a circle. Similarly, the photographic image of any subject consists not of an infinite number of points but of an infinite number of tiny overlapping circles called *circles of confusion*. The smaller these circles of confusion are, the sharper the image appears. Sharpness is always a matter of degree because absolute sharpness does not exist.

For practical purposes, the definition of sharpness has been related to the size of the negative, for the simple reason that small negatives must be sharper than larger negatives because they must stand higher degrees of

magnification during enlarging. Generally, depth-of-field scales and tables are computed on the basis that negatives 2¼ × 2¼ inches and larger are "sharp" if the diameter of the circles of confusion is not larger than $1/1000$ of the focal length of the lens that is standard for the respective negative size. And a 35 mm. negative is considered "sharp" if the diameter of the circles of confusion does not exceed $1/1500$ of the standard lens, which in this case corresponds to a diameter of $1/30$ mm. or $1/750$ inch.

Whether or not this desirable degree of sharpness is actually achieved in practice depends mainly on three factors:

the sharpness of the lens
the resolving power of the film
the accuracy of focusing

THE SHARPNESS OF THE LENS

It is a well-known fact that some lenses are sharper than others. As a rule, the sharpest lenses (the process lenses and apochromats) are relatively slow, but not all slow lenses are sharp (box-type camera lenses are even slower than process lenses but are incapable of yielding anything but fuzzy pictures). For obvious reasons, most lenses designed for use in 35 mm. cameras are sharper than lenses intended for use in conjunction with larger cameras. Standard lenses are generally sharper than high-speed, wide-angle, and telephoto lenses. With most lenses, sharpness can be improved by stopping down the diaphragm. The optimum in this respect is usually reached around two or three stops from the maximum aperture. Use of still smaller diaphragm stops increases the extension of sharpness in depth (depth of field) but may actually decrease the sharpness of rendition. When effective apertures of f/32 and smaller are reached (particularly common in extreme close-ups where the images of the subjects are rendered in several times the natural size on the film), definition deteriorates rapidly, and everything appears uniformly "soft" as the result of diffraction and interference phenomena.

Strange as it may sound, all other factors being equal, some films produce sharper images than others. Unsharpness can be caused by light dispersed within the emulsion, manifesting itself in the form of tiny haloes that surround every dot and line of the image and make sharp contours impossible. Generally, the thinner the emulsion, the finer the grain, and the better the antihalo protection of the film, the sharper the image and vice versa.

One measure of the sharpness of a film is *resolving power*. It is indicated by the number of lines per millimeter (of a test chart) that can be distinguished in the image. The more lines per millimeter a film can resolve, the finer the detail that it is capable of showing clearly. As a rule, slow and contrasty emulsions have greater resolving power than fast and soft emulsions, a fact that makes them better suited to 35 mm. photography. For scientific purposes, emulsions with a resolving power of 500 lines per millimeter have been produced. For comparison: People with good vision can resolve at most 6 lines per millimeter or 150 lines per inch. The following lists the resolving power of a number of Kodak films.

Kodak films	lines per mm.
Micro-File	175
Fine Grain Positive	120
Panatomic-X	100
Verichrome Pan	95
Plus-X Panchromatic	95
Super-XX Panchromatic	90
Tri-X Panchromatic	65

Unfortunately, resolving power as a measure of the sharpness of a film has the serious drawback that it is essentially based upon the subjective judgment of the investigator: Some people still distinguish lines in a pattern that others find unacceptably blurred. Resolving power as a measure for the sharpness of films has therefore been replaced largely by the concept of *acutance*, which is based upon exact measurements: A knife edge is laid on the film, the film is exposed to light and developed, and the silhouette of the

knife edge is examined under a microscope. Because light scatters within the emulsion, the transition from light to dark is not abrupt but somewhat gradual. It is this zone between pure white and pure black that, microdensitometrically evaluated, is the measure of the acutance of a film: The narrower it is, the higher the acutance and the sharper the film. Acutance is highest in thin and lowest in thick emulsions, but it is also affected by exposure (which makes this method still not ideal): A minimum of exposure preserves a film's acutance; overexposure, which promotes light scattering within the emulsion, lowers it. To get around this problem, which still tends to introduce an element of uncertainty into the measurement of a film's sharpness, highly sophisticated concepts like modulation-transfer function, spread function, and S.M.T. acutance have recently been developed. They, however, are too complex to be reviewed here.

THE ACCURACY OF FOCUSING

Focusing means adjusting the lens-to-film distance in accordance with the lens-to-subject distance. No matter how good the lens and how sharp the film, the negative is bound to be unsharp unless the camera is correctly focused. For critical work, use of a focusing magnifier is strongly recommended (most single-lens reflex cameras not equipped with a pentaprism, and all twin-lens reflex cameras have a focusing magnifier built into the viewfinder hood; in conjunction with a groundglass panel, use the excellent Kodak focusing magnifier or the 8-power Agfa Lupe). Theoretically, focusing with the aid of a groundglass (reflex or view camera) is more accurate than by means of a rangefinder because it is very difficult to mass-produce rangefinders that, in conjunction with a variety of lenses of different focal lengths, are accurate at all distances. Besides, rangefinders sometimes get out of adjustment. Cameras without either groundglass or rangefinder (rollfilm folding cameras of the oldfashioned Kodak type) have to be focused by their foot scales after measuring or guessing the subject distance. Unavoidable inaccuracies can be compensated for by use of a relatively small diaphragm aperture, which creates a "safety zone of sharpness in depth." Fullest use of this principle is made in the fixed-focus cameras of the box type, which cannot be focused at all.

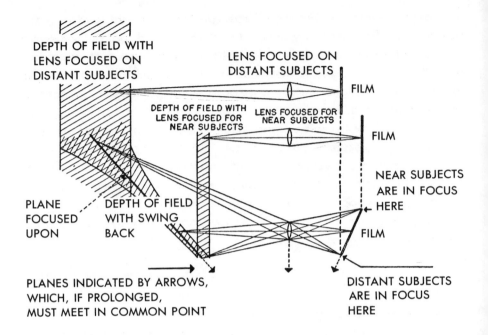

DEPTH OF FIELD WITH
LENS FOCUSED ON
DISTANT SUBJECTS

LENS FOCUSED ON
DISTANT SUBJECTS

FILM

DEPTH OF FIELD WITH
LENS FOCUSED FOR
NEAR SUBJECTS

LENS FOCUSED FOR
NEAR SUBJECTS

FILM

NEAR SUBJECTS
ARE IN FOCUS
HERE

PLANE
FOCUSED
UPON

DEPTH OF FIELD
WITH SWING
BACK

FILM

PLANES INDICATED BY ARROWS,
WHICH, IF PROLONGED,
MUST MEET IN COMMON POINT

DISTANT SUBJECTS
ARE IN FOCUS
HERE

Focusing for depth

Independent of the size of the diaphragm aperture, considerable extension of sharpness in depth can be produced in oblique shots with the aid of the swing back of a view camera as demonstrated in the accompanying diagram.

Tilt the camera back backward (or swing it laterally if the plane of focus is vertical) until imaginary lines drawn through the planes of subject, lens, and film meet in a common point (compare the diagram). Even though the diaphragm is wide open, everything within the oblique plane of focus will then be rendered sharply. If the subject is perfectly flat (like, for example, a rug on a floor), subject plane and plane of focus coincide, and no stopping down at all is needed. If parts of the subject protrude from this oblique plane of focus (like, for example, a coffee table standing on the rug), the diaphragm must be stopped down sufficiently to bring these parts into

focus. However, instead of having to cover the entire depth of the subject, such stopping down requires covering only the relatively small distance (depth) between the oblique plane of focus and the protruding parts of the subject. Consequently, only a comparatively small amount of stopping down is necessary—a fact which is equivalent to a corresponding gain in exposure speed.

This method of *extended focusing*, which, of course, requires the use of a view camera, is applicable regardless of whether the camera is pointed at a flat horizontal or at a flat vertical subject (like the "foreshortened" wall of a building seen "in perspective"). When oblique shots of subjects with great extension in depth have to be made, "focusing for depth" is often the only practical approach. This applies when use of even the smallest available diaphragm stop is insufficient to create the required zone of sharpness in depth, or when subject movement must be considered and a small diaphragm stop would result in an exposure that would be too long to "freeze" the motion.

Close-up focusing

Photographers using cameras with front focusing (the majority) may encounter considerable difficulty when trying to focus on small subjects for close-ups in nearly natural, natural, or more than natural size. The cause of this difficulty lies in the fact that moving the lens forward changes not only the lens-to-film distance but also the lens-to-subject distance. Ordinarily, of course, lens-to-subject distances are so great that the minute increases or decreases due to focusing the lens are, by comparison, completely negligible. But in close-ups, such changes in subject distance can amount to a comparatively large percentage of the total lens-to-subject distance. As a result, front focusing, by *simultaneously* changing *both* lens-to-film and lens-to-subject distances (instead of adjusting one in accordance with the other), often makes it impossible to achieve the proper balance between the two; as a result, the image may never become really sharp.

The simplest way out of this difficulty is to focus the lens as best one can on the nearby subject, then either to move the entire camera slowly back and forth until the image appears sharp in the viewfinder or on the groundglass or to move the subject until it appears in focus.

Photographers who frequently have to take close-ups should use a camera or auxiliary bellows that permit rear focusing, as, for example, does a view camera. Then the lens can remain stationary while the back of the camera is rocked back and forth until the subject is in focus. In this way, the subject-to-lens distance remains constant and the lens-to-film distance can be adjusted without difficulty.

CAUSES FOR UNSHARPNESS

Even with the sharpest lens and film and the greatest care in focusing, it is still possible to get unsharp pictures for one or more of the following reasons.

Dirt on the lens. Fingermarks on the glass or a filmy coating of grease and dust act as a diffuser and produce general softness of the image.

Dirty filter. Filters should be treated as carefully as lenses. They should be carried in separate cases, and their surfaces should never be touched. A dirty filter acts as a diffuser and should be cleaned as carefully as a lens.

Camera movement during a hand-held exposure is perhaps the most common cause of unsharp pictures. In single-lens reflex cameras, the up-swinging mirror sometimes jolts the entire camera at the critical moment of exposure and thereby makes slow shutter speeds hazardous. The lens board of a view camera that does not fit tightly enough, a camera front that has too much play, or making a time exposure without benefit of a cable release are further potential causes for unsharp pictures.

Subject movement. If the shutter speed is too slow to "freeze" the motion of the subject, rendition becomes blurred. Often, however, a slight degree of blur suggests motion and therefore should not automatically be considered a fault.

Inferior filter quality. Cheap filters are often not flat enough for photographic purposes. Inexpensive solid glass filters are especially likely to cause unsharpness, as are acetate color filters; they must not be confused with gelatin filters which are among the best. The longer the focal length of a lens is, the better the optical quality of the filter must be, for long-focus lenses magnify not only the subject but also the defects of the filter. For this reason, filters that are adequate for use with standard lenses may produce unsharp pictures when used on a telephoto lens.

Buckling film. Because it is flexible, film does not always stay as flat in the camera or holder as would be desirable. Especially under conditions of high humidity, film, because of its affinity for water, tends to buckle and bulge from the plane of focus, a tendency that increases with film size and is most pronounced in 4 × 5 inch film-pack sheets. Under humid atmospheric conditions, to minimize the danger of partial or total unsharpness due to buckling of the film, it is advisable to work with the smallest feasible diaphragm stops in order to create a "safety zone" of extended sharpness in depth at the focal plane (*depth of focus*).

Heat haze. Objects seen or photographed through curtains of rising hot air appear more or less blurred. This phenomenon can be seen clearly by looking along the metal roof of a car standing in the sun—the air above it undulates. Hot air rising from the sun-baked ground is a frequent cause of "mysterious" unsharpness. Other potential trouble sources are hot radiators when shooting pictures from a window, smoke stacks and chimneys, sun-exposed *black* surfaces like slate and asphalt-shingle roofs, black-topped parking lots, and so on. The only way to avoid unsharpness due to heat haze is to avoid shooting through curtains of rising hot air, particularly when working with a telephoto lens, which magnifies this phenomenon in direct proportion to its focal length.

Ultraviolet radiation. Normally too weak to be of any consequence, ultraviolet radiation can be the cause of unsharpness in photography at high altitudes. Use of an ultraviolet-absorbing filter like the Kodak Wratten Filter 2B, which requires no increase in exposure, prevents this type of unsharpness.

Difference between groundglass and film. This kind of trouble is found only in sheet-film and film-pack cameras. Although quality film holders and film-pack adapters should fit any make of camera of corresponding negative size, it happens occasionally that the frame that holds the groundglass is just a hair too thick or thin, with the result that the film is not in exactly the same plane as the groundglass. Should this be the case, the negative, of course, will be more or less unsharp despite the great care that may have been taken in focusing—particularly if the shot is made with a large f-stop. Whenever pictures taken on sheet film or film pack are unsharp for no apparent reason, it is advisable to use a depth gauge and to check the planes of groundglass and film relative to the camera body to determine whether or not they coincide. In addition, the photographer should make sure that the film holder or film-pack adapter makes complete contact with the camera. Sometimes, the ridge that forms the light trap at the short end of the film holder does not quite fit into the corresponding groove in the camera, and consequently the film is set too far back.

Rangefinder out of synchronization with the lens. Rangefinder-equipped cameras should be checked periodically to make sure that the rangefinder is still in sync with the lens.

Camera front too weak. A heavy lens can bend down the weakly designed front standard (lens support) of a view or press camera, especially if it requires double or triple bellows extension and thus exerts a considerable lever effect. In such cases, the whole optical system is thrown out of alignment, and unsharp negatives result. Reinforcing the camera with a flat aluminum rail $\frac{1}{4} \times 2$ inches in cross section, which can be attached to the camera body with screws in the tripod sockets, will prevent this.

Focus shift. Some otherwise perfectly satisfactory lenses shift the plane of focus in accordance with the diaphragm stop. If a photographer focuses such a lens with the diaphragm wide open and then stops down without refocusing, he will get a more or less unsharp negative, the degree of unsharpness usually depending on the ratio between the diaphragm stops. High-speed lenses are particularly prone to this fault, the effect of which can only be prevented by focusing the lens with the same f-stop with which the picture will be made.

How to Get Sharpness in Depth

Most photographic subjects are three-dimensional: In addition to height and width, they have depth. This fact immediately raises two questions: Which depth zone of my subject shall I focus on? How can I extend sharpness beyond the plane of focus in order to cover the entire depth of my subject?

AN EXPERIMENT

The simplest and most instructive way to learn how to create sharpness in depth is by way of experiment: Take a groundglass-equipped camera, mount it on a tripod, focus it obliquely on a subject with great extension in depth (say, a picket fence), and observe the groundglass image.

The first step. With the diaphragm wide open, focus on a pale about three feet from the camera. Notice that the pale you focus on is perfectly sharp, that the pale in front of it and two or three behind it appear reasonably sharp, but that all the others are definitely out of focus and appear increasingly blurred the farther they are from the plane of focus, the pale you have focused on.

The second step. With the diaphragm wide open, focus on a pale about fifteen feet from the camera. Notice that now several pales in front of the one you have focused on appear sharp and that a still greater number are also rendered sharply beyond the plane of focus.

The third step. With the diaphragm wide open, focus on a pale fifty feet or more away. Notice that this time ten or more pales in front of that on which you have focused appear sharp and that beyond the plane of focus everything is sharp.

The fourth step. Focus on a pale about fifteen feet from the camera, and, while gradually closing down the diaphragm, observe the image on the groundglass. Notice that more and more pales are covered sharply as the diaphragm opening is decreased.

1. A certain amount of sharpness in depth is inherent in any lens. Even though we can focus a lens only on a specific plane, objects in front of and behind this plane will still, within certain limits, be rendered sharply. The "slower" the lens, the shorter its focal length, and the farther the plane of focus is from the camera, the more extensive this inherent zone of sharpness in depth.

2. In most cases, the inherent depth of a lens is insufficient to cover the entire depth of the subject. It then becomes necessary to increase the zone of sharpness in depth. The means for this is the diaphragm.

3. The more the diaphragm is stopped down, the more extensive the zone of sharpness in depth.

4. However, the more the diaphragm is stopped down, the darker the image, and the greater the necessary increase in exposure time with all its attendant disadvantages.

5. As a result, practical considerations make it desirable to create a maximum amount of sharpness in depth with a minimum of stopping down.

6. Stopping down the diaphragm increases the zone of sharpness in depth in two directions from the plane of focus—toward and away from the camera. Consequently, it would be wasteful to focus on either the beginning or the end of the depth zone which must be rendered sharply.

7. Stopping down the diaphragm creates proportionally more sharpness in depth behind the plane of focus (away from the camera) than in front of the plane of focus (toward the camera). Consequently, the best way to cover a three-dimensional subject is to focus the lens on a plane situated approximately one third within the subject depth and to stop down the diaphragm until the entire depth is covered sharply.

The simplest way of determining the f-stop necessary to cover a given zone in depth is to observe the image on the groundglass while gradually stopping down the lens. Alternatively, use the *depth-of-field scale* which is engraved on either the lens mount or the focusing knob of all modern single-lens and twin-lens reflex and 35 mm. rangefinder cameras. To take full advantage of this scale, proceed as follows: Focus first on the closest, then on the most distant part of the subject that must still appear sharp in the picture, to determine their distances from the camera; read these distances off on the foot scale. Refocus the lens until identical f-stop numbers appear on the depth-of-field scale opposite the foot numbers that correspond to beginning and end of the zone that must be covered sharply. Leave the lens focused in this position and stop down the diaphragm to the f-value that appears opposite the foot numbers that correspond to the distances marking the beginning and end of subject depth. *In this way, a maximum of depth is created with a minimum of stopping down.*

CONCLUSIONS

Generally speaking, the smaller the diaphragm aperture, that is, the higher the f-stop number, the greater the extent of the sharply covered zone in depth. The actual extent of this zone—*the depth of field*—however, is largely dependent on two additional factors.

The subject-to-lens distance. The farther away the plane of focus is from the camera, the greater the zone of depth covered by any given diaphragm stop; and vice versa. For this reason, close-ups generally require smaller diaphragm apertures than long shots; at short distances, stopping down is "less effective."

The focal length of the lens. The shorter the focal length, the greater the extension in depth of the zone sharply covered by any given diaphragm stop (and vice versa), *provided the lenses are used at the identical subject distance.* For this reason, a popular outfit for documentary photography is a 35 mm. camera equipped with a moderate wide-angle lens with a focal length of 35 to 40 mm. (instead of a 55 mm. standard lens).

Such a gain in sharpness in depth over a lens of standard focal length, however, is paid for by *a loss in image size*. If this factor is taken into consideration, that is, *if lenses of different focal lengths are used at different subject distances so that they produce images in identical scale*, then it will be evident that, *regardless of their focal lengths, all lenses from tiny wide-angle to huge telephoto produce identical zones of sharpness in depth if the f-stops at which they are used are the same*.

A SNAPSHOT SYSTEM

Subject distance, focal length, and *diaphragm aperture* are so closely related that it is possible to speak of *optimum combinations* that produce maximum depth coverage with minimum stopping down. By presetting his camera controls accordingly, a photographer can convert his camera into a "picture shotgun" with which he can score "hits" without having to "aim" too accurately. Thus prepared, he can forget the technical side of shooting and pay undivided attention to his subject. When the moment is right, all he then has to do is point the camera and "fire," confident of making a "hit." The following table contains settings recommended for three camera sizes. Shutter speeds must be preset in accordance with the brightness of the incident light and the ASA speed of the film.

Settings for medium close-ups			Film size and focal length of lens (standard lens)	Settings for maximum depth to infinity (hyperfocal distance)		
Aperture	Focus at	Depth		Aperture	Focus at	Depth
f/8	10 ft.	7'8"–14'2"	35 mm. camera	f/8	30 ft.	15'–∞
f/11	15 ft.	9'4"–39'	(50 mm. lens)	f/11	24 ft.	12'–∞
f/8	10 ft.	8'4"–12'8"	2¼" × 2¼" camera	f/8	39 ft.	19'–∞
f/11	15 ft.	10'4"–28'	(80 mm. lens)	f/11	28 ft.	14'–∞
f/8	10 ft.	8'–13'	2¼" × 3¼" camera	f/8	41 ft.	20'–∞
f/11	15 ft.	10'–30'	(105 mm. lens)	f/11	30 ft.	15'–∞

It often happens that a photograph must be sharp from a specific distance from the camera to infinity. To accomplish this with a minimum of stopping down, *the lens must be focused at a plane twice as far from the camera as the plane where sharpness should begin*, and the diaphragm must be stopped down accordingly. In such a case, the camera is said to be *focused at hyperfocal distance*.

For example, a shot must be taken with a 35 mm. camera equipped with a lens of 55 mm. focal length, and everything from 3 m. to infinity must be rendered sharply. To do this, according to the depth-of-field scale on the lens mount, the lens must be focused at 6 m. and the diaphragm stopped down to approximately f/16.

The hyperfocal distance can be defined as follows: When a lens is focused at infinity, sharpness in depth extends toward the camera from infinity to the *hyperfocal distance;* how far from the camera this is depends on the focal length of the lens and the diaphragm stop. However, because sharpness in depth also extends *beyond* the plane of focus yet "depth" beyond infinity is absurd, focusing a lens at infinity is wasteful as far as creation of a zone of sharpness in depth is concerned. If we were instead to focus the lens at hyperfocal distance and to leave the diaphragm set at the same stop, *everything from half the hyperfocal distance to infinity would be rendered sharply*. Such a combination of focus and f-stop produces the maximum depth of field for that particular lens at that particular stop.

The hyperfocal distance for any lens of any focal length in conjunction with any diaphragm stop can be determined by means of the following formula:

$$\text{Hyperfocal distance (in inches)} = \frac{F^2}{f \times C} \text{ inches}$$

In this formula F is the focal length of the lens in inches
f is the diaphragm stop number
C is the diameter of the circle of confusion in fractions of an inch.

For example, a photographer using a 4 × 5-inch view camera intends to make a picture in which sharpness in depth extends from infinity to a plane as close to the camera as possible. He uses a 5-inch lens, and light conditions permit stopping down to f/16. Sharpness of the negative should

p. 85 be governed by the requirements stated previously, according to which the diameter of the circle of confusion must not exceed $1/1000$ of the focal length of the lens. In this case, this diameter would be equal to $5/1000$, or $1/200$, of an inch. In order to produce the maximum extent of sharpness in depth, he must focus the lens at hyperfocal distance. Then everything from half this distance to infinity will be rendered sharply at f/16. To find the hyperfocal distance he uses the formula already given and arrives at the following equation:

Hyperfocal distance equals

$$\frac{F^2}{f \times C} = \frac{5^2}{16 \times 1/200} = \frac{25}{16} \times 200 = 312.5 \text{ inches} = 26 \text{ feet}$$

Consequently, by focusing his lens at 26 feet and stopping down to f/16, he creates a sharply covered depth zone that begins at half the hyperfocal distance, or 13 feet, and extends all the way to infinity.

Conversely, the f-number that will cover any depth zone from infinity to any given distance from the camera can be determined by the following formula:

$$f \text{ (stop number)} = \frac{F^2}{H \times C}$$

In this formula F is the focal length of the lens in inches
H is the hyperfocal distance in inches
C is the diameter of the circle of confusion in fractions of an inch.

For example, a photographer using a 4 × 5-inch view camera intends to make a picture in which sharpness extends from infinity to 13 feet. He uses a 5-inch lens and wants his negative to be sharp in accordance with the

98

specifications stated before, assuming a circle of confusion with a diameter of $1/200$ inch. He knows that, in order to get a maximum of depth, he must focus his lens at twice the distance of the nearest plane that is to be rendered sharply or, in this case, at 26 feet. But how far must he stop down the diaphragm in order to create a zone of sharpness in depth sufficiently large to cover the distance from 13 feet to infinity? Here is the answer:

$$f = \frac{F^2}{H \times C} = \frac{25}{312 \times 1/200} = \frac{25}{312} \times 200 = \frac{5000}{312} = 16$$

Consequently, by focusing his lens at hyperfocal distance, or 26 feet, and stopping down to f/16, he can create a sharply covered depth zone that begins at 13 feet (half the hyperfocal distance) and extends to infinity.

With the aid of these two formulas, anyone who is interested and has half an hour to spare can easily compute a chart of hyperfocal distances for his lenses at different diaphragm stops. Such a table will prove invaluable when light conditions are marginal and a maximum of depth must be covered with a minimum of stopping down to conserve lens speed and reduce exposure time.

Why stopping down improves sharpness in depth

Let us imagine two luminous points at different distances from the camera (see the drawings on p. 100). Each point sends out light in all directions, either by radiation (the sun) or by reflection (any illuminated nonluminous object). But only a cone of light emitted by each point, with its apex at the light source and its base at the surface of the lens, is utilized in producing a photographic image. If the lens is focused at point A, light leaving the lens will be refracted to form a second cone of light inside the camera. The apex of this cone will just touch the plane of the film, and a sharp image of the luminous point will be formed at A. However, because a lens can never be focused simultaneously at two different distances, the image of the nearer point B will theoretically fall behind the film. As this is impossible because the film intercepts the light, the image of point B must in this case be rendered unsharp in the form of a circle with a diameter corresponding to

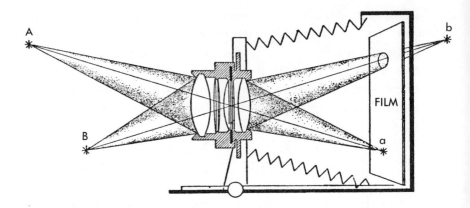

the diameter of the cone of light at the plane of intersection with the film. This circle is the *circle of confusion*.

In order to sharpen the image of point B without refocusing the lens (which in turn would throw the image of point A out of focus), the diameter of the circle of confusion must be reduced. As we already know, this is done by stopping down the diaphragm. How this operation improves sharpness in depth is illustrated in the following sketch:

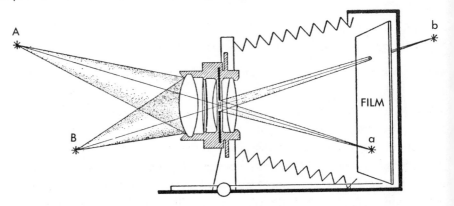

Decreasing the effective aperture of the lens by means of the diaphragm narrows the cone of light that leaves the lens. As a result, when this cone meets the film plane, it is already so narrow that the resulting circle of confusion becomes small enough to appear to the eye as a point—the image of point B appears "sharp."

100

Many of the world's most colorful and exciting sights make notoriously disappointing photographs. The reason is not so much that color is absent in black-and-white photography as that photographers often do not know how to create graphically effective black-and-white contrast, which alone can substitute successfully for the absence of color. In itself, lack of color should not be considered a disadvantage of our medium. As a matter of fact, time and again good photographers transform commonplace subjects into striking photographs just because of this absence of color. Many subjects, if rendered on color film in the most natural form imaginable, are boring and trite. But these same subjects, rendered imaginatively in black-and-white photographs with brilliant whites and powerful blacks, can be surprisingly new and exciting.

In black-and-white photography, the film automatically translates the colors of the subject into black, white, and intermediate shades of gray. As far as the average photographer is concerned, these automatically produced shades are adequate. Beginners especially seldom suspect any necessity for changing this simple method of color translation. However, as they progress and become more critical, they usually begin to realize that many of their pictures turn out unsatisfactorily because, somehow, they haven't succeeded in capturing the essence of their subjects. Especially if vivid color is an important characteristic of the subject, the reason for their failure is usually the inability to produce pictures in which color is translated into graphically effective shades of black and white.

Contrast control becomes necessary for two apparently contradictory reasons: because black-and-white films don't translate colors "literally" enough into black and white and because they translate colors too "literally." Here is the explanation of this paradox.

Color translation not "literal" enough. No negative material exists as yet that *simultaneously* translates the brightness aspect of *all* colors into corresponding shades of gray. Panchromatic film, for example, renders red lips too light in portraits made in tungsten light. Orthochromatic film is

101

oversensitive to blue and consequently renders blue skies too light, with the result that white clouds don't stand out effectively. In such cases, that is, when a more *literal* translation of color into shades of gray is desirable, color translation must be improved. The means for this are the *color-correction filters* that have already been discussed.

p. 71

Color translation too "literal." In reality, differentiation of form is mainly based upon differentiation of color. Red roses become visible against a background of green leaves because of the contrast of red and green; if both leaves and flowers were green (or red), differentiation would be largely lost, one would blend with the other, and the effect would be one of dullness.

Now, color is everywhere but, unfortunately for the black-and-white photographer, most colors are neither particularly light nor particularly dark. As a result, if "literally" translated into terms of black and white, these "medium" colors all appear as "medium" shades of gray. The previously exciting color contrast becomes lost in the monotony of virtually identical gray shades, contrast is lacking, objects blend into one another, and clarity of form and space is gone. Unless a photographer knows how to preserve the effect of color in the form of "exaggerated" contrast of light and dark, the result will be disappointing.

THE MEANS FOR CONTRAST CONTROL

In the majority of cases, contrast control is used to produce photographs in which contrast between light and dark is *greater* than it originally appeared in the subject. This is desirable for two reasons: to *separate* colors that are different in hue (red, blue, green, and so on) but more or less identical in brightness (lightness or darkness) and to improve the appearance of subjects in which natural contrast is too low to be graphically effective (for example, long-distance shots in which atmospheric haze makes everything appear "blue in blue" or "gray in gray"). Occasionally, of course, contrast control becomes necessary because subject contrast is so great that it exceeds the contrast latitude of the film (for example, subjects in which brilliantly illuminated areas alternate with ink-black shadows). The follow-

102

ing summary lists the different means which can be used to control subject contrast in accordance with the demands of graphically effective rendition.

Negative emulsion type—consider two qualities: gradation and color sensitization.

Color filters—distinguish between two types: contrast and color correction filters.

Illumination—distinguish between different types of light; consider different ways of using a specific type of illumination and different methods of shadow fill-in.

Exposure in conjunction with development.

Paper gradation—for correction of unsatisfactory overall contrast of the negative.

Dodging—contrast control in the print during enlarging on a local scale.

Combinations of several or all of these means for contrast control.

NEGATIVE EMULSION TYPE

Differences in the gradation of negative emulsions can be used advantageously for preserving, increasing, or reducing the brightness contrast of a subject. As a rule, the slower the speed of a film, the more contrasty the negative, and, the faster the film, the softer the rendition.

Differences in color sensitivity are particularly important in the rendition of red and green. Orthochromatic films are insensitive to red, which they render as black. However, pure red is rare in nature. Most "reds" contain some yellow, blue, or green. As a result, most so-called "reds" are not rendered as "black" by ortho films but merely appear darker in the photograph than they appeared to the eye in the subject. In portraiture, for example, differentiation between the pink skin tones and the red of lips is important. Orthochromatic film, because of its insensitivity to red, often produces better separation between "pink" and "red" than panchromatic film, which generally renders red too light. On the other hand, this insensitivity of ortho film to red makes it inferior to panchromatic film in

103

almost every instance except, perhaps, where green is the predominant color. Pan film is low in green sensitivity and generally renders green darker than it appears to the eye in the subject. As a result, predominantly green subjects like many landscapes, trees, foliage, and so on often show improved differentiation when photographed on ortho film, provided that its oversensitivity to blue is curbed through use of a yellow filter. However, unless specific reasons, like those mentioned here, make the use of ortho film desirable, panchromatic film is generally preferable because of its sensitivity to all colors, which permits the use of "dramatizing" red filters; its high sensitivity to red, ideal for taking pictures in incandescent light, which is rich in red; and its generally higher speed, an especially valuable asset in indoor and night photography.

Before selecting the most suitable type of film for a specific job, a photographer must determine whether subject contrast should be preserved, increased, or reduced to achieve the most desirable effect. Accordingly, he will narrow his choice to a group of films with the required gradation: normal, hard, or soft. Furthermore he must consider the color scheme of his subject and decide which would produce better results: an orthochromatic or a panchromatic film. The ideal combination of gradation and color sensitivity may, of course, not exist or may exist only in a film that does not fit his camera. If this is the case, a photographer must compromise, and the degree of skill with which he is able to satisfy the different and sometimes contradictory demands of his subject in regard to film selection may have a considerable effect upon the outcome of his picture.

COLOR FILTERS

A photographer has the choice of correction filters and contrast filters.

Correction filters improve the representation of color in terms of gray, so that the natural lightness or darkness of a color as it appears to the eye is translated into a gray of corresponding lightness or darkness (so-called *monochromatic color translation*). Consult the previously given table of Kodak filters for use in color correction and their factors, which, in conjunction with panchromatic films, will produce monochromatically correct color translation in terms of black and white.

p. 71

Contrast filters alter the response of a negative emulsion to specifically selected colors. Unlike color-correction filters, which often reduce contrast in the negative, contrast filters always increase contrast and thereby permit a photographer to reproduce colorful subjects in a way that is effective in black and white. *Correction filters* produce what may be called "scientifically correct" or "literally true" translation of color into shades of gray, although the pictorial effect is often dull. *Contrast filters*, on the other hand, enable a photographer to create contrast in accordance with the characteristics of the subject and to produce therefore what might be called "emotionally true" pictures. And since, by its very nature, any black-and-white photograph is an "abstraction"—"unnatural" in that color is "symbolized" by shades of gray—one might as well accept the logical consequences and, instead of trying for a "literally true" rendition, try for one that is "emotionally true," which alone can adequately express the subject. Selection of a contrast filter is governed by two rules.

1. To make a color appear lighter in the picture than it appeared in nature to the eye, a filter in the same (or a closely related) color must be used. Conversely, to make a color appear darker, a filter in the complementary (or a nearly complementary) color must be used. Such complementary color pairs are:

> red and blue-green
> orange and blue
> yellow and purple-blue
> green and red-purple
> purple and green-yellow

2. If two colors that are different in hue but similar or identical in brightness must be separated in the black-and-white translation, the warmer, more aggressive color should normally be rendered lighter, and the cooler, more passive and receding color should be rendered darker.

Warm and aggressive colors	Neutral colors	Cool and passive colors
red	green-yellow	blue-green
orange	green	blue
yellow	red-purple	purple-blue

The following list of filters and their uses is intended mainly for beginners.

Kodak filter	Used in conjunction with	Effect of filter	Common use	Filter factor in daylight (tungsten)
Light yellow 8 (K2)	ortho and pan film	darkens blue moderately	to improve cloud rendition	2 (1.5)
Deep yellow 9 (K3)	ortho and pan film	darkens blue considerably	to darken pale blue sky; more dramatic cloud rendition	2 (1.5)
Red 25 (A)	pan and infrared film	renders blue almost black, red almost white, darkens green	most dramatic cloud rendition; long-distance photography; haze penetration	8 (5)
Orange (minus blue)	pan film	almost the same as red	best all-around filter for aerial photography	6
Black (87C)	infrared film	obliterates haze, renders blue sky and water black, green foliage white	extreme telephotography; high altitude aerial shots. Fake night and moonlight effects in daylight if combined with red (25 A) filter	20–30
Yellow-green 11 (X1)	ortho and pan film	renders green foliage lighter, darkens red	landscapes and foliage; monochromatic rendition in tungsten light	4 (4)
Green 58 (B)	ortho and pan film	lightens green, darkens red	a rarely used filter of little practical value	6 (6)
Blue 80	ortho and pan film	lightens blue, darkens red	to darken red lips in portraits taken in tungsten light	3 (4)
Ultraviolet (2B)	ortho and pan film	absorbs ultraviolet	aerial and ground photography above 5,000 ft.	1.5

106

The purpose of any illumination is to accentuate the forms and characteristics of the subject, with the aim of creating an illusion of three-dimensionality and space within the flat plane of the picture. This is achieved through light and shadow. Translated into terms of photography, light corresponds to white and shadow to black. Up to a point, the greater the contrast of light and shadow—of white and black—the stronger the illusion of three-dimensionality and depth. Conversely, the lower the contrast of light and shadow—the grayer the print—the flatter the appearance of the picture. Normally, a strong feeling of depth is desirable, necessitating strong black-and-white contrast. However, there are occasions when too strong a black-and-white effect is undesirable. It is then up to the photographer to tone down the illumination to produce the desired degree of contrast. For example, direct sunlight is unsuitable for portraits because shadows tend to be too black. As a result, eye sockets appear in the picture no longer as depressions but as "holes," giving the portrait a skull-like appearance. Here we have evidence of the depth effect becoming too strong—we don't want the effect of a hole; we merely want the effect of a depression. By reducing the overall contrast of the subject, by filling in with auxiliary light (*daylight flash* or *reflector panel*) until the shadows appear not black but gray, by "balancing" the illumination, we can reduce (control) the depth effect until it appears just right.

Contrast in both graphic black-and-white effects and the creation of a feeling of depth can be controlled through the illumination in three different ways.

Filling in. By means of additional lamps or reflector panels, shadows that otherwise would appear too dark in the print can be lightened to any desired degree. Indoors, the best fill-in light is produced by softly diffused photo floods or by indirect light reflected from walls and ceiling. If several photo lamps are used, merely turning one against the ceiling is often sufficient to balance the illumination. Outdoors, when sunlight is too harsh, a small speedlight at the camera, if necessary diffused and toned down by a handkerchief laid over the reflector, makes an ideal fill-in light. For

close-ups, several thicknesses of handkerchief may have to be used to avoid overlighting. If flash equipment is not available, a reflector consisting of a piece of white cardboard, a bedsheet, or a plywood panel covered with crinkled aluminum foil makes an excellent fill-in "lamp," which furthermore has the advantage of permitting the photographer to see the exact extent to which the shadows are lightened.

A word of caution: The danger of every type of fill-in illumination is *not* that it is not efficient enough but that it is *too efficient*. Beginners especially, excited by their new-found control of illumination, are apt to fill in so much that they inadvertently reduce contrast to such a degree that the picture appears flat. Unfortunately, pictures that are too flat usually look worse than pictures that are too contrasty. Hence, when in doubt, fill in too little, rather than too much.

Type of light. By selecting the type of light most suitable to produce the desired effect, a photographer assumes complete control over the contrast range of his picture. For example, normally a portrait requires a softly diffused light of low contrast. Consequently, the best type of illumination for outdoor portraits is light from a hazy or evenly overcast sky. If an outdoor portrait must be made on a sunny day, an experienced photographer will pose his model in the open shade, where the light is suitably diffused. On the other hand, "glamor portraits" derive their effect from the strong contrast of black and white. Consequently, a contrasty type of illumination like direct sunlight or spotlight illumination indoors, is the type of light most likely to produce the desired effect.

Modification of light. Within certain limits, every light source can produce light of different qualities. As an example, let's take the sun: On a clear day, direct sunlight is harsh and contrast between light and shadow extreme. A hazy, lightly overcast sky considerably softens sunlight with the result that contrast is reduced. And light from a cloudy sky or light in open shade can be so evenly diffused that it is practically shadowless.

Indoors, matters are even simpler. The intensity of the illumination can be controlled merely by regulating the distance between the subject and the light source. Most spotlights can be focused; their spread and intensity can be adjusted to fit the character of the subject. Photo floods can be made to

produce light of softer or harder quality by means of different types of reflectors and diffusers. And a virtually shadowless illumination can be created by turning all lamps against the walls and ceiling and illuminating the subject exclusively with reflected light.

EXPOSURE AND DEVELOPMENT

The ability of a negative emulsion to render contrast is not unalterable. Within certain limits, it can be influenced, changed, and thus controlled by means of the way it is exposed and developed. Deviations from standard procedure produce changes in the contrast latitude (gradation) of the negative, which can be used to produce pictures with a specific contrast range.

Experienced photographers know that, the simpler their equipment, the easier their work. For this reason, they try to get along with as few different types of film as possible. Rather than carry a specific type of film for every different purpose, they modify the characteristics of one all-purpose film to fit the requirements of many different situations in accordance with the following principles:

To increase contrast, the film must be exposed for a shorter time than normal and developed for a longer time than normal. Depending on the degree to which contrast should be increased, exposure must be shortened by 30–50 percent and the time of development increased by 20–50 percent.

To decrease contrast, the film must be exposed for a longer than normal time and developed for a shorter than normal time. Depending on the degree to which contrast should be decreased, exposure should be increased by 50–200 percent and the time of development shortened by 20–50 percent.

The term "normal" always refers to the standard recommendations for exposure in accordance with the rated ASA speed of the film, development at a temperature of 68 degrees F., and duration of development as listed in the instructions for use that accompany the film.

Technically, the easiest way to control the contrast range of a print is to enlarge the negative on a paper of appropriate gradation.

To increase contrast, the negative must be printed on a paper of hard gradation.

To decrease contrast, the negative must be printed on a paper of soft gradation.

However, simple as this method of contrast control may be, it has the following drawbacks: A negative that requires printing on paper of harder or softer gradation than "normal" will rarely yield a print as smooth in tone and as rich in modulation as a negative so perfect in contrast that it can be printed on a paper of normal gradation. For this reason, it is advisable to strive from the beginning for negatives that have the desired contrast range and consequently can be printed on paper of normal gradation. Of course, this does not always mean "negatives of *normal* gradation," for many subjects demand for best effect a rendition based upon either higher or lower contrast. In such cases, best results will always be achieved if contrast has already been controlled in the negative by one or several of the means discussed. Then the desired gradation is already present in the negative and can be transferred to the print by using a paper of normal gradation.

A still more serious drawback of contrast control through use of a paper of soft or hard gradation is the fact that negatives that are excessively contrasty often have areas in which contrast is abnormally *low*. Backlighted outdoor photographs, for example, are usually abnormally contrasty; the bright areas in the negative are overexposed, and the shadow areas are underexposed. At the same time, contrast *within* both the bright and the shadow areas, respectively, is abnormally low—in the bright areas due to overexposure and consequent blockage of the highlights, in the shadow areas due to underexposure, with resulting loss of detail. Consequently, printing such a negative on paper of soft gradation would, on one hand, reduce the undesirably high overall contrast to a printable level but, on the other hand, would also reduce the already insufficient contrast *within* the

110

dense and the thin negative areas to an even lower level—a gain on one side would be offset by a loss on the other. This kind of negative will yield a satisfactory print *only* if it is enlarged on a paper of *hard* gradation (paradoxical as this may sound): The "hard" paper will strengthen the insufficient contrast within the highlights and shadows, and "dodging" (to be discussed next) will enable the photographer to reduce the excessive contrast between the highlights and the shadows to a printable and pictorially effective level.

DODGING

Every experienced photographer knows that hardly a negative exists from which a "straight" (unmanipulated) print can be made. Even though the print on the whole may look all right and contrast in general may be satisfactory, there are usually a few areas that can stand improvement: A shadow may print a little too black, a highlighted area may seem to have too little detail, or a corner of the print may appear too light. By making the whole print lighter or darker or by using a paper of different gradation, a photographer could, of course, improve such details. But the rest of the print would suffer if such a change were made. In such a case, the only satisfactory way to improve the picture is by means of *dodging*. Dodging means contrast control on a "local" level. It works as follows:

To make a certain area appear lighter in the print, it must be given *less exposure during printing* than the rest of the picture. One inserts a piece of cardboard or red acetate of appropriate shape and size between the printing paper and the light of the enlarger during part of the exposure time (experienced photographers use mostly their hands for this kind of "shading"). In order to avoid sharp outlines in the print, such a " dodger" (or the hands) must be constantly moved slightly back and forth during the exposure. Attaching the piece of cardboard or acetate to the end of a stiff wire permits the printer to reach any area within the picture without unnecessarily shading border zones. This type of dodging is called *holding back*.

To make a certain area appear darker in the print, it must be given *more exposure during printing* than the rest of the picture. This is done by

using a piece of cardboard through which a hole of the appropriate shape and size has been cut (here, too, experienced printers use largely their hands and fingers to form the required aperture). The light is allowed to fall through this hole upon the area that is to be darkened for an additional period while the rest of the picture is shielded by the cardboard (or the hands) from overexposure. In order to avoid sharp outlines in the print, the dodger (hands) must constantly be moved slightly back and forth during the exposure. This type of dodging is called *burning in*.

COMBINATIONS

Each of the six contrast controls discussed here works on a different principle. Therefore, a photographer can approach a particular problem in various ways. Best results are often achieved through combining two or more of these methods of contrast control. At first, this may seem complicated and confusing. With growing experience and confidence, however, reaching for the right type of film, filter, photo lamp, sensitized paper, or the like becomes as automatic as reaching for a knife, fork, or spoon at the dinner table. The following chart sums up the different means of contrast control.

Means and methods for increasing contrast	Means and methods for normal contrast	Means and methods for decreasing contrast
Contrasty (slow) film	Medium-fast film	Soft (fast) film
Contrast color filters	Color-correction filters	Diffused light, light in open shade or from an overcast sky, fill-in light
Contrasty illumination (direct sunlight, spotlights)	Balanced illumination	
	Standard exposure according to exposure meter in conjunction with normal development	Longer-than-normal exposure in conjunction with shorter-than-normal development
Shorter-than-normal exposure with longer-than-normal development		
Contrasty printing paper	Normal printing paper	Soft printing paper
Dodging	Dodging	Dodging

How to "Freeze" Motion

Every subject that moves while being photographed will appear blurred in the picture, however slightly. This is a natural consequence of the exposure, for, as the lens projects the image of the moving subject onto the film, the motion is also recorded in the projected image. The result is analogous to making an imprint with a rubber stamp while moving the stamp sideways: Naturally, the impression will be blurred—increasingly so, the faster the motion (the higher the speed of the subject) and the longer the duration of contact between stamp and paper (the longer the exposure).

That pictures of subjects in motion appear "sharp" is only an illusion, similar to the illusion of "sharpness" that I discussed before. Sufficiently enlarged, even the sharpest picture will "fall apart" and look blurred. Similarly, if sufficiently enlarged, subjects whose motion appears completely "frozen" will reveal unsharpness in the direction of the motion. The picture "appeared" sharp only because the resolving power of the eye was insufficient to detect the slight degree of blur. Out of these facts evolve two principles according to which motion can be "frozen" in a photograph.

1. The image of the moving subject must be immobilized on the film for the duration of the exposure.

2. The motion of the image on the film must be restricted to such an extent during exposure that the unavoidable blur remains below the resolving power of the eye.

Here is how these results can be accomplished in practice.

1. Immobilizing the image of the moving subject

This method of "freezing" motion has the advantage of being within the range of any camera, from the simplest "box" to the most expensive instrument, regardless of the speed range of the shutter. It can be implemented in two different ways.

1-a. Panning. To use an analogy, you use the camera as you would use a shotgun on a flying bird: Aim through the viewfinder at the image of the

moving subject, follow through with the camera, and release the shutter while swinging. In this way, the image of the moving subject remains for all practical purposes stationary on the film during the exposure and consequently is rendered sharply, whereas the less important background becomes blurred owing to the motion of the camera. *Panning*, as this method is called, is pictorially more effective than any other method of "freezing" motion because it renders the subject sharply (and therefore easily recognizable in the picture) while preserving the feeling of motion through contrast between sharpness and blur. It recreates the impression one gets when following a moving object with the eye.

1-b. Catch the peak of the action when movement is practically at a standstill. For example, photograph a pole vaulter as he crosses the bar at the peak of the jump, a golfer at the completion of the swing when the club is over his shoulder, a diver at the start of his downward plunge, and so on. Figuratively speaking, photograph the pendulum at the end of its swing before it goes into reverse—and motion will appear "frozen" even when seen through the lens of a "box."

2. Restricting the motion of the image on the film

You have the choice of four different approaches, each of which can be used either separately or in combination with one or more of the others.

2-a. High shutter speed. The higher the shutter speed, the shorter the exposure, the less the image changes its position on the film, the smaller the degree of blur, and the sharper the final picture. Whether or not shutter speed is high enough to produce the desired result depends on the speed of the moving subject: The faster its motion, the higher the shutter speed must be to "freeze" image movement on the film. This shutter speed, however, is determined not only by the *actual speed* of the moving subject but also to an even higher degree by its *apparent speed relative to the camera*, its *angular velocity*. Technically, it makes a great difference whether an automobile traveling at 60 m.p.h. is photographed in side view as it passes the camera at right angles to the line of sight or in a narrow-angle end view while traveling at the same speed toward or away from the camera. In the first case, the *effective* speed of the car relative to the camera is very high; in the

second case it approaches zero, even though *in both cases* the *actual* speed of the car is the same. The following table lists the approximate shutter speeds required to obtain sharp pictures of various subjects moving at different speeds.

Subject	Distance: Object-Camera	Direction of Motion	Focal Length of Lens					
			2 in.	3 in.	4 in.	5 in.	6 in.	10 in.
People walking, children playing, waves, slow-moving animals	25 ft.	(parallel / diagonal / toward)	$1/50$ $1/30$ $1/20$	$1/75$ $1/50$ $1/30$	$1/100$ $1/75$ $1/40$	$1/125$ $1/85$ $1/50$	$1/150$ $1/100$ $1/60$	$1/250$ $1/150$ $1/80$
People running, horses galloping, bicycles racing, automobiles moving 30 m.p.h	50 ft.	(parallel / diagonal / toward)	$1/180$ $1/120$ $1/60$	$1/275$ $1/180$ $1/90$	$1/360$ $1/240$ $1/120$	$1/450$ $1/300$ $1/150$	$1/550$ $1/360$ $1/180$	$1/900$ $1/600$ $1/300$
Horses trotting, bicycles coasting, children racing / Automobiles, trains, etc., at 40–60 m.p.h.	25 ft. / 100 ft.	(parallel / diagonal / toward)	$1/200$ $1/120$ $1/75$	$1/300$ $1/180$ $1/100$	$1/400$ $1/240$ $1/125$	$1/500$ $1/360$ $1/160$	$1/600$ $1/450$ $1/200$	$1/1000$ $1/750$ $1/330$
Fast athletic events	25 ft.	(parallel / diagonal / toward)	$1/300$ $1/200$ $1/100$	$1/425$ $1/300$ $1/150$	$1/550$ $1/400$ $1/200$	$1/700$ $1/500$ $1/250$	$1/850$ $1/600$ $1/300$	$1/1400$ $1/1000$ $1/500$

If a camera doesn't have the exact shutter speed recommended here, the one that is closest to it should be used. When indicated distances are doubled, exposure times may be twice as long; when distances are halved, shutter speeds have to be twice as high.

2-b. Direction of motion. If the range of available shutter speeds does not include speeds high enough to take sharp pictures of fast-moving subjects, image motion on the film can be reduced considerably and sharp pictures can be obtained at comparatively slow shutter speeds, if the moving subject is photographed coming toward or going away from the camera instead of

115

passing it at right angles. How slow shutter speeds can be is shown in the table. Provided that such a head-on or rear view of the subject is pictorially acceptable, this method for "freezing" motion is recommended especially for simpler cameras with limited shutter speeds.

2-c. Subject distance. The farther the moving subject from the camera, the lower is its *angular velocity*, that is, its *apparent speed*, its speed relative to the observer and the film. Seen from afar, a racing car in competition may not seem to travel particularly fast, but this same car passing the stands at the same speed is, because it is near, hardly more than a blur. By making use of this phenomenon—by increasing the distance between moving subject and camera—photographers who have to work with cameras equipped with insufficiently fast shutters can still produce sharp pictures of fast-moving objects. For example, if the distances in the accompanying table are doubled, shutter speeds only half as fast as those listed are required to "freeze" the motions in question. Afterward, the photographer can always enlarge the now *sharp* negative to the desired print size.

Incidentally, in this respect, subject distance is proportional to image scale. Doubling the subject distance or shooting with a lens of half the focal length produces identical results: The subject is rendered only half as large on the film. Consequently, *angular velocity* can be reduced *either* by increasing the distance between subject and camera *or* by photographing the subject from the same distance with a lens of shorter focal length. For example, if the 6-inch standard lens of a 4 × 5-inch press camera requires a shutter speed of $1/600$ sec. to "freeze" a given motion, the same motion can be "frozen" satisfactorily at a shutter speed of only $1/200$ sec. by using a 35 mm. camera equipped with a 2-inch lens. As the focal length of the lens of the 35 mm. camera is only one-third that of the 4 × 5-inch camera, a shutter speed only one-third as high is sufficient to produce the same result. This fact is evident in the table, in which minimum shutter speeds are listed for lenses ranging from 2 to 10 inches in focal length.

2-d. Speedlights. An exposure can be timed in two different ways: by opening and closing the shutter or by turning the illumination on and off. Few mechanical shutters permit exposures as short as $1/2000$ sec. Beyond

this speed, inertia and insufficient strength of the shutter material make higher speeds impractical. But there is almost no limit to the shortness of duration of an illuminating electric spark, such as is used in the tube of a speedlight. Commercial and amateur speedlights operate at speeds around $1/1000$ sec.; for scientific purposes, speedlights with flash durations as short as $1/1,000,000$ sec. are available. Exposures of this order, of course, will "freeze" any kind of motion, no matter how fast, and have been used successfully to take tack-sharp pictures of bullets leaving the muzzle of a gun and of fragments of material shattering under the impact of an exploding shell.

With speedlights, furthermore, it is virtually impossible to get pictures that are unsharp due to accidental camera motion. As far as motion rendition is concerned, a needle-sharp photograph can be taken with a hand-held camera inside a truck jolting at high speed over a bumpy road.

Since speedlight exposures are timed by the duration of the spark and not by the speed of the shutter, which, as far as cameras equipped with focal-plane shutters are concerned, can only be synchronized at fairly low speeds (normally less than $1/100$ sec.), such photographs can be taken successfully only if the incident light is so dim that it does not permit objects to register noticeably on the film. Otherwise, because the shutter is open for a comparatively long time, a secondary "ghost image" would be superimposed upon the sharp image produced by the speedlight, and the resulting photograph would appear unclear and confused owing to motion of the subject.

SUMMING UP

Motion can be "frozen" in many different ways, and best results will often be achieved by combining two or more of the methods discussed here. The basis for any motion photograph should be a *fast film*, for fast films alone permit utilization of high shutter speeds. *Shutter speeds* should be as high as light conditions permit. If necessary, in order to use a larger diaphragm aperture to permit use of a higher shutter speed, depth must be sacrificed. If a combination of these principles is still not sufficient to "freeze" the motion

in question, following the moving subject with the camera (1-a) or catching it at the peak of motion (1-b) should be considered. If motion is so fast that even this does not suffice to produce sharp pictures, the subject's *angular velocity* must be reduced by shooting from a different direction (2-b), shooting it from farther away (2-c), or using a lens of shorter focal length (2-c). In cases of extremely fast motion, especially at very short subject distances, speedlights (2-d) may enable the photographer to succeed where other methods failed. The following survey sums up the different means and methods for "freezing" motion:

High-speed film for practical utilization of highest shutter speeds

High shutter speed (2-a), if necessary in conjunction with a large f-stop

Panning (1-a), following the moving subject with the camera and exposing while swinging

Shooting at the peak of a motion (1-b)

Shooting more or less in the direction of the motion (2-b) instead of at right angles to it

Increasing the distance between the moving subject and the camera (2-c)

Using a lens with a shorter focal length (2-c)

Speedlight illumination (2-d)

A WORD OF ADVICE

"Technically" it is possible to "freeze" any kind of motion and to render the subject clear and sharp. Whether or not this always leads to the pictorially best results, however, is debatable. In a still photograph, motion, like color in a black-and-white picture, can be rendered only in symbolic form. For color, this form is graphic black-and-white contrast. For motion, it is blur. There is, for instance, absolutely no difference between the sharply rendered picture of an automobile standing still and one in motion. If it is important to indicate that the car is moving, motion must be symbolized in the form of blur. In other words, the picture must be shot with a shutter speed low enough *not* to "freeze" the motion of the car. Of course, *the degree of blur must be just right*. If it is too great, the car becomes

unrecognizable. If it is too small, the car appears to be standing still, and no feeling of motion exists. One must choose between a "literally true" and an "emotionally true" rendition. Which of these offers the better solution depends on the nature of the subject, the purpose of the picture, and the intent of the photographer.

How to Expose Correctly

At the moment of exposure, the first and most important step in the making of a photograph is completed. Prior to this moment, the photographer has many opportunities to create, arrange, select, and reject to make the picture exactly as he wants it. These opportunities are gone the instant he releases the shutter. Subsequently, he can do little to influence the result as far as composition, distribution of light and dark, color translation into black and white, symbolization or "freezing" of motion, and so on are concerned. Consequently, it is vitally important to consider fully all these aspects *before* the exposure is made.

The basis for any "technically perfect photograph" is a correctly exposed negative. "Exposing correctly" means admitting to the film the amount of light necessary to produce negatives with the right degree of density and contrast. There are a number of different factors that must be considered when computing an exposure (they will be discussed next), but *the basis* for any exposure should be a brightness reading taken with the aid of a photoelectric exposure meter, either built into the camera or in the form of a separate instrument.

HOW TO USE AN EXPOSURE METER CORRECTLY

Correctly used, an exposure meter guarantees correctly exposed negatives. The corresponding savings in film alone should in time pay for the cost of the meter. The gain in enjoyment and satisfaction that comes with improvement in one's work is, of course, incalculable.

119

On the other hand, an incorrectly used exposure meter is potentially harmful and of less practical value to a photographer than the exposure chart that is part of the instructions for use packed with every roll or box of film. The following discussion applies to any exposure meter, regardless of type or make, that is designed to measure **reflected light.**

The film-speed dial must be set in accordance with the rated ASA speed of the film that is to be exposed. For a few (primarily orthochromatic) films, film speed in daylight may differ from that which applies in tungsten light.

The brightness reading of the most important object in the picture must be taken. When taking an overall reading for a landscape shot, beginners often make the mistake of pointing the meter toward the horizon, too high. This allows direct skylight to enter the photoelectric cell, with the result that the reading will be too high, leading to underexposure. To avoid this, when measuring overall brightness for a landscape shot, aim the meter at a point halfway between the horizon and the camera. Only when the subject of the picture is the sky, as in sunset shots or cloudscapes taken from a plane, should the meter be aimed directly at the sky. In such a case, the sky itself is the subject, and exposure should be in accordance with its brightness. If part of the ground is included in such a shot, it can usually be permitted to go too dark through underexposure without endangering the intended effect of the picture.

When taking a close-up reading of, for instance, a face, be sure that your meter or hand does not cast a shadow on that part of the subject at which you aim the meter. Otherwise, the reading will be too low, causing overexposure. If necessary, in order to avoid measuring the shadow, take the reading at a slight angle.

Three different methods of measuring the brightness of the reflected light are at the disposal of a photographer, each of which has particular advantages over the others.

1. The camera-position method is the easiest and fastest (but may result in over- or underexposure of a *small* yet important part of the subject). The reading is taken from the camera position by pointing the meter at the subject. Outdoors, make sure that skylight does not inflate your reading.

120

2. The brightness-range method is the most accurate way to determine correct exposure. Two different readings must be taken: one of the brightest and the other of the darkest part of the subject, *except* white and black areas that don't have to show detail. These readings must be taken from so close that *only* the brightest and darkest areas are measured. To do this, the photographer must be able to get close enough to the subject, and he must be careful not to measure a possible shadow cast by the exposure meter. Exposure is then determined by setting the arrow of the meter midway between the values that correspond to the highest and lowest readings. In cases in which it is not possible to get close enough to the subject accurately to measure its brightest and darkest parts (as in landscape photography), substitute readings can sometimes be taken from similar objects of similar brightness located nearby. For example, instead of measuring the brightness of a distant tree, a nearby tree that is lighted in a similar way can be measured even though it may be outside the field of view of the camera. And instead of measuring the brightness of a face (perhaps of a stranger in a foreign town), the photographer can take a substitute reading from the back of his own hand, provided that it is more or less the same color, that it is lighted in the same way, and that the reading is not falsified by the shadow of the meter.

3. The close-up method is a variation of the brightness-range method and produces the most accurate results in cases in which it is important to get the best possible exposure for a subject that fills only a relatively small area of the picture, *provided this subject is neither exceptionally light nor exceptionally dark*. Only one close-up reading of the object in question is taken (avoid a possible shadow cast by the meter); all other objects within the frame of the picture, regardless of brightness, are disregarded. This method gives best results when an object of limited extent is of paramount interest while the remaining subject matter is of negligible importance or is background.

All the methods and rules discussed so far apply to the measuring of light *reflected* by the subject. However, exposure can also be determined by directly measuring the intensity of the illumination itself, the *incident light*. Differences between the two methods are as follows.

Reflected-light reading is the method according to which *the meter is aimed at the subject from the camera position*. Most hand-held instruments and all exposure meters built into cameras work according to this principle. This is the most accurate method of determining correct exposure because it permits the photographer to measure directly the brightness (contrast) range of his subject and to take close-up readings, which the second method does not. It is also more adaptable to specific circumstances than the method of measuring incident light, though sometimes not quite as easy.

Incident-light reading is the method according to which *the meter is aimed at the camera from the subject position*. Meters not expressly designed for this method can usually be converted to incident-light measuring with the aid of a special adapter. This method is particularly effective for taking pictures by artificial light, for it integrates all the light from all the photo lamps regardless of their position and distance.

FACTORS THAT INFLUENCE THE EXPOSURE

No matter how accurate a brightness reading is, it usually provides no more than *a basis for the exposure*, for some or all of the following factors must be considered in computing the final data:

> **film speed**
> **depth of subject**
> **movement of subject**
> **contrast of subject**
> **color of subject**
> **distance of subject**
> **filter factor**
> **slip-on lens factor**
> **type of developer**
> **time of exposure**

p. 60 **Film speed.** The film-speed dial of the exposure meter must be set in accordance with the rated ASA speed of the film that will be used. A few

(mostly orthochromatic) films have two different speed ratings, one for daylight, the other for tungsten light (photo lamps).

Depth of subject. The greater the extension in depth that must be covered sharply, the smaller the required diaphragm stop. And the smaller the diaphragm stop, the slower the corresponding shutter speed. Normally, practical considerations force a photographer to compromise between an f-stop that is small enough to produce sufficient sharpness in depth yet large enough to enable him to use a shutter speed that is high enough to permit a hand-held exposure ($1/60$ sec. is normally the minimum) or to "freeze" subject motion. Whichever is more important—depth or motion—determines whether an exposure "for depth" (relatively small f-stop in conjunction with a relatively slow shutter speed) or "for motion" (relatively high shutter speed in conjunction with a relatively large f-stop) must be selected.

Movement of subject or camera. Subjects at rest can be exposed for any length of time, provided the camera is firmly supported. To avoid unsharpness caused by accidental camera movement, pictures that must be taken with the camera hand-held should normally be exposed not longer than $1/60$ sec. For the exposure of subjects in motion, consult the previously given table of applicable shutter speeds for subjects moving at different rates of p. 115 speed. However, a certain degree of blur is normally required to create a feeling of motion. In some cases, a compromise between a relatively high shutter speed (to "freeze" motion) and a relatively small f-stop (to produce sufficient sharpness in depth) may be unavoidable.

Contrast of subject. Exposure meters are calibrated to give correct data for subjects of average contrast. If subject contrast is very much *higher* than average, exposure can advantageously be *increased* by 50 to 100 percent beyond the value indicated by the meter. Conversely, if subject contrast is *abnormally low*, the *exposure should be halved*. This way, it is still possible to produce well-balanced negatives by correspondingly *decreasing the time of development for the overly contrasty subjects* and *increasing the time of* p. 109 *development for the contrastless subjects*, as already discussed.

Color of subject. Exposure meters are calibrated to give correct data for *subjects of medium-bright color*. In order to get correctly exposed negatives

of abnormally bright and abnormally dark subjects respectively, exposure as indicated in the first case must be *increased* from 2 to 5 times (depending on the degree of subject brightness), and in the second case *reduced* by a factor of 1.5 to 3. The explanation of this apparent paradox lies in the fact that exposure meters are designed to "think gray." For example, if we measure the brightness of a medium-bright color or gray shade and expose accordingly, we get a gray tone of corresponding brightness in our picture. However, if we were to take a meter reading of, say, a white dress in direct sunlight (a subject of abnormal brightness), the intense brightness of this object would, of course, result in a very high meter reading—a reading in fact so high that it would cause underexposure, and an underexposed white is rendered in a photograph as gray. Conversely, if we were to take a meter reading of, say, a black sweater in the shade (an abnormally dark subject), our meter would, of course, give a very low reading—a reading in fact so low that it would lead to overexposure, and an overexposed black is rendered in a photograph as gray. It is for these reasons that, when taking a brightness reading, a photographer must disregard black and white areas of the subject; that abnormally bright scenes require additional exposure; and that abnormally dark subjects must be exposed for less time than the exposure meter indicates.

Distance of subject. If subject-to-camera distance is shorter than approximately five times the focal length of the lens, discrepancies in value between the "listed" and the "effective" f-stops become so great that they must be considered if underexposure is to be avoided. The formula according to which the necessary increases in exposure can be computed has already been given. A very practical little device that permits a photographer simply to dial the necessary data is the *Effective Aperture Kodaguide* made by Kodak; it is available at most photo stores.

p. 47

Filter factor. All filters absorb a certain amount of light that otherwise would be available for the exposure. This light loss must be compensated for by a corresponding increase in exposure if underexposure of the negative is to be avoided. The amount of increase—the exposure factor by which exposure as indicated by the meter must be multiplied—depends on the color and density of the filter, the type of film in conjunction with which it is used, and the type of illumination (daylight or tungsten light). These filter

124

factors have previously been given. For example, if the meter indicates an p. 106 exposure of $^1/_{100}$ sec. at f/11 and the filter that is to be used has a factor of 2, exposure must be doubled. This can be accomplished either by increasing the diaphragm aperture by one stop and exposing 100 sec. at f/8 or by doubling the exposure time and exposing $^2/_{100}$ or $^1/_{50}$ sec. at f/11.

Slip-on lenses change the focal length of the lens in conjunction with which they are used. As a result, the f-stop values engraved on the lens are no longer valid because they were computed for the focal length of the primary lens and *not* for the focal length of the lens system consisting of primary lens plus slip-on lens. Compared to the primary lens alone, the combination of *lens plus positive slip-on lens is faster*, and the combination of *lens plus negative slip-on lens is slower*. In practice, positive (wide-angle) slip-on lenses are used almost exclusively for close-ups of small objects in a scale larger than that which would have been possible with the primary lens alone (because of insufficient extension of the camera). In such cases, discrepancies in the value of the stop numbers caused by the slip-on lens can safely be disregarded because the gain in speed through use of the positive slip-on lens is balanced by the loss in speed caused by the increase in distance p. 46 between lens and film necessary for making the close-up shot.

The combination of lens and negative slip-on lens, because it increases the focal length of the primary lens without increasing its relative aperture, is always considerably slower than the primary lens alone and requires corresponding increases in exposure if underexposure is to be avoided. The simplest way to arrive at the correct exposure is to increase the exposure by the factor supplied by the manufacturer of the slip-on lens. Alternatively, the photographer can measure the distance between lens center and film after focusing, measure the diameter of the diaphragm that will be used to take the picture, and divide the first by the second; the resulting figure is the *effective* f-stop that must be used when reading the exposure-meter dial.

Type of developer. Film-speed ratings are always based on film development with standard developers. Some fine-grain developers, however, produce negatives with comparatively fine grain because they only partly develop each individual negative grain; others do not penetrate the emulsion but confine their action more or less to the surface. As a result of this

incomplete development, such fine-grain developers produce negatives that would appear underexposed unless exposure had been increased accordingly. The amount of increase—the exposure factor—varies with the type of fine-grain developer. As a rule, developers producing the finest grain demand the greatest increases in exposure. Consult the manufacturer's instructions.

The simplest way to provide for the necessary exposure increase is to deduct the resulting speed loss from the rated speed of the film and to set the film speed dial of the exposure meter for the lower *effective* speed. Let us assume, for example, that a film with an ASA rating of 125 should be developed in a fine-grain developer that has a factor of 2. Instead of setting the dial for the full "theoretical" speed of 125, set it at ASA 64, the new "effective" speed of this film; f-stops and shutter speeds will automatically be computed for correct exposure of this particular film in conjunction with this particular fine-grain developer.

Time of exposure. Under normal conditions, decreasing the diaphragm aperture by one full stop must be compensated for by doubling the time of exposure if the result is to be the same in regard to negative density. However, when light intensities become abnormally low, this ratio no longer applies and increases in exposure produce proportionally less and less density in the negative (*reciprocity failure*). This fact must be considered whenever exceptionally long exposures are involved, as, for example, in extreme close-up photography or when taking time exposures at night. For example, if an exposure of 5 sec. at f/4 is correct but the diaphragm must be stopped down to f/16 in order to produce sufficient sharpness in depth, exposure according to the meter would have to be 80 seconds. Actually, however, because of failure of the law of reciprocity, an 80-second exposure would be quite insufficient to produce a negative of the same density as the one exposed 5 seconds at f/4. Depending on the type of film, an exposure of 3 to 5 minutes would probably be needed. As reciprocity failure manifests itself to different degrees with different types of film, no definite rules can be given and, unless the film manufacturer provides the necessary information (as Kodak does for its films in its Professional Data Book F-5), data must be gathered through actual tests.

Subjects that cannot be measured with an ordinary exposure meter must be exposed in accordance with the following guidelines. The data listed are computed for medium-fast panchromatic films with an ASA speed of 400. If films of higher or lower speeds are used, these data must be modified accordingly.

brightly lighted downtown street scenes—$^1/_{60}$ sec. at f/3.5
brightly lighted night-club or theater districts, Times Square—$^1/_{60}$ sec. at f/4.5
floodlighted buildings and monuments—$^1/_{15}$ sec. at f/2
neon signs and advertising "spectaculars" at night—$^1/_{60}$ sec. at f/5.6
night baseball, race tracks—$^1/_{125}$ sec. at f/3.5
amusement parks and fairs at night—$^1/_{30}$ sec. at f/3.5
indoor and outdoor Christmas lighting at night—$^1/_{30}$ sec. at f/2
campfires, burning buildings at night—$^1/_{60}$ at f/4.5
fireworks (aerial displays)—keep shutter open for several bursts at f/18
lightning at night—keep shutter open for one or two strokes at f/11

Practical application. To illustrate the degree to which data yielded by an exposure meter may have to be modified before they can be used to set the diaphragm and shutter of the camera, let us consider a hypothetical example: The subject is a close-up in natural size of a dark red rose; the filter is light red (Kodak 23A, with a factor of 3 in tungsten light) to improve separation between the red of the flower and the green of the surrounding leaves; the illumination is from two photo flood lamps; and the developer is fine-grain with a factor of 1.5. Exposure according to meter should be $^1/_{10}$ sec. at f/20.

The following factors must be considered: rendition in natural size = 4; abnormally dark subject = -1.5; red filter = 3; fine-grain developer = 1.5. To get the final factor by which to multiply exposure as indicated by the meter, we now must multiply the individual factors by one another: $4 \times 3 \times 1.5 = 18$. But, because the subject is abnormally dark in color, this factor must now be multiplied by -1.5 so that we arrive at a combined factor of 12.

It is this factor of 12 by which the original exposure meter-derived figure of $1/10$ sec. must now be multiplied. Consequently, instead of $1/10$ sec. at f/20, we must now expose $12/10$ or roughly one full second at f/20. Unfortunately, this gets us into a new problem: reciprocity failure. For most Kodak films, the reciprocity factor for a 1-second exposure is 2. Consequently, all that remains to be done is to multiply $12/10$ sec. by 2 and we arrive at a final, correct exposure of $24/10$ or approximately 2½ seconds at f/20.

CONCLUSIONS

Exposing can be reduced to a science. We can eliminate the prime source of failure if, instead of relying on our eyes and "guessing" at exposures, we rely on tables, dial readings, and scientifically established exposure factors. If in doubt, "bracket" your exposures; instead of only one, take *several* exposures at different diaphragm or shutter-speed settings to be certain of at least one correctly exposed negative. The best way of *bracketing* such a series is to shoot around an exposure that is likely to be correct, starting with an exposure that is probably a little bit too short and doubling the exposure with each consecutive shot. If, for practical reasons, only one exposure can be taken, one should remember that, *in black-and-white photography*, erring on the side of overexposure is always preferable to exposing too little (underexposure). For a quick check and recapitulation, here is a list of the most common causes of faulty exposure:

incorrect use of exposure meter (too much skylight)
film speed dial set for the wrong type of film (too high or too low)
filter factor not considered or wrong factor used
fine-grain developer factor not considered (exposure would have been correct if film had been developed in a standard developer)
one of several involved factors forgotten or factors added instead of multiplied
the close-up factor forgotten (applicable only if subject distance is five times the focal length of the lens or shorter)
the possibility of reciprocity failure not considered (applicable only to exposure times 1 sec. or longer)

Double exposure—two pictures shot on the same film. To prevent double exposure, be sure to transport the film or pull the film-pack tab immediately after each exposure. However, if shutter and film transport are coupled (and double exposures impossible), do not leave the shutter cocked for any great length of time, as this is bad for the springs inside the shutter mechanism.

Dirt on film prior to exposure produces black marks similar to those in the sky of this picture. To prevent this, clean inside of camera regularly with a camel's-hair brush. If camera has bellows, extend bellows completely, open back of camera, hold camera vertically, and tap bellows gently but firmly from all sides.

Dirt on negative during printing and enlarging produces white marks. To prevent this, carefully clean negatives and glass plates of printing frame or enlarger before printing (see p. 197). Furthermore, be sure that underside of condenser in enlarger is also clean, for dust adhering to it will show up in the print.

Faulty focusing—lens focused on trees in background instead of subject in foreground. This fault can be recognized by the fact that unsharpness is confined to a certain zone in depth, whereas the rest of the picture is sharp.

Subject movement—shutter speed too slow to "stop" motion of the subject. This fault can be recognized by the fact that only the moving subject is unsharp, whereas stationary objects in the photograph appear perfectly sharp.

Unsharpness and its most common causes

Camera movement—camera not held perfectly motionless during the exposure. This fault can be recognized by the fact that every part of the picture appears equally blurred in the same direction and nothing is really sharp.

Shutter failure—a leaf shutter, stiff from cold, that failed to close completely after the exposure was responsible for these mistakes. Transporting the film while the shutter was still partially open caused the light to trace parallel lines, straight (left) because the camera was stationary on a tripod, wavy (right) because the camera was hand-held and moved during the winding of the film. To prevent this, have your shutter "delubricated" by a competent repairman before you take pictures in extreme cold (around 0° F. and below). It is "sticky" oil or just plain dirt that causes the shutter mechanism to act so sluggishly.

Static marks, caused by friction generated during the winding of the film. This danger is greatest during cold, dry weather and absent under warm and humid atmospheric conditions. To avoid such marks, wind the film very slowly and evenly.

131

Light-struck negatives like these can be avoided: Never leave camera exposed to bright light longer than necessary. Do not load and unload camera in bright light. If there is no shade, turn away from the light, and use the shade cast by your body. Be sure that film rolls are wound tight. Hold film packs by their edges only, and do not press on their flat sides, for this may partially open them to light. Check camera periodically for light leaks, which occur most often along sides of hinged or detachable camera backs. Check sheet-film holders for worn light traps and worn and cracked slides, paying particular attention to their corners.

Flares caused by strong direct light striking the lens. Their shapes depend on the position of the light source and the construction of the lens. The more complicated the lens and the greater the number of its glass-to-air surfaces, the more the danger of flares increases. If the light source does not have to appear in the picture, flares can be prevented by shielding the lens from direct light with a correctly designed lens shade or a screen interposed between light and lens. If the light source has to appear in the picture, use of a coated lens minimizes the danger of flare but does not always eliminate it.

Diaphragm stars caused by light reflected from the blades of the diaphragm. These star patterns, which appear only around strong lights, become more pronounced as the exposure time increases.

Fingermarks and scratches are unmistakable signs of carelessness. To prevent these, do not touch the flat sides of dry negatives with your hands (or marks like those above may result); handle negatives instead by the edges only. Use print tongs for handling paper during printing and enlarging (if hands and fingers are used, marks like those below, left, which were caused by touching the unexposed paper with hypo-contaminated fingers, may result). When developing sheet films in a tray, be sure that your fingernails are short; otherwise scratches and digs like those below, right, are almost unavoidable.

Cinch marks caused by winding roll film too tightly. Cinch marks occur particularly often during the last stage of rewinding exposed 35 mm. film when the photographer tries to pull the tail end out of the take-up spool. To avoid these, rewind film only until sudden resistance indicates that the end of the film is reached, then open camera, take out both spools, and disengage the tail end of the film gently from the take-up spool. Then wind the film all the way back into the cartridge to avoid confusing exposed and unexposed film.

Scratches caused by sand inside the camera or by burr on the film guides. Such scratches are the almost unavoidable result of carelessly exposing a camera to sand. Tiny grains of sharp-edged sand get into the camera and scratch the film directly or, being trapped between film and film guides, cut into the metal and cause burr, which in turn scratches the film as it passes across the guides. To avoid such scratches, protect your camera from sand, clean the inside of the camera each time after use on a beach, and have burrs removed by a good camera repairman.

135

Different manifestations of damage caused by water

Raindrops on the lens caused these strange halations. To prevent these, shield lens with an adequate lens shade, use an umbrella, or take the picture from a sheltered place—a doorway, the interior of a car, or the like.

Water drops that dried on the negative caused these unsightly spots. To prevent such spots, wipe negatives carefully on both sides with a damp viscose sponge before you hang them up to dry.

Negative emulsion reticulated partially because of insufficient hardening and excessive temperature of the solutions and/or wash water. This danger is particularly acute in warm weather. To prevent this, use only fresh acid hardening fixing bath; the temperature of the solutions must not exceed 75° F.

Too short Correct Too long

Too short

Normal

Too long

Underexposed
and underdeveloped

Overall density: extremely
low

Contrast: much too low

Shadow detail: completely
lacking

Highlights: much too weak

Remedy: none; such nega-
tives are total losses

Correctly exposed
but underdeveloped

Overall density: too low

Contrast: too low

Shadow detail: present but
thin

Highlights: too weak

Remedy: print on paper of
hard gradation

Overexposed
and underdeveloped

Overall density: almost
normal

Contrast: too low

Shadow detail: abnormally
strong

Highlights: too weak

Remedy: print on paper of
extra hard gradation

Underexposed
but normally developed

Overall density: too low

Contrast: too great

Shadow detail: practically
nonexistent

Highlights: too weak

Remedy: none; no intensi-
fier can produce shadow
detail that is not there

Correctly exposed
and correctly developed

Overall density: normal

Contrast: normal

Shadow detail: normal

Highlights: strong but still
transparent

Overexposed
but normally developed

Overall density: too high

Contrast: too low

Shadow detail: abnormally
strong

Highlights: too dense,
pronounced graininess

Remedy: reduce in Kodak
Reducer R-4a; print on
paper of hard gradation

Underexposed
and overdeveloped

Overall density: about
normal

Contrast: much too high

Shadow detail: too weak

Highlights: rather dense
and black

Remedy: if extremely dense,
reduce with potassium
persulfate; print on paper
of extra soft gradation

Correctly exposed
but overdeveloped

Overall density: too high

Contrast: somewhat higher
than normally desirable

Shadow detail: strong

Highlights: very black and
blocked; pronounced
graininess

Remedy: reduce in potas-
sium persulfate; print
on paper of soft grada-
tion

Overexposed
and overdeveloped

Overall density: extremely
high; negative appears
practically black

Contrast: about normal

Shadow detail: much too
strong

Highlights: perfectly black
and detailless; graininess
extremely pronounced

Remedy: reduce in Kodak
Reducer R-5; print
on paper of normal grada-
tion

139

Uniform up-and-down agitation that pumped developer in always the same way through the perforation holes of the 35 mm. film caused these streaks in the sky. Similar effects often result when sheet films are developed in hangers and agitation is mechanically up-and-down, pumping developer through the holes in the channels of the sheet-film hangers.

Incorrect development

Insufficient agitation. Some of the components of stagnant, insufficiently agitated developer separated and thereby caused the two dark streaks and the light edge at the right side.

A **"perfect print."** Compare with the following faulty prints and notice evenness of grays, long scale of tonal gradation.

Uneven immersion of the exposed paper into the developer, a frequent result of insufficient solution, caused these streaks.

The three most common mistakes in print processing

"Forcing" an underexposed print in the developer produces nothing but a washed-out, chalky, harsh, contrasty, and often yellow-stained print similar to this.

"Pulling" an overexposed print prematurely from the developer produces a mottled, contrastless, and often brownish discolored print similar to this.

141

← PRINT EXPOSURE →

Too short

Correct

Too long

The commonly used method of exposure determination—test strips—has the disadvantage that it allows solely for the comparison of different images in different degrees of lightness or darkness. A more practical method for making comparative test exposures is through use of a template —four different exposures of an identical negative section are thus produced, and comparison of the results becomes much easier.

Test strip with seven different exposures. Different sections of the negative must be compared. In this particular instance, comparison is fairly easy because, in terms of subject, the different sections are almost identical. In other instances, however, variations in subject matter make accurate evaluation of test strips almost impossible. It then becomes advisable to make test exposures through the template illustrated below.

Exposure determination for enlargements

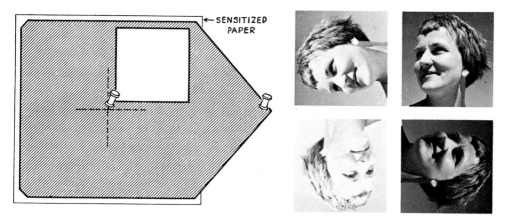

Cut template according to sketch at left out of thin, hard cardboard or thin sheet metal, making hole about 1½ inches square. Cut a supply of squares of sensitized paper (in different gradations) ⅛ of an inch larger than the template. Put template on enlarger easel so that the most important section of the picture appears in the window. Place test paper beneath template, and pin it down at center so it can be rotated around the pin. Through the window in the template, expose test paper four times at different exposures, rotating the paper 90 degrees for each consecutive exposure. Develop, fix, and examine it; use best exposure for making final print.

Solarization. *Left:* photograph of a sunset, short exposure. *Right:* same subject, photographed with longer exposure to produce more shadow detail. As a result, the sun appears black. Such a reversal of tone values into the negative form caused by enormous overexposure is called "solarization." The rest of the picture remains unaffected, since, because of its darker subject matter, it was proportionally less overexposed than the sun.

Forgetting to take the lens cap off a rangefinder camera or to pull the slide of a film holder or film-pack adapter will produce a picture like this.

Vignetting and increasing un-sharpness toward the top of the picture, caused by a lens with insufficient covering power, which, in an effort to improve perspective, was raised too high. If a lens with greater covering power had been used, this mistake would not have happened.

Daylight is usually a more or less given factor over which the photographer has very little influence. By contrast, artificial illumination is often completely under the photographer's control. Though it may sometimes be inadequately handled, daylight, because of its "naturalness," can never be really bad as far as pictorial considerations are concerned, no matter how dull or commonplace the illumination. Artificial illumination, however, because of its flexibility, which makes it adaptable to any imaginable whim, positively invites misuse. With the aid of artificial light, the most bizarre effects can be created. But unless the illumination—no matter whether natural or artificial—is used by the photographer as a means for expressing specific ideas or feelings, the result is apt to be confused, haphazard, or meaningless.

PURPOSE AND PRINCIPLES OF LIGHTING

Before he starts to take a picture, a photographer should know what he expects his lighting to do. A few moments of constructive thinking often make the difference between "knowing" and "guessing," planned experimentation and pointless "trial," success and failure, satisfaction and disgust. In photography, light plays a triple role.

1. Light is the photographic medium

Light is to the photographer what color is to the painter; stone, clay, and wood to the sculptor; sound to the composer. In perfect darkness, even the best photographer is powerless. With the aid of light, he can do anything. Light has as many nuances and degrees as color or sound. Light and dark are essentially the same, being different manifestations of the same medium, infinite in their number of shades and transitions, and different in value only, like positive and negative. Differences in value produce differences in impression and mood. Illumination sets the key of a picture. Basically, lightness is cheerful; darkness is somber. Overall lightness can make a photograph friendly, joyous, exhilarating. Overall darkness tends

to make it serious, sad, or depressing. Between these extremes, any mood from objective documentation to subjective interpretation can be projected by a photographer who has a feeling for light and knows how to handle it.

For example, the interior of a night club must be photographed. The mood of the place is one of intimacy, of darkness pierced by many tiny lights. In order to preserve this mood, which is the outstanding quality of the subject, a photographer with a feeling for light will take the picture more or less as it is. He may use a few carefully subdued fill-in lights to preserve a minimum of shadow detail—but no more than is absolutely necessary to create the right atmosphere and avoid the impression of unrelieved black. On the other hand, a photographer without much feeling for mood, determined to get a "technically perfect negative," may simply take the picture with flash. Naturally, his picture will be sharper and more detailed than that of the first photographer, gradation will be better, contrast will be less abrupt, and the movement of people will be "stopped." In short, he will get everything except the essential—the mood of the place—which he destroyed in a burst of uncontrolled light. His will be a beautiful negative but a lousy picture.

2. Light as creator of volume and form

Volume and space are three-dimensional, but a photograph has only two dimensions. Therefore, to translate volume and space directly into a photograph is physically impossible. All a photographer can do is to create *an illusion* of three-dimensionality. If he succeeds, his subjects acquire roundness and volume, and his space has depth. If he is unsuccessful, his photographs seem flat.

Light is the most effective medium for creating illusions of depth and space. If a face is illuminated from directly in front with shadowless light, it appears flat. However, if the lamp is moved to one side to cast shadows, the same face then acquires roundness and volume.

Any draftsman knows that shading adds depth to his drawing. This is also true of a photograph. Drowned in a flood of uncontrolled light, even a veritable Brunhilde appears as flat as a paper doll. On the other hand, correctly lighted, even a shallow bas-relief acquires depth. It is the interplay of light and shadow that creates the illusion.

146

3. Light and shadow as black and white

In a photograph, brightly illuminated objects appear white; objects in deep shade appear black. In between lies the range of different shades of gray. Pictorially, these *graphic* qualities of the illumination are just as important as the qualities of light that create space effects. White is dominating and aggressive. Black is passive and receding, like a cave. In any subject, the forms that stick out aggressively catch the light first; those that recede are left in shady darkness. In a picture, aggressive white can be used to attract the eye of the observer to points of major interest. Black induces a feeling of strength, solidity, and power. Gray is neutral. To make white appear "whiter," one can contrast it with black. To make black appear "blacker," one must contrast it with white. In juxtaposition with gray, white or black appears less luminous or powerful than when white and black are contrasted with each other.

Through selection of the right kind of illumination, almost any subject can be photographed either as it appears to the eye, lighter, or darker. To convince yourself of this, make the following experiment: Take a small black object, and place it in front of a white background, but not too close to it. Illuminate this setup evenly with one photo flood; then take a picture. It will show object and background in their natural values of black and white. Now place the light much closer, and, by interposing a piece of cardboard between the background and the lamp, arrange the illumination so that the black object is brilliantly lit while the background is in deep shade. The resulting picture will show the originally black object as white against a background of black. As a third step in this exercise, balance the illumination until both object and background appear as equal shades of gray. Such a series not only proves that light can be used to create very different graphic effects but also illustrates the dangers that can result from incompetently handled illumination.

HOW TO LIGHT A PICTURE

Anyone wishing to acquire more than a theoretical knowledge of the functions of different types of light (and different types of photo lamps)

should perform the following experiment in portraiture. Step by step, it will teach him how to arrange effective illumination. For this experiment he requires a model and four lamps.

Preparations. Pose the model comfortably and naturally in front of but not too close to a neutral background. Darken the room illumination until there is just enough light left to see what you are doing—but not enough to interfere with the effect of your lights.

The main light

The first step. Place the *main light*. Its purpose is to establish the form of the subject and to fix roughly the ratio of light to dark. It is the most important of your lights. The ideal main light is a large spotlight approximating the effect of the sun. If you lack this type of light, a 500-watt photo flood will do almost as well. Place the light somewhat to one side and slightly higher than the model. This position automatically produces a good illumination. Later, as your experience grows, you may try other positions for more spectacular effects. But at the beginning it is advisable to stick to a safe setup. The main light is placed correctly if what it reveals makes sense and does not consist merely of a number of unrelated meaningless spots of illuminated subject matter. It must accentuate the main forms of the subject, model its planes with plastic light, and throw strong and significant shadows. Regardless of how much or how little it reveals, what we see must be graphically pleasing in composition, pattern, and black-and-white effect. The ratio of light to shadow sets the key of the picture. Predominance of light makes a photograph gay and light; predominance of shadow creates a more serious, "glamorous," or somber impression. Equal distribution of light and dark should normally be avoided because the effect is often dull.

The fill-in light

The second step. Place the *fill-in light*. Its purpose is to lighten slightly the shadows cast by the main light—not too much, just enough so they will not print too black but will show traces of detail.

The fill-in light should be a well-diffused photo flood. It should be placed as close to the camera as possible and slightly higher than the lens. In this

position there is the least danger of producing shadows within shadows —separate, criss-crossing shadows cast respectively by the main light and the fill-in light. Such double shadows are extremely ugly and must be avoided at any cost. Multiple shadows result if the fill-in light is either too strong or placed too far away from the imaginary line that represents the continuation of the optical axis of the lens. To attempt to "kill" a shadow within a shadow by "burning it out" with an additional lamp is futile and will only produce a third set of shadows.

The fill-in light is properly placed if it does not change the character of the illumination produced by the main light. Its sole function is to reduce overall contrast in the negative to a printable level.

The accent light

The third step. Place the *accent light.* Its purpose is to enliven the rendition by adding highlights and sparkle.

The accent light should be a small spotlight that can be focused on a definite area. It is used as a backlight to emphasize the outlines of the subject, highlight the hair, add catchlights, glitter, and sparkle. Because it must be placed somewhere in back of and to one side of the subject, it cannot cast "secondary shadows." However, care must also be taken to prevent it from shining into the lens and producing flares and ghost images on the film. A sheet of cardboard interposed vertically between the light and the lens will prevent this.

The accent light should be used sparingly and with discrimination. Its effects are the final touches that give a picture sparkling life and make a print "colorful" and rich. They are the seasoning that flavors the picture, and if we overdo it the result will be comparable to that of too much pepper in the soup.

The background light

The fourth step. Place the *background light.* Its purpose is to separate subject and background graphically through contrast between light and dark.

This lamp can be either a spotlight or a photo flood. What matters is not so much the quality of its light but its correct intensity and position, both of which must be adjusted carefully by placing it at the proper distance from the background that it must illuminate. By lightening the background behind the shadow side of the model and leaving it in the shade on the highlighted side, the photographer graphically separates model and background and introduces a feeling of space into the picture. A well-placed background light creates the feeling of roundness and "air," without which the model seems to "stick to the background." Contrast between light and dark creates the illusion of space.

CONCLUSIONS

The lighting scheme described here produces what may be called a *standard illumination*. It is always successful and can be used equally well to light a girl or a grasshopper, a dahlia or a drill press. It applies to incandescent light as much as to flashbulb or speedlight illumination. It can be varied in innumerable ways simply by varying the intensity or spread of the different lights. By changing the ratio of light to dark, one can produce pictures that are either more cheerful or more somber. By increasing the contrast until the shadows print pure black, one can achieve the typical "Hollywood glamor lighting," guaranteed to produce the most seductive effects. Once a photographer has familiarized himself with the purpose and effects of the different lights he can do anything he likes, and he will succeed as long as he observes the following basic rules that apply to any lighting scheme.

1. Never add a second lamp until you are thoroughly satisfied with the effect of the first.
2. Criss-crossing shadows must be avoided at any price.
3. Too many lamps and too much light will ruin any lighting.

ADVICE TO USERS OF ELECTRIC POWER

Ordinary home wiring is designed for average household needs. Photographic lights consume relatively huge amounts of power. To find out how many photo floods and the like can safely be connected to one circuit, multiply the voltage of the power line by the number of amperes of the fuse. The result is the number of watts that can safely be drawn from the circuit. For example, if the line carries 110 volts and the fuse can take a load of 15 amperes (the most common combination), multiply 110 by 15. The result is 1650 watts, the maximum load that you may draw from this circuit without danger of blowing a fuse. Divided among your photo lamps, it means that you can use simultaneously either three 500-watt bulbs, two 500-watt and two 250-watt bulbs, one 500-watt and four 250-watt bulbs, or six 250-watt bulbs. In any case, the combined wattage of these lamps amounts to 1500 watts, which leaves 150 watts available for other purposes (for example, ordinary ceiling lights or a radio).

To avoid blowing a fuse, additional lights must be connected to a different circuit. You can determine the different circuits in your home by connecting lamps to different outlets and unscrewing the fuses one by one. All the lamps that go out when a certain fuse is unscrewed are connected to the same circuit; the lamps that remain lit are controlled by a different fuse (and the outlets they are connected to belong to a different circuit).

The fuse is the safety valve of the power line. It is an artificial weak link designed to break under an overload, in order to protect the line and save it from destruction. If you accidentally blow a fuse, do not replace it with a stronger one, and don't ever use a penny or a wad of aluminum foil instead of a fuse. If you do, the next time it will be the power line itself that melts, and the resulting short circuit may start a fire that can burn down the house.

HOW TO USE FLASH

Although all the rules of good lighting apply to any kind of illumination, regardless of whether it is produced by incandescent light or flash, there is one practical difference between the two: Incandescent light is continuous,

and flash is discontinuous; it bursts into light and is extinguished within a fraction of a second. This characteristic of flashbulbs and speedlights complicates their use in two respects.

1. The effect of the illumination cannot be studied prior to exposure. Especially if several flashes are fired simultaneously (multiflash, slave lights), exact prediction of the overall effect of the illumination is extremely difficult, if not impossible. To solve this problem, many photographers balance their illumination, compose, and focus with the aid of photo floods. Then, when everything is set, they switch over from house current to batteries, replace the photo floods with flashbulbs without changing the position of their lamp stands, start the action, and flash the picture. To simplify matters, some photographers use two independent sets of lights—photo floods and flashbulbs in separate reflectors mounted side by side on the same light stands. In this way, no time is wasted in exchanging bulbs and reconnecting wires. And the larger, studio-type speedlights have special "modeling lights" built into their reflectors on the basis of which the illumination can be arranged; after completion, it is then duplicated by the flash.

2. Flash exposure cannot be determined with the aid of an exposure meter (except for exposure meters for speedlights which are expensive and normally found only in commercial studios). To compute the exposure, manufacturers have assigned special *guide numbers* to the different types of flashbulbs and speedlights. Tables containing such data are available at any photo store, usually free of charge; specific data are part of the instructions for use that accompany the respective flashbulb or speedlight. Exposure is then computed as follows: The guide number that applies is divided by the distance in feet between flash lamp and subject. The resulting figure, which, however, *applies only if flash is used at the camera as front light*, is the f-stop number that must be used to produce a correctly exposed negative.

Very important: The f-stop number established on the basis of guide numbers is correct only if the flash illuminates the subject from directly in front and only if a single flash is used. In all other instances, the f-stop number must be modified as follows: for sidelight, increase the diaphragm

152

aperture by one stop; for backlight, increase the diaphragm aperture by two stops—always provided that only a single flash is used. If two or more flashes are used simultaneously (multiflash), *only the flash that acts as the main light should be considered* when computing the diaphragm stop; all others (for backlight, fill-in illumination, and so on) are disregarded. However, if the main illumination is provided by a number of flash lamps of the same size (all directed toward the same subject area), the f-stop must be computed for only one flash and then modified by decreasing the diaphragm aperture by one full stop for each two flash lamps. If a number of identical flash lamps are strung out in order to cover a large area evenly in an overall shot—each lamp illuminating only its own section of the subject—the f-stop must be computed as if the shot were made with only one flash at a lamp-to-subject distance equal to the average distance of all the lamps.

POINTERS FOR PHOTO SOPHOMORES

Light is the strongest creator of mood. Arrange your illumination to fit the mood of your subject.

Arrange your illumination step by step. Start with the main light. Never use an additional light until the previous one is placed to your satisfaction.

Concentrate your light on the background, and keep the foreground darker. A dark foreground suggests a frame around the picture and guides the eye toward the center of the rendition, where interest belongs.

Flat front light and single flash at the camera normally produce the pictorially worst kind of illumination.

Low, skimming side- or backlight renders surface texture better than any other type of light.

Backlight is the most dramatic type of illumination—and the one most difficult to handle satisfactorily.

Light areas in a photograph usually draw the attention of the observer

first; use light to guide the eye to points of major interest. Catchlights in the eyes, highlights on shiny hair, reflections on a curving surface —these are the kinds of lights that draw attention.

On the other hand, be careful when placing spots of brightness close to the edge of the picture—they may lead the eye out of the photograph or give the impression that somebody has "nibbled its edges."

Don't be afraid of pitch-black, detailless shadows—provided that such shadows are expressive in form and placed so that they contribute to the pattern of the composition.

Shadows that criss-cross one another signify the beginner or the blunderer; they should be avoided at any cost.

In portraiture, the most important shadow is cast by the nose. It should never touch, cross, or even come close to the lips. If it does, the effect suggests a mustache or a beard, even if the subject is a lovely girl.

Watch out for the *blind spots* in a face, and make sure that they receive enough light. You find them in the corners of the eyes near the nose, in the angles between nose and mouth, and beneath the jaw.

Keep your fill-in light well diffused in order to avoid the danger of shadows that criss-cross one another.

Place your fill-in light as close as possible to the imaginary line that represents the prolongation of the optical axis of the lens; in this position, there is the least danger of the fill-in casting ugly shadows.

Always place your fill-in lamp slightly higher than the lens to prevent the subject from casting ugly shadows on the background; with the lamp in this position, possible shadows will be lower than the subject and, seen from the lens position, covered by it.

A fill-in light that is too weak is preferable to one that is too strong.

A fill-in light that is too strong produces almost the same effect as a single flash at the camera.

Whenever possible, make use of natural light and local illumination.

4

How to Develop and Print

Photographer at the crossroads—to do or not to do

Having shot your picture, you can do one of two things. You can take the exposed film to the drugstore or photo finisher and have it processed. This is quite uninspiring, and so usually is the result: finished pictures that differ only little, if at all, from the average snapshot. Or you can do the finishing yourself. Doing the whole job of picture making from start to finish literally doubles the pleasure you can get out of photography. And if you are ambitious, this is the only way to achieve your goal: to make pictures that have individuality; pictures that are composed, enlarged, and cropped according to *your* ideas; printed with the degree of contrast, lightness, or darkness that *you* visualized when you arranged the lights, selected the filter, calculated the exposure, "dodged," "burned in," or "held back" for most effective presentation of your subject.

To do this you need a darkroom.

The Darkroom

To most beginners the concept of a "darkroom" is something rather formidable and expensive, the privilege of the "advanced amateur." Nothing is farther from the truth. A workable darkroom is literally nothing but a "dark room." It does *not* have to have running water, built-in sinks, or a waterproof floor. It does not have to be "permanent" but can just as well

be "improvised" somewhere in the corner of an ordinary room. Lack of a "real" darkroom is absolutely no excuse for sloppy work or for not doing darkroom work at all. Many of our best photographers have done some of their best work in improvised darkrooms, the windows of which have had to be darkened each time before they could begin to work.

QUALIFICATIONS

A workable darkroom must fulfill the following conditions:

It must be dark. If there are windows, they must be made light-tight with the aid of opaque blinds. Black roller shades of the type used in lecture halls and auditoriums are ideal but expensive. Home-made blinds of masonite on wooden frames made light-tight with strips of black felt that fit into the window casings are considerably less expensive and just as effective, though less convenient. If it is too difficult or too expensive to make special arrangements for darkening the windows, take the easy way out, and develop and print at night, when heavy drapes are probably sufficient to keep out the feeble light of street lamps and sky. Minute amounts of stray light are usually harmless. To be sure, make the following experiment.

p. 160 Darken the room. Do *not* use the safelight (a colored work light that will not affect film or photographic paper). Place a few coins on a sheet of film and a piece of photographic paper and leave them exposed on the work table for three to four minutes. Then develop and fix both samples in darkness with the safelight still turned off. Examine the fixed samples. If the film is perfectly transparent and the paper perfectly white, your darkroom is dark enough, in spite of the slight amount of stray light.

If the film is more or less gray (or even black), except where it was protected by the coins, but the paper remains perfectly white, the darkroom is too light for developing but dark enough for printing. If both film and paper are gray or black except where they were protected by the coins, the darkroom is too light for any kind of photographic work, and the darkening arrangement must be improved.

An electric outlet is needed to plug in the safelight and the enlarger.

156

The room temperature should be somewhere between 65° and 80° F. If the room is colder or warmer, maintaining the correct temperature of the solutions becomes too difficult. In winter, an electric heater can be used to raise the temperature. In summer, a room air conditioner or an exhaust fan built into the wall or installed above the door prevents a darkroom from getting too hot. Special darkroom fans with light baffles are available at most photo stores.

The water supply should not be too far away. In the darkroom itself, a pail and a tray full of water are all that is needed. Negatives and prints can be washed later anywhere outside the darkroom.

The work table should be covered with linoleum, a sheet of plastic, or Formica, impervious to water and photographic solutions. Several thicknesses of newspaper beneath the trays prevent accidentally spilled liquid from flooding the table or running down to the floor. However, a careful worker hardly ever spills any solutions, mainly because he does not fill his trays too full.

The color of walls and ceiling should be light to reflect a maximum of (safe) light and thus to improve visibility. The better we see, the more efficiently we work. A good wall and ceiling color is a light yellow-green, similar to the color of the safelight filter used for printing.

LOCATIONS

The fortunate photographer who has the run of a whole house should have no trouble finding a place to install a permanent darkroom of modest scale. The less fortunate apartment dweller, especially one who lives in a furnished room, has to use a little more ingenuity to arrange a darkroom. The following suggestions for the location of permanent and improvised darkrooms are arranged in order of suitability.

The basement. A corner of a dry and finished basement that can be partitioned off is an ideal location for a darkroom. Advantages are fairly even temperature the year round, usually electricity and running water nearby, privacy and seclusion, and permanence of the setup, which permits gradual development into a first-class darkroom.

A large closet. A walk-in closet of the type usually found only in old houses can easily be converted into an excellent darkroom, provided that the ventilation problem is solved by installing an exhaust fan with light baffle, perhaps above the door. Negatives and prints can be washed in the bathroom.

The kitchen. After dinner, the kitchen is particularly well suited for improvised darkroom work. It provides water, electricity, and generous water-impervious working space. And, if the photographer is lucky, he can even appropriate a kitchen cabinet (or at least shelf space) for most of his darkroom equipment.

The attic. Advantages are privacy and seclusion, which permit a permanent setup. However, there are often serious shortcomings: It is too hot in summer, it is too cold in winter, and running water may not be available on the same floor. Use of an air conditioner and an electric heater respectively should overcome some of these drawbacks.

An ordinary room. Advantages are plenty of space and even temperature the year round. Drawbacks: Before he can start work, a photographer must darken the windows, clean a table, set up his equipment, get water from the bathroom or kitchen, unpack the enlarger, switch from desk lamp to safelight, and so on. All this makes for extra work. But once it is done, operations should proceed just as smoothly and efficiently as in any permanent darkroom setup.

The bathroom. Despite certain advantages like running water, waterproof floor, electricity, and light walls and ceiling, the bathroom is normally the least desirable location for a darkroom. The drawbacks are steam and moisture, which spoil equipment, chemicals, and sensitized material in a very short time, and the danger of constant interruptions unless, of course, a second bathroom exists.

ORGANIZATION

The efficiency of any darkroom depends upon its organization. Cleanliness and order rank first. Strict separation of "wet" and "dry" operations follows in importance. On one side of the darkroom should be negatives,

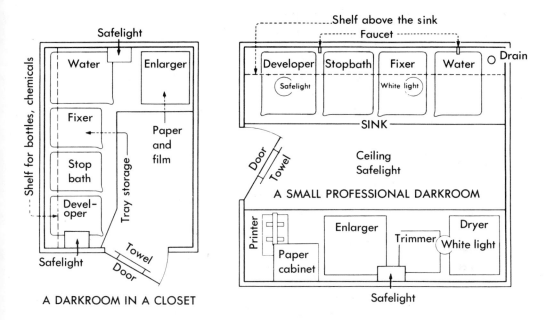

A DARKROOM IN A CLOSET

A SMALL PROFESSIONAL DARKROOM

sensitized paper, printer, enlarger; on the other side, developer, stop bath, fixer, hyponeutralizer, water. In this way, the negatives, which are the most valuable and vulnerable objects, are kept farthest from liquids and chemicals, and the various steps in processing can follow one another in logical and uninterrupted succession.

Darkroom Equipment

How much or how little he wants to spend on his darkroom equipment is almost entirely up to the photographer. Except for the enlarger, the essential pieces of equipment are few and relatively cheap. What is expensive are the gadgets and accessories that mainly increase the comfort and ease of operations, for example, electronic timers, motor-operated print washers, electric dryers, dry-mounting presses, and similar equipment. The following list contains only those items that I consider absolutely necessary for the successful operation of a darkroom.

159

General equipment
safelight with interchangeable filters
timer
thermometer
two graduates, one large, one small
two stirring rods
several quart bottles for developers
gallon bottle for fixer
funnel
apron
towel

Equipment and material for film development
developing tank
film developer
acid stop bath
fixer (hypo)
viscose sponge
film clips

Equipment and material for contact printing and enlarging
contact-printing frame
enlarger and paper easel
developing trays in different sizes
trays for stop bath and hyponeutralizer
deep tray for fixer
two print tongs
sensitized paper
paper developer
acid stop bath
acid fixer (hypo)
hyponeutralizer
print washer and cork clips
print dryer

GENERAL EQUIPMENT

The safelight. Special photographic-darkroom lamps with interchangeable filters are best. Colored incandescent bulbs are usually not "safe" and should be avoided. The color of the safelight filter depends on the work.

Dark green (Kodak Wratten Filter Series 3), for panchromatic film de-

velopment. However, as panchromatic film is sensitive to *all* colors, this illumination is only "safe" if the lamp, equipped with a bulb of only 15 watts, is located at a distance of at least four feet from the film and even then is used only for a few seconds' inspection after development is 50 percent complete.

Dark red (Kodak Wratten Filter Series 2) for orthochromatic film development.

Light amber (Kodak Wratten Filter Series OC) for paper development.

Film processing, and especially the loading of the developing tank with high-speed panchromatic film, should be done in total darkness in order to avoid accidental fogging. But successful printing and enlarging can be done only in a well-lighted darkroom. Ideal illumination is achieved as follows:

Suspend one large safelight equipped with a Kodak Wratten Filter Series OC in the center of the darkroom, turned toward the ceiling for general illumination with indirect (reflected) light (the ceiling of course, should be painted either in the color of this safelight or white). Mount a small safelight next to the enlarger, so that its light is directed toward the easel. Connect this safelight to the enlarger lamp by means of a two-way foot switch in such a way that one light is on when the other is off—the safelight goes off when you step on the switch to turn on the enlarger light for focusing and exposing but goes back on the moment you take your foot off the switch. This arrangement makes focusing, calculation of exposure time, and dodging much easier than when the safelight is on constantly, for its light weakens the projected image. A third safelight should be mounted directly above the developer tray, its light directed onto the developing paper for easy supervision of the developing print. Finally, a white light equipped with a 15-watt bulb should be mounted above the fixer tray, its light directed downward and carefully shaded by means of a suitable reflector to prevent it from spilling beyond the fixing bath and fogging developing prints. It should be operated by means of a foot switch. After a print has been in the fixer for about ten seconds, this light can safely be turned on by stepping on the foot switch, and the print can be inspected. It is rather difficult to judge the exact shade and contrast of a print in amber light, which tends to

161

make the picture appear lighter (but sometimes also darker) than it actually is. Prints that appear "just right" in amber light after appear too dark (or too light) when dry and viewed by daylight.

Timer and thermometer are indispensable for successful film development. Excellent and relatively inexpensive darkroom timers are made by General Electric and Kodak. The thermometer should be accurate to within half a degree. Instruments with scales etched on the stem are most reliable. Separate scales that are not firmly anchored to the stem are apt to work loose in time and to slide up and down, upsetting the accuracy of the thermometer. Dial thermometers are usually less accurate (but easier to read) than rod thermometers. Experienced photographers often have one of each type; they check the first against the latter, then use the dial thermometer because it is more convenient.

Graduates are needed for measuring specific quantities of developer stock solutions, for diluting them with water in the prescribed proportions, and for dissolving chemicals. Plastic or glass graduates are preferable to enameled-steel graduates, which rust when chipped and then become useless.

Stirring rods should be of glass or plastic impervious to the action of chemicals. They must be rinsed immediately after use to avoid contamination of one solution with chemicals from another.

Polyethylene quart bottles with plastic caps are best for storing developer solutions. All developers are sensitive to air, the oxygen of which affects and destroys the developing agent by oxidation, which gradually turns the almost colorless solution into an ugly dark-brown fluid. For this reason, freshly prepared developer stock solutions should be poured into several small bottles instead of being kept in a single large one. In this way, a small amount of developer can be withdrawn for use without the necessity of exposing the entire stock to air. As a further precaution, bottles containing developer solution should always be kept completely filled. If there is not sufficient solution to make this possible, drop small glass marbles into the solution until it reaches the proper height.

A gallon jug for storing fixer solution.

162

A funnel for pouring liquids back into their bottles after use and for filtering solutions. Negative developers especially must be filtered each time after use to eliminate floating particles of emulsion which otherwise might adhere to the next batch of developing films and cause spots. To speed the filtering process, use absorbent cotton instead of filter paper.

An apron and a towel belong in every darkroom. Most developers cause indelible stains, and a single drop can spoil clothing. Nonabsorbent plastic aprons are best. A towel should always be handy because wet fingers leave permanent marks on negatives and prints. The towel's degree of wetness is an indication of the manual skill of its user: An experienced craftsman hardly ever gets his fingers wet. Instead, he uses film clips, film hangers, and print tongs for handling films and papers.

EQUIPMENT AND MATERIAL FOR FILM DEVELOPMENT

Film-developing tank. Its size and construction depends, of course, on the size and type of the negative material that has to be developed. Some roll-film developing tanks have adjustable reels to accommodate films of different sizes. A few tanks have been made for 120 and 35 mm. film that can be loaded in daylight, eliminating the necessity for a darkroom since contact printing and enlarging can be done at night in any ordinary room. Film reels and film hangers must be absolutely dry before they can be loaded; otherwise, the film sticks the moment it hits a wet spot. Tanks and reels of stainless steel are more practical than those made of plastic, which may break when dropped. Plastic sheet-film hangers should be avoided in favor of stainless-steel ones.

Film developer. Ready-mixed developers prepared by the manufacturer, either in powder form or in the form of a stock solution, are more practical than developers that the photographer must make by combining the individual chemical components. Furthermore, they are generally more uniform and dependable, can be stored almost indefinitely, and need only be dissolved in water or diluted to be ready for use. They eliminate the need for a scale and for storing a number of different chemicals, many of them

sensitive to light, dampness, and air. They also eliminate a great deal of worry—about purity of chemicals, accidental omission of an ingredient, inaccuracy of measuring and weighing, and waste due to deterioration, pollution, and incorrect storage of chemicals.

On the other hand, user-mixed developers are somewhat (though not much) cheaper than perpared formulas. Another advantage is that their exact composition is known to the photographer, who occasionally may want to modify the formula in order to vary the characteristics of the developer and make it more suitable for a specific job.

Although mixing thus has advantages for the more advanced amateur, beginners should use prepared formulas. Until they are more experienced, they should employ the brand of developer that the film manufacturer recommends. He made the film, he ought to know it best, and it is as much in his interest as in yours that *you* get the best possible results. After all, he wants you to be satisfied so that you come back and buy more of his film.

As a photographer, you have the choice of five different types of developer:

1. Standard developers act fast and thoroughly, utilizing the full inherent speed of a film. They are intended primarily for processing negatives 2¼ × 2¼ inches and larger. Typical representatives are Kodak Developers DK-50 and D-76.

2. Rapid developers act more rapidly than standard developers and are widely used by professional photo finishers and press photographers. They produce negatives of slightly higher contrast and somewhat coarser grain than standard developers. They are most suitable for the development of negatives with low-contrast subjects and for "coaxing" the utmost out of underexposed films. Typical representative: Kodak Developer D-19.

3. Fine-grain developers produce negatives with a relatively fine grain and are intended primarily for the development of 35 mm. films. Some fine-grain developers require certain increases in the exposure of the film. A typical representative is the Kodak Developer Microdol-X.

The reader is cautioned not to overestimate the capacity of fine-grain developers. They can produce only a comparatively fine grain if they are

correctly used, if the film has an inherently fine grain, and if the negative is correctly exposed. Overexposure and overdevelopment always promote graininess. As a matter of fact, laboratory tests have shown that many standard developers will produce a film grain practically as fine as that produced by special fine-grain formulas if the developing time is somewhat shortened and negatives are developed to the same low contrast as those processed in fine-grain developers. The real advantage of fine-grain developers is the fact that they make it more difficult to overdevelop than standard developers.

4. Tropical developers permit development at temperatures up to 90 degrees F., at which point ordinarily the emulsion becomes so soft that it begins to dissolve and float off its base. They should be used only where conditions prevent employment of regular-temperature developers. Typical representative: Kodak Developer DK-15.

5. High-contrast developers produce negatives of more than ordinary contrast and are intended primarily for the development of reproductions of black-and-white subject matter, line drawings, printed pages, and so on. Typical representatives: Kodak Developers D-8 and D-11.

Stop bath. Its function is to terminate development by neutralizing the alkalinity of the developer retained by negatives and sensitized papers. It furthermore protects the acidity of the fixing solution, prevents premature exhaustion of the fixer, and reduces the danger of chemical stain in prints.

Fixing bath or hypo. It serves to clear the negative (and paper emulsion) by dissolving the undeveloped silver halides (light-sensitive particles of the emulsion) that otherwise would darken in time and obscure the image. More p. 233 on fixing baths later.

A viscose sponge is needed to wipe negatives on both sides before they are hung up to dry. Otherwise, drops of moisture and adherent particles of emulsion will cause indelible spots on the film.

Film clips are needed to hang films up to dry. Stainless steel is best. Each roll of film needs two clips, one at the top and one at the bottom to prevent the film from curling. For sheet film and film packs, hangers of stainless steel consisting of a number of clips attached to a rod are more practical.

EQUIPMENT AND MATERIAL FOR CONTACT PRINTING AND ENLARGING

Contact printing frame (or, if the higher price is no obstacle, a contact printer). Printing frames come in different sizes, corresponding to the different sizes of negatives. If negatives are contact-printed for recording purposes only, printing all the frames of one roll together on one single sheet of paper (gang printing) has practical advantages. For this purpose, an 8 × 10-inch printing frame is needed. It accommodates conveniently, on one sheet of 8 × 10-inch paper, twelve negatives 2¼ × 2¼ inches, in the form of three strips of four frames each (or four strips of three frames each), thirty-six 35 mm. negatives in strips of six frames each, or four negatives 4 × 5 inches.

Enlarger and paper easel. An enlarger is basically a camera in reverse. Like a camera, an enlarger has a lens that must be focused in order to produce sharp prints and a diaphragm that permits regulation of the brightness of the projected image. Image size (degree of enlargement) is directly proportional to the distance between lens and sensitized paper. But, whereas a camera produces negatives by means of light from the outside, an enlarger produces prints with light that comes from within. In this respect, distinguish between three types of lighting systems:

1. *Condenser (specular) enlargers* are constructed like ordinary projectors. Their lighting system consists of a projection lamp and a condenser (light-collecting lens). It produces critically sharp, very bright, and relatively contrasty images. Advantages: shortest exposures, excellent definition and contrast. Disadvantages: Owing to the extreme precision of rendition, blemishes of the negative—tiny scratches, abrasions, marks, specks of dust, and the like—appear with utmost clarity in the print, and enlargements seem rather grainy. As a result, specular enlargers are excellent for making photo murals and reproductions, but they are not suitable to ordinary photographic work, especially not for the needs of the average amateur.

2. *Diffusion enlargers* represent the other extreme. Their lighting system consists of an opal bulb or a grid of fluorescent tubes in conjunction with a diffuser. It produces images that are relatively soft and contrastless. As a result, minor defects of the negative are suppressed in the enlargement to a surprisingly high degree, and prints appear grainless and smooth. On the other hand, prints often turn out too gray and flat unless the negative is rather contrasty. Diffusion enlargers are most suitable for large negatives from 5 × 7 inches on up, for "pictorial" work of the more romantic type, and for idealized portraits of women and children. They are not suitable for amateur use.

3. *Diffuse-condenser enlargers* successfully combine most of the advantages of condenser and diffusion enlargers while avoiding their shortcomings. Their lighting system consists of an opal bulb and a condenser. It produces images that are sharp but not painfully revealing, contrasty but not harsh, and prints that appear relatively grainless. The majority of enlargers belong to this type, which is best suited to the needs of the average photographer.

Manual versus automatic focusing. Enlargers have to be focused, just as cameras do. This can be done in two ways: by hand or automatically. Manual focusing involves racking the lens in or out while visually checking the sharpness of the projected image. In automatic focusing, the image is always sharp, regardless of the scale of the enlargement, because lens focusing is coupled mechanically with the vertical movement of the enlarger. Each system has its advantages and shortcomings. Manual focusing is more reliable and accurate if done by a careful worker. On the other hand, it is less convenient and takes more time. Automatic focusing is much faster but requires frequent checks to detect and correct possible inaccuracies of focus caused by use and wear. Moreover, auto-focus enlargers are naturally more expensive than manually operated instruments of the same type. As far as print quality is concerned, there is, of course, no difference between the two.

The enlarger lens. Enlarger lenses are specially computed for near-distance work. Flatness of field and sharpness of definition are all-important; speed is not. To get more manageable exposure times, most enlargements are

made with the lens stopped down to approximately f/8, if not more. Typical representatives are the Kodak Enlarging Ektars and the Schneider Componon lenses.

The diaphragm of the enlarger lens should preferably be equipped with click stops, which facilitate accurate (and precisely repeatable) stopping down in the semidarkness of the darkroom.

The negative carrier. Choose between two types: glass plates and glassless carriers. Glass plates always hold the film perfectly flat and in focus. However, dust and lint can adhere to the four surfaces, and the glass plates tend to produce "Newton's rings," which show up in the form of irregular concentric shapes in the print. However, special "anti-Newton's-rings" glass is available that avoids this nuisance. Glassless negative carriers eliminate the danger of Newton's rings and minimize the effects of dust and lint. However, they do not hold the negative as flat as glass plates and consequently may cause partial unsharpness in the print. For negative sizes up to and including 2¼ × 2¼ inches, glassless carriers are, in my opinion, more practical. For larger sizes, glass plates are preferable. Large negatives buckle more easily under the heat of the enlarger lamp than do small ones and need to be held more rigidly in focus.

The size of the enlarger. Most of the larger instruments permit interchangeability of lenses and condensers. By acquiring such a versatile instrument, a photographer who owns two or more cameras for different film sizes can enlarge all his negatives with the aid of a single enlarger.

The scale of enlargement. Before one buys a specific enlarger, it is advisable to know how much it will enlarge a negative. Degree of enlargement is always measured with *linear* measures. For example, a 4 × 5-inch negative enlarged "twice linear" makes an 8 × 10-inch print; enlarged "four times linear," it makes a 16 × 20-inch print. Abnormally large prints or exceptionally big enlargements of only small sections of a negative can be made by placing the enlarger "backward" near the edge of a table, turning its head 180 degrees on its column, and projecting onto a chair or the floor. As not all enlargers permit such a backward turn of the enlarger head, it is advisable to check whether or not a particular instrument can be used in this

way. Alternatively, a 45° mirror attached to the front of the enlarger lens can be used to project outsized prints on a wall (in the manner of a slide projector), to which the sensitized paper is fastened with adhesive tape.

The light distribution should be uniform over the entire surface of the print. Some enlargers produce a "hot spot," prints in which the center is darker than the edges. To check, expose a sheet of high-contrast paper without a negative in the carrier. Select an exposure that will produce a medium shade of gray, develop, fix, and check for uniformity of tone. If the center of this sheet is darker than the edges—showing a "hot spot"—light distribution is uneven and will cause trouble. Such an enlarger should be returned to the dealer and exchanged for a different brand.

Distortion control. In a picture of a building taken with the camera tilted upward, the typical converging of vertical lines can be corrected during enlarging by projecting the image on an easel that is not in the ordinary horizontal position but more or less tilted. However, in order to create sufficient sharpness in depth to cover the entire enlargement, the enlarger lens has to be stopped down all the way. The result is often impossibly long exposure times, not to mention the fact that even the smallest diaphragm stop may be insufficient to extend sharpness uniformly over the entire image. This can be avoided if the negative carrier can be tilted indepen- **p. 199** dently of the lens. If the easel is then tilted a corresponding amount in the opposite direction, the converging verticals not only will be restored to their original parallel positions, but the picture will also be sharp in its entirety, without the need for stopping down the enlarger lens beyond what is required to obtain a manageable print-exposure time.

The easel. The best way to hold the sensitized paper flat and in focus is by means of an easel with adjustable masking strips that accommodates sheets up to 11 × 14 inches.

Developer trays. A good average size is 8 × 10 inches. Smaller trays are impractical, even for the development of smaller prints. Larger prints, of course, require larger trays. The best material is stainless steel, the next best high-impact plastic. Glass breaks too easily; enameled steel trays chip easily, rust, and then become useless.

Stop-bath tray. Same as for developer tray.

Fixing-bath tray. Same as for developer tray. In addition, for practical reasons, it should be larger and especially deeper than the other trays.

Hyponeutralizer tray. Same as for developer tray.

Print tongs are indispensable for agitating prints in the various baths and transferring them from one solution to the other. Touching prints with the fingers during processing may cause spots and stains. As fixer is "poison" to developers, two tongs are needed. One is used to agitate the prints in the developer and to transfer them to the stop bath. This must be done carefully, for the developer tongs must not touch the stop-bath solution itself. If accidentally contaminated with stop bath or fixer solution, the developer tongs should be rinsed briefly before reuse in the developer. The second pair of tongs is used to transfer prints from the stop bath to the fixer and to agitate them during fixation.

Sensitized paper. All photographic papers, regardless of type or make, can be classified according to five different characteristics:

1. *Emulsion and speed*. One must distinguish between two basically different types: slow-speed chloride and high-speed bromide papers. Between these are the medium-fast chlorobromide emulsions. *Chloride papers* are used almost exclusively for contact printing, for which they are especially suited because of their relatively slow speed; faster emulsions would lead to impractically short exposure times. *Bromide papers* are used exclusively for printing by projection (enlarging). Here slow chloride emulsions would lead to dangerously long exposure times during which the negative might overheat and buckle out of the plane of focus. The medium-fast chlorobromide papers are equally suited to contact printing and enlarging.

2. *Gradation*. Gradation is the ability of a photographic paper (or film) to render contrast. Most papers are manufactured in three to six different gradations, ranging from "soft" to "ultrahard." By selecting a paper with the appropriate gradation, a photographer can make drastic corrections of undesirable negative contrasts. For example, if a negative is too "hard" (contrasty), he can use a "soft" paper that reduces contrast and produce a

print in which contrast is normal. Conversely, if a negative is too "soft" (contrastless, flat), the use of a "hard" paper, which increases contrast, would produce a normal print. Negatives in which contrast is normal should, of course, be printed on "normal" paper. The gradation of photographic papers is indicated by numbers: The number 1 stands for a paper of very soft gradation, 2 for a soft gradation, 3 for a normal gradation, and 4 to 6 for papers of increasingly hard gradations.

3. Surface. The smaller the print is, the smoother should be the surface of the paper; otherwise, paper texture will obscure the finer detail of the image. Contact prints always look best on glossy paper. Larger projection prints can stand paper with a rougher surface. Fancy papers imitating the textures of canvas, tweed, silk, tapestry, and so on seem to me in bad taste. Prints intended for reproduction, regardless of size, should always be made on glossy paper and preferably ferrotyped. Ferrotyping gives glossy papers (papers with other surfaces cannot be ferrotyped) an extra smooth and shiny finish.

Glossy papers have a greater tone range than papers with rougher surfaces. Their whites are brighter and their blacks deeper and more lustrous. Prints on glossy paper always have more sparkle than prints on rougher surfaces. Glossy papers are most "typically photographic." Prints on very rough or fancy surfaces easily look pretentious—as if the photographer were ashamed of his work and had tried to improve on it by imitating one of the "fine" arts.

4. Base weight. Distinguish between two thicknesses: single-weight (or S.W.), which is relatively thin, and double-weight (or D.W.), which is about twice as thick, corresponding in thickness to a heavy postcard. Single-weight papers are best suited for print sizes up to and including 8 × 10 inches and for larger prints that have to be mounted. Double-weight papers are preferable for larger sizes. Single-weight papers are cheaper, wash and dry more rapidly, and are easier to mount and less bulky than double-weight stock. The latter, however, does not curl so easily, stands up better under rough treatment, and is preferable for prints that are exposed to much handling.

5. Base tint. The most common color of photographic papers is white. The

different shades of cream, buff, ivory, and so on, in which some papers are available, in my opinion give prints a faded, old-fashioned, sunburned, "yellow with age" appearance.

For final selection of all but glossy papers (all of which look alike) consult the manufacturer's sample book at your dealer's. When ordering a specific paper, you must mention the name of the manufacturer, the trade name of the paper, the gradation of the emulsion, the type and color of the surface, the weight of the stock, and the size of the paper. Here is an example: Kodak Kodabromide, normal (No. 3), glossy, white, single-weight, 8 × 10 inches.

Paper developer is different from negative developer in that it is faster and more contrasty in action. For best results, use the developer that the paper manufacturer recommends. Prepared developers that need only be dissolved in water are most practical. Typical representatives: Kodak Developers Dektol, D-72, and Versatol.

Stop bath. Used as a short rinse between developer and fixer, it prevents prints from staining in the fixer as a result of insufficient agitation. Apart from this, it fulfills the same purpose as in film development.

p. 165

Fixer or hypo. Acid-hardening fixing baths are best for prints. Prepared fixers that need only be dissolved in water, or diluted if in liquid form, are most practical. A formula for mixing at home will be given later.

p. 235

Print washer. A simple but efficient print washer in which the prints float on cork clips can be built by any tinsmith in accordance with the accompanying sketches. To make the cork clips, split bottle corks lengthwise, shape and groove, then join the two halves with rubber bands. Commercially available syphon print washers are, in my opinion, less efficient. Professional print washers, with rotating perforated drums, are best but large and very expensive.

Print drier. Matte and semimatte prints are dried most conveniently in a *photo blotter roll*. Electric print driers are much faster but also much more expensive. *Ferrotype tins* are needed to give prints on glossy paper a high-gloss, mirrorlike finish; their use requires an electric flat-bed print drier.

172

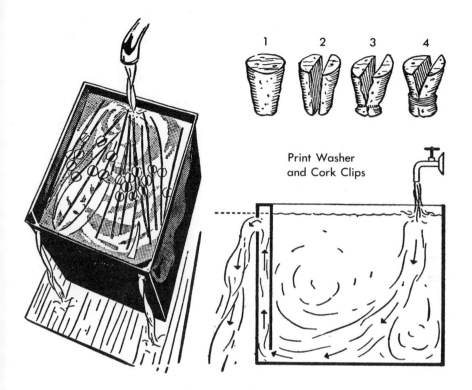

Print Washer
and Cork Clips

How to Develop a Film

GENERAL RULES AND PRINCIPLES

Developing a film is hardly more difficult than boiling an egg. Anyone who can read a watch and a thermometer can do it successfully, for the time of development is determined by the temperature of the developer. If the developer is warm, the time of development must be shorter than if the developer is cold. The terms "warm" and "cold" used here cover a temperature range from 65° to 75° F. "Normal" or standard temperature is always 68° F. Naturally, different types of film, as well as different types of film developer, require different times of development. But these can be learned readily from the handy little tables that film manufacturers provide for this purpose and pack with all their films.

173

Habits are easy to form but hard to change. Therefore, it is important that the student photographer learn from the outset correct methods of film processing. Specific instructions are given in the following sections. A few more general but equally important pointers are reprinted here.

Cleanliness is the first prerequisite for success—in the darkroom more so than elsewhere, because chemicals stain and solutions splash, and the resulting spots are "permanent."

Always perform the same operation in the same way. Standardize whenever you can. Develop a "system" for every step in processing films and prints; then stick to it.

Do not switch from one process or developer to another merely because someone else may have had success with it. Photography is as much a matter of individual taste and preference as any other art or craft. Methods that are suited perfectly to someone else's way of working may be entirely unsuitable to you. Remember that there are about as many rumors in photography as in politics and war, and most of them are just as unfounded.

Without gauges and instruments, no airplane could fly, no car could be driven safely, no ship could be maneuvered. The same applies to photography if you wish to bring it under control and are not content with occasional success. These are the control instruments of our craft: EXPOSURE METER, TIMER, THERMOMETER. There are only these three, but they are indispensable. Use them constantly.

Do not try to "save" on materials, least of all on developer, fixer, and chemicals. Most of them are comparatively cheap anyway. Before the developer and fixer are exhausted, replace them with fresh solutions. "Saving" on chemicals leads inevitably to the waste of much more valuable things, such as irreplaceable negatives, irrevocable opportunities, precious time. It always means that something must be done over—provided that you get a second chance.

Buy only products of reputable manufacturers. "Nameless" films, developers, and chemicals sold by certain chain stores are admittedly cheaper. Unfortunately, they are often outdated stock bought up in

bulk for quick resale to "suckers" or are so inferior in quality that they are practically valueless. After all, is it worth while to spend time, energy, money, and enthusiasm only to discover that it has all been in vain because your material let you down?

If you feel like "giving up" after comparing your pictures with the superior work of more famous and experienced photographers, remember that even the best were once beginners and depended on the friendly advice of authorities—or had to learn from their own mistakes.

THE CHEMISTRY OF DEVELOPMENT

Any photographic emulsion consists of a suspension of microscopic crystals of light-sensitive silver halides in gelatin. Under the influence of light, these crystals undergo chemical changes: An invisible (*latent*) image is formed in accordance with the intensity of the light that produces it. To transform the latent image into a visible one, the exposed emulsion must be *developed*; that is reduction of the light-struck silver salts has to be completed by treatment with chemicals that separate the silver from the salts and deposit it in the form of minute, irregular tangles of metallic silver—the *grain* that forms the image. Such chemicals are called *developing agents*. To make the resulting image permanent and insensitive to further exposure to light, the remaining unexposed and undeveloped silver halides, which upon exposure to light would gradually darken and obscure the image, must be converted into soluble form so that they can be washed out of the emulsion. This is the purpose of the fixing bath. Finally, the converted, undeveloped salts, together with all the chemicals used in developing and fixing, have to be eliminated by washing the film in water before it can be dried and printed.

PRACTICAL FILM DEVELOPMENT

The exposure and development of films have been standardized so completely that the best results are nowadays obtained by the most thoroughly mechanized method. Intelligent use of the three control instruments

—exposure *meter,* darkroom *timer,* and *thermometer*—enables a photographer to produce negatives that are technically far superior to those obtained by subjective methods. In my opinion, exposing negatives "by experience" and developing them "by visual inspection" are obsolete and inferior to the *time-and-temperature method of negative development,* which we shall discuss in the following.

Preparations

Regardless of the type of film or developer, the preliminary steps are always the same. Consult the chart on the opposite page as you proceed.

p. 156 **Darken the room.** A simple test to determine whether or not a room is dark enough for film processing has already been given.

Prepare the developer. Decide which type of developer to use. When undecided, follow the recommendations of the film manufacturer. Before using a fine-grain developer, make sure that the film was exposed accordingly; otherwise the negatives may turn out too thin. A developer that has been used should be filtered before reuse, to eliminate floating particles of gelatin that otherwise may cause spots in the negatives. Simply pour the solution through a funnel that is loosely stoppered with a wad of cotton. Do not filter developers that are colder than 65° F., or you may inadvertently filter out crystallized components of the developer and thereby make it useless.

Prepare the stop bath in accordance with the manufacturer's instructions.

Prepare the fixing bath. Follow the manufacturer's instructions implicitly; otherwise the bath may spoil immediately. If the fixer has been used before, make sure it is not exhausted. Testing solutions for fixing baths are available at most photo stores.

Check the temperature of all solutions. The normal temperature is 68° F. Differences of up to seven degrees, higher or lower, are harmless. Greater differences in temperature of solutions can cause reticulation (wrinkling) of the film emulsion. Solutions that are too warm may melt the emulsion and cause it to frill and float off its base. Solutions that are too

HOW TO DEVELOP A FILM

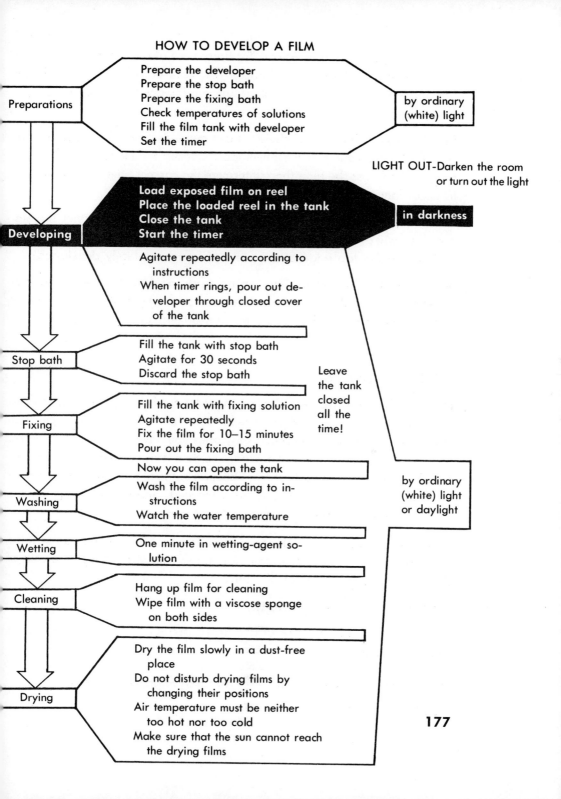

Preparations
Prepare the developer
Prepare the stop bath
Prepare the fixing bath
Check temperatures of solutions
Fill the film tank with developer
Set the timer

by ordinary
(white) light

LIGHT OUT-Darken the room
or turn out the light

Developing
Load exposed film on reel
Place the loaded reel in the tank
Close the tank
Start the timer

in darkness

Agitate repeatedly according to
instructions
When timer rings, pour out de-
veloper through closed cover
of the tank

Stop bath
Fill the tank with stop bath
Agitate for 30 seconds
Discard the stop bath

Leave
the tank
closed
all the
time!

Fixing
Fill the tank with fixing solution
Agitate repeatedly
Fix the film for 10–15 minutes
Pour out the fixing bath

Washing
Now you can open the tank
Wash the film according to in-
structions
Watch the water temperature

by ordinary
(white) light
or daylight

Wetting
One minute in wetting-agent so-
lution

Cleaning
Hang up film for cleaning
Wipe film with a viscose sponge
on both sides

Drying
Dry the film slowly in a dust-free
place
Do not disturb drying films by
changing their positions
Air temperature must be neither
too hot nor too cold
Make sure that the sun cannot reach
the drying films

177

cold act sluggishly and erratically or do not act at all. If temperatures are higher than 75° F. or lower than 65° F., cool or heat, respectively, by floating in the solution a small aluminum cup filled with cracked ice or very hot water.

Set the timer. The time of development depends on the film type and the type and temperature of the developer. Consult the manufacturer's chart that accompanies the film; then determine the correct time of development in accordance with the temperature of the developer.

Fill the film tank with developer. Make sure it is filled neither too high (or else it will overflow when you immerse the film reel) nor too low (or else a strip along the top edge of the film will be incompletely developed).

Arrange film, film reel, developing tank, and tank cover so that you can find them easily in the dark. Then turn off the light. If you are working with panchromatic or infrared film, turn off the safelight also.

Roll-film development

Load the film on the reel. Before you risk your first exposed film, take a roll of *unexposed* film* and practice loading the reel, first in daylight, then in the dark. Loading a film reel is easy once you have the knack. However, the first time something may go wrong, so do not risk exposed film. Be sure that the film reel is *completely dry*. Otherwise, the film will stick the moment it hits a wet spot; it will kink and get scratched, and you will have what is called in movie-production jargon a "film salad."

Place the loaded reel in the tank. Rap it sharply a few times against the tank bottom, in order to dislodge air bubbles trapped between the coils of the film. Place the cover on the tank.

Start the timer immediately.

Now you can turn on the white light, provided, of course, that your tank has a light-tight cover.

* Perhaps your photo dealer can give you a roll of expired film for this purpose.

178

Agitate repeatedly. Correct agitation is a prerequisite for the production of evenly developed negatives of correct density. It is essential to avoid mechanical uniformity of agitation, which may cause streaky development. For this reason, motor-driven agitators are not recommended. Their action is too even and is more likely to produce streakiness than to prevent it. After the film has been in the developer for approximately half a minute, start agitation by holding the tank in both hands and moving it backwards and forwards while tilting and rotating it simultaneously. Continue for about five seconds. Repeat at half-minute intervals during the entire period of development. If you use a daylight-loading tank or a tank in which you can turn the reel by means of a rod inserted through the cover, slowly rotate the reel back and forth for the first minute and thereafter for about five seconds every two minutes until development is completed. In addition, every second time, *turn off the white light*, and in total darkness remove the tank lid, lift the reel completely out of the tank, and plunge it in again in order to stir the developer vertically as well as horizontally.

When the timer rings, without removing the cover of the tank, pour the developer back into the bottle, and fill the tank with the stop bath.

Stop bath. Agitate for thirty seconds, then pour the stop bath out through the tank cover and discard it. It can be used only once. Pour in the fixing solution.

Fixing. Agitate at once for half a minute, repeat again several times during the next ten minutes.

Now you can take the cover off the tank.

Washing. Correct washing is of the greatest importance to the permanence of the negatives. Even minute traces of chemicals left in the emulsion may in time produce discoloration and fading of the image. Roll film can be washed on the reel in the developing tank. First, put a piece of cork underneath the reel to raise it until the opening of the center core is higher than the edge of the tank (without, of course, blocking the lower opening of the core). Then put the tank under the faucet, and let a thin stream of water run directly into the center core of the reel. Another method, equally effective, is to connect one end of a piece of rubber hose to the faucet and

put the other end in the hollow center of the reel. In both cases, water is forced through the core of the reel, out at the bottom, and up through the coils of the film, taking with it all the chemicals that have to be removed. Most other methods of washing are less effective. Washing film in a sink or tray by simply letting water run into the vessel and out over the edge is ineffective, for the hypo is heavier than water and sinks to the bottom, where it is more slowly (or not at all) removed by this method of "washing."

p. 173 If a greater quantity of films have to be processed, time can be saved by suspending them on cork clips and washing them in the print washer described before. Position of the clips should be changed once during washing.

p. 176 The temperature of the wash water must be within seven degrees of the temperature of the other solutions; otherwise the negatives may reticulate. Occasional temperature checks during washing are recommended. Negatives must be washed for at least half an hour under water running fast enough to fill the washing vessel every five minutes.

Cleaning. Remove the washed film from the water, place a film clip on one end, and hang it up. With a damp viscose sponge, carefully wipe both sides to remove water drops, gelatin particles, and other foreign matter. Thirty-five millimeter films have to be cleaned especially well because the smallest specks of foreign matter will appear objectionably in the strong enlargements. Moreover, if the emulsion is very soft, it is almost impossible to rid the film completely of tiny particles of gelatin, because wiping only loosens more particles from around the edges of the sprocket holes. To prevent this from taking place, rinse the washed film briskly under the faucet on both sides, immerse it for about two minutes in a 2 percent solution of a wetting agent (like *Kodak Photo-Flo*), take it out, and hang it up to dry without touching the emulsion again. The wetting agent will cause the water to run off smoothly, and the film will dry perfectly clean. Check the film after ten minutes. If a few drops have formed, remove them, not by wiping, but by absorbing them with the corner of a damp viscose sponge. Some wetting agents precipitate in the presence of calcium and must be diluted with distilled water only. Follow the manufacturer's instructions.

Drying. Films must be dried slowly and at a uniform rate in clean air.

180

Rapid drying seems to increase the size of the negative grain. Drying under a fan is the surest way to ruin a film because, unless filtered air is used, the forced draft propels particles of dust and dirt like tiny projectiles into the emulsion. Films that have been disturbed during the drying process may develop streaks, for changes in position usually cause changes in temperature and air currents, affecting the rate of drying. The part that dries faster will look different from the part of the negative that dries more slowly. To prevent drying roll films from adhering, space them far enough apart, and weigh their lower ends with film clips.

Film-pack tank development

As far as the principle is concerned, film pack is developed exactly as roll film is, except that the individual sheets are developed in the compartments of a special developing cage instead of on a reel. Sometimes the back of the film tends to stick to the walls of the cage. This can be prevented by leaving the paper backing on the films to provide a separator between film and cage. Rap the loaded tank a few times on the table to dislodge air bubbles; then agitate at half-minute intervals by turning the tank once slowly end over end. After completion of development, take the sheets out—of course, in darkness—tear off the paper backing, rinse the negatives for half a minute in the stop bath, and fix them in a tray. To insure complete fixation, leaf through the stack of film sheets two or three times immediately after immersion, then once every two minutes until fixation is complete. Suspend films at one corner on cork clips, and wash for at least half an hour under running water in the tank described before. Take them out, wipe both sides p. 173 carefully, then hang them up to dry, following the instructions given before.

Sheet-film tank development

In darkness, load the developing hangers, lower them smoothly into the developer-filled tank, and start the preset timer. Strike the hangers down hard two or three times to dislodge air bubbles; then agitate vertically for about five seconds. Leave the hangers undisturbed for one minute; then lift the whole rack out of the solution, let the developer drain from one corner,

and put the hangers back into the tank. Repeat this operation once every minute for the entire duration of development, draining the hangers alternately from different corners.

When the timer rings, lift the whole rack out of the tank, drain, and put it into a second tank filled with a stop bath. Lift and drain four or five times, drain, and then transfer the hangers to a third tank filled with fixing solution.

Agitate the negatives vertically in the fixer for half a minute; then lift and drain the hangers once every two minutes for the entire duration of fixation. From here on, proceed by white light.

p. 173
Wash the negatives in their hangers in a fourth tank, or float them suspended by one corner on cork clips in the tank described before. The negatives must be washed under running water for at least half an hour. Then take them out of their hangers, wipe both sides carefully, and hang pp. 180–181 them up to dry according to instructions given above.

Film-pack and sheet-film tray development

If up to six film-pack or sheet-film negatives must be developed in a hurry, the following method can be used, provided that the operator is careful, that he has short fingernails, and that the temperature of the developer is not higher than 70° F.; otherwise the film gelatin softens and becomes too vulnerable.

In darkness, immerse the exposed films, emulsion side up, one after another in a tray of water not warmer than 68° F. Be sure that the first film is thoroughly wet on both sides before you place the next one on top of it; otherwise they will stick together permanently. After the last film is immersed, carefully draw the bottom film out and place it on top of the pile, touching it only at the extreme edges. Be careful that its corners do not scratch any of the other films. Similarly, take one film after another from the bottom and place it on top until the entire stack has been leafed through twice.

Start the preset timer, and transfer the films to the developer, pulling

182

them one at a time from the bottom of the water tray. Repeat the operation of slowly leafing through the films from bottom to top for the entire duration of the development, turning the films sideways once in a while but always keeping the emulsion side facing up.

When the timer rings, transfer the films individually to the stop bath, leafing through them twice as described.

Transfer the films one by one to the fixer, and, immediately after immersion, repeat the performance of leafing through the pile twice; then continue every two minutes until fixation is complete.

Suspend films by one corner on cork clips, and wash for at least half an hour under running water in the tank described before.

p. 173

Clean and dry as previously outlined.

pp. 180–181

How to Make a Print

Distinguish between *contact prints* and *enlargements*; the latter are also called *projection prints* and *blowups*.

A contact print is identical in size to the negative from which it is made. It is a positive replica of the negative with most of its merits and faults. Contact prints are made with the aid of a printing frame (or a contact printer) on slow chloride papers.

An enlargement is, of course, always larger than the negative from which it is made. It is possible to control enlargements to a surprisingly high degree and thereby to correct undesirable features of the negative. Enlargements are made with the aid of an enlarger on fast bromide or medium-fast chlorobromide papers.

Aside from these differences, the processing of contact prints and enlargements is identical.

The following two graphs show the steps involved in the making of contact prints and enlargements. Most of the necessary operations are so simple that no further explanation is needed. However, there are a few exceptions, and the additional instructions contained in the following paragraphs are intended to clarify these.

THE NEGATIVE

A good print starts with a good negative. A "good" print signifies not only one that is correctly exposed and developed but also one that is CLEAN. So, before you put your negative into the printing frame or the enlarger, remove particles of dust and lint with a soft camel's-hair brush. Be sure that the glasses of the printing frame and negative carrier are also clean. Getting rid of dust can be quite a problem. The more you brush and rub, the more electrically charged negatives and glasses become, and consequently the more they attract other particles of dust. On dry, cold winter days, it is almost impossible to clean a negative properly, and brushing must be done very gently in order to prevent the film from becoming excessively charged. To determine whether or not a negative is clean, examine it under the light beam of the enlarger. If the negative is tilted at the proper slant, even the smallest specks of dust will appear glaringly white against the dark background of the film. Fresh fingermarks can sometimes be removed by wiping the negative with a tuft of cotton dampened in carbon tetrachloride. Old fingermarks cannot be eliminated. Minor scratches and abrasion marks can be minimized or temporarily eliminated by lightly rubbing a thin film of vaseline into them. However, this is feasible only if the negative is used in an enlarger equipped with a glassless carrier; otherwise the vaseline will stain the contact paper or smudge the carrier glasses. After the enlargement has been made, the vaseline must be removed from the negative with carbon tetrachloride.

Although for contact printing it does not matter too much if a negative is thin or dense, negatives that are extremely dense must be "reduced" (made

p. 203

HOW TO MAKE A CONTACT PRINT

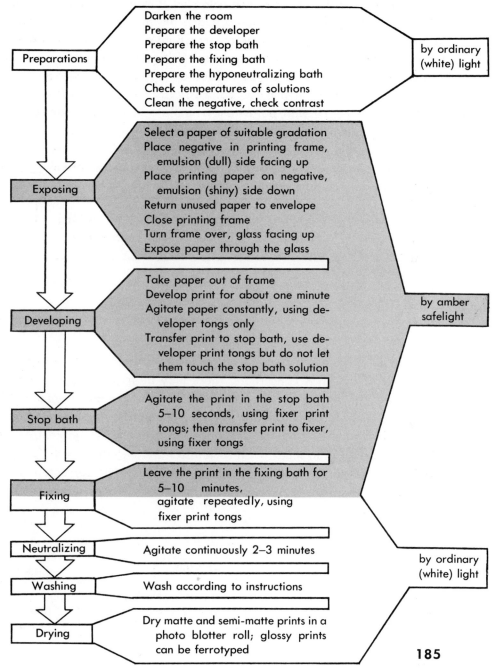

Preparations
- Darken the room
- Prepare the developer
- Prepare the stop bath
- Prepare the fixing bath
- Prepare the hyponeutralizing bath
- Check temperatures of solutions
- Clean the negative, check contrast

by ordinary (white) light

Exposing
- Select a paper of suitable gradation
- Place negative in printing frame, emulsion (dull) side facing up
- Place printing paper on negative, emulsion (shiny) side down
- Return unused paper to envelope
- Close printing frame
- Turn frame over, glass facing up
- Expose paper through the glass

Developing
- Take paper out of frame
- Develop print for about one minute
- Agitate paper constantly, using developer tongs only
- Transfer print to stop bath, use developer print tongs but do not let them touch the stop bath solution

by amber safelight

Stop bath
- Agitate the print in the stop bath 5–10 seconds, using fixer print tongs; then transfer print to fixer, using fixer tongs

Fixing
- Leave the print in the fixing bath for 5–10 minutes, agitate repeatedly, using fixer print tongs

Neutralizing
- Agitate continuously 2–3 minutes

by ordinary (white) light

Washing
- Wash according to instructions

Drying
- Dry matte and semi-matte prints in a photo blotter roll; glossy prints can be ferrotyped

185

more transparent) before they are enlarged. Otherwise, exposure times would be so long that accumulated heat from the enlarger lamp would buckle the film, and accumulation of stray light and reflected light would fog the paper. A negative is "too dense" if it requires an exposure that exceeds one minute. Before you reduce a negative that is too dense, examine its gradation. If it is too contrasty (usually as a result of over-development), reduce with potassium persulfate; if it is too contrastless (usually as a result of overexposure), use Kodak Farmer's Reducer R-4a. If a negative is so thin that it requires an "impossibly" short exposure, stop down the diaphragm of the enlarger lens; if this is not adequate, enlarge the negative on slow contact printing paper.

p. 205
p. 204

> The first prerequisite for successful printing and enlarg-ing is a clean negative of correct density and contrast.

THE PAPER

Unfortunately, not every negative is "technically perfect" as far as grada-tion (contrast range) is concerned. There may be many reasons for this: Either the exposure was too long or short, the developer too warm or cold, the development too long or short, or subject contrast simply was abnor-mally high or low and the photographer failed or was unable to take corrective measures in time. In all such instances, negatives with "abnor-mal" gradation result. Luckily, such faults can usually be corrected in the print by selecting a paper of appropriate gradation in accordance with the following table.

Character of the negative →	Extremely contrasty	Contrasty	Normal	Soft	Extremely contrastless
Recommended paper grada-tion (contrast grade numbers in brackets) →	Extra soft (No. 1)	Soft (No. 2)	Normal (No. 2 or 3)	Hard (No. 4)	Extra Hard (No. 5 or 6)

186

HOW TO MAKE AN ENLARGEMENT

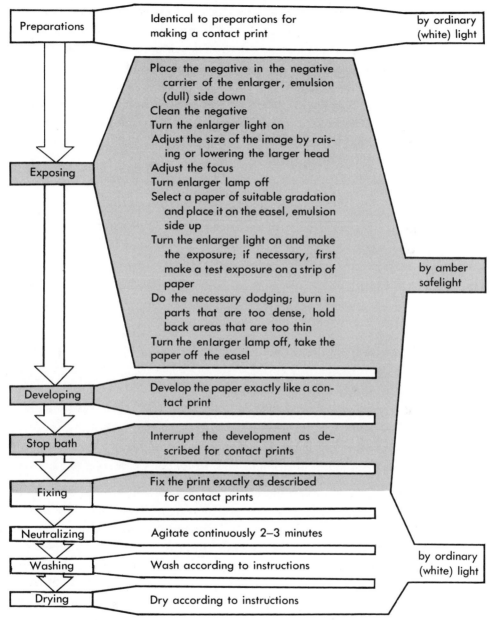

| Preparations | Identical to preparations for making a contact print | by ordinary (white) light |

| Exposing | Place the negative in the negative carrier of the enlarger, emulsion (dull) side down
Clean the negative
Turn the enlarger light on
Adjust the size of the image by raising or lowering the larger head
Adjust the focus
Turn enlarger lamp off
Select a paper of suitable gradation and place it on the easel, emulsion side up
Turn the enlarger light on and make the exposure; if necessary, first make a test exposure on a strip of paper
Do the necessary dodging; burn in parts that are too dense, hold back areas that are too thin
Turn the enlarger lamp off, take the paper off the easel | by amber safelight |

| Developing | Develop the paper exactly like a contact print |

| Stop bath | Interrupt the development as described for contact prints |

| Fixing | Fix the print exactly as described for contact prints |

| Neutralizing | Agitate continuously 2–3 minutes |

| Washing | Wash according to instructions | by ordinary (white) light |

| Drying | Dry according to instructions |

187

In analyzing a negative to determine the most suitable paper gradation, do not confuse negative contrast with density. One has nothing to do with the other. A very thin negative can be extremely contrasty (as a result of underexposure in conjunction with overdevelopment) or extremely lacking in contrast (overexposed and underdeveloped). And a very dense negative that appears almost uniformly black can be very contrasty (if considerably overdeveloped) or totally lacking in contrast (if considerably overexposed). When in doubt, make a test print on paper of normal gradation. If it is too contrasty, make the final print on softer paper. If it lacks sufficient contrast, change to a paper of harder gradation.

> The second prerequisite for successful printing and enlarging is the selection of a paper with a gradation appropriate to the contrast range of the negative.

THE EXPOSURE

The operation most likely to cause trouble is the exposure of the print. Unlike most films, which have a relatively wide exposure latitude—can absorb considerable overexposure and even some underexposure and still produce usable negatives—photographic paper must be correctly exposed to yield good prints. A negative is only an intermediary step in the process of picture making, and mistakes made at this stage can largely be corrected during the next step, the making of the print. But a print is the final step, and most mistakes made in printing can no longer be corrected.

The simplest way to find the correct exposure is by trial and error. In my opinion, print-exposure meters are impractical because they are either ambiguous, depend too much on the subjective interpretation of the user, or are too complicated and expensive. Besides, very few negatives can be printed "straight," without resorting to corrective measures like "burning in" or "holding back" (which we discussed on pp. 111–112); but if a negative has to be "dodged" (as these two corrective processes are called summarily), a print-exposure meter is all but useless anyway. After he has

successfully exposed a few prints, any beginner will acquire enough experience to judge the density of his negatives correctly.

Contact-print exposure determination. Duration of exposure depends on four factors:

> the intensity of the light source
> the distance between the light and the printing frame
> the sensitivity of the printing paper
> the density of the negative

The first three factors can be standardized and eliminated as "hazards" if the photographer always prints on the same type of paper with the same lamp kept at the same distance. The only remaining unknown quantity is then the density of the negative. If the negative is small, simply make a few test exposures until you hit on the right one. Start by exposing a sheet of, say, Kodak Azo or Velox Paper for nine seconds, using a 40-watt bulb at a distance of eight inches from the printing frame. If the negative is large (but how large can it be?), to save paper, use a strip about an inch wide and as long as the negative for the test exposure. Develop the exposed strip for one minute, fix, and examine it by white light. If the image is too dark, exposure is too long. If it is too light, exposure is too short. In either case, try again, using a somewhat shorter or longer exposure time.

Enlargement exposure determination. Theoretically, of course, exposure is determined by the same factors as those that exist in contact printing. In practice, however, matters are slightly more complicated by virtue of the fact that two additional variables have to be considered, one of which takes the place of "distance between the light and the printing frame," bringing the total to five:

> the brightness of the enlarger lamp
> the degree of magnification of the projected image
> the sensitivity of the printing paper
> the density of the negative
> the f-stop of the enlarger lens

Other factors being equal, the higher the degree of magnification and the smaller the diaphragm aperture of the lens, the longer the required exposure time—and vice versa.

The simplest way to determine the exposure time for an enlargement is with the aid of a *test strip*: Take a sheet of paper of appropriate gradation, and cut it into strips about 1½ inches wide. Place one of these strips on the easel, cover four-fifths of it with a piece of cardboard, and expose for 32 seconds. Then uncover an additional fifth, and expose for 16 seconds. Repeat this operation, exposing the remaining three-fifths for 8, 4, and 4 seconds respectively. In this way, the five sections of the strip receive exposures of 64, 32, 16, 8, and 4 seconds respectively. Develop the strip for no less than one and no more than two minutes, fix, and examine it by white light. Decide which exposure is correct, and use it to make the final print. Of course, the best exposure may fall between two steps. If this is the case, interpolate, and make the necessary correction when you expose the print.

The crucial test for the correctness of an exposure is the reaction of the sensitized paper in the developer. The print must appear just right not sooner than one and not later than two minutes after it goes into the developer. If, beyond this time, the print is still too light, if highlights are chalky and shadows grayish and weak, the exposure is too short. And if the image appears rapidly after immersion and soon turns too dark, exposure is too long. In both cases, the print is a total loss. In the first instance, prolongation of development would only produce overall grayishness, resulting from fog, and yellow stain from the oxidizing developer. In the second instance, if the paper were prematurely taken out of the developer, the result would be a contrastless brownish print with mottled and streaky tones.

> The third prerequisite for successful printing and enlarging is correct exposure of the paper.

Exposure of the sensitized paper produces a *latent* image, which must be developed exactly as the latent image in a film is developed, except that the type of developer and the time of development are slightly different. Typical paper developers are the Kodak Developers Dektol, D-72, and Versatol.

In print development, the three important factors are *freshness* and *temperature* of the developer and *duration* of the development. A developer that is nearing exhaustion produces prints in sickly brownish tones. A relatively cold developer acts sluggishly and produces prints with an underexposed look with chalky highlights and grayish shadows. A developer that is too warm yields brownish prints that resemble the results of overexposure. The best working temperature lies between 65° and 75° F.

> The fourth prerequisite for successful printing and enlarging is freshness of the developer and a solution temperature somewhere between 65° and 75° F.

To bring out the full richness of tone inherent in the paper, prints must be fully developed within a certain time, usually from one to two minutes. The only way to regulate the developing time is by adjusting the exposure time accordingly. Prints that appear fully developed before this time are overexposed; those that have not yet acquired their full strength within this time are underexposed—and will always look it.

> The fifth prerequisite for successful printing and enlarging is maintenance of a developing time between one and two minutes.

Never touch the emulsion side with your fingers. Slide the paper edgewise into the developer with the emulsion side facing up. Be sure to immerse the paper smoothly without interruption, or developing streaks may result. Agitate continuously. If the developer tray is small, agitate by gently rocking it from side to side and from front to back. If the tray is large, agitate the print by moving it around in the developer with the aid of the developer tongs. Do not dip your hand into the solution because the developer may become contaminated by the residue of another solution adhering to your fingers, be spoiled in a short time, and then produce prints with brown and yellow stains. Always use print tongs. Stop bath and fixer are "poison" to any developer—be careful to keep your developer print tongs from becoming contaminated with them.

Stop bath. When the print is fully developed, transfer it to the stop bath. Use the developer tongs, but be sure that they do not touch the stop-bath solution. Slide the print edgewise into the bath; then dunk it with the fixer tongs (stop bath and fixer are compatible). Agitate for five seconds. The stop bath not only stops development instantly but also prevents the prints from staining in the fixer. Such staining happens frequently if prints are transferred directly from the developer to the fixer without sufficient agitation in the fixing bath.

Fixing. Transfer the prints to the fixing bath, using the fixer tongs. Agitate for ten seconds. After this time, the paper is no longer light-sensitive, and the print may be inspected by white light. Complete fixation, however, takes from five to ten minutes, during which time the accumulating prints must be separated and agitated occasionally. Photographers concerned about the permanence of their prints use the *two-bath method of fixing*. Prepare two identical fixing baths. Use the first for the prescribed time; then transfer the prints to the second bath, and fix them for an additional five minutes. When the first bath begins to show signs of exhaustion (make a test with one of the commercially available fixer-testing solutions), discard it, replace it with the second bath, and prepare a new bath for the second fixing.

192

Hyponeutralizing. Although not absolutely necessary, this step is recommended in the interest of shortening the time of washing and greater print permanence. Take the print from the fixer, rinse briefly in a water-filled tray, then transfer it to the hyponeutralizing bath. Treat single-weight papers for one minute and double-weight papers for two minutes, agitating constantly. Prints thus treated require only a ten-minute wash under running water for single-weight, twenty minutes for double-weight paper. A used hyponeutralizing bath does not keep and must be discarded.

Washing. Wash prints suspended on cork clips for one hour under running water in the print washer described before. If a hyponeutralizing bath has p. 173 been used, single-weight papers require only a ten-minute and double-weight papers only a twenty-minute wash. Stir prints occasionally to prevent them from sticking together. If running water is not available, soak the prints in a large tray for five minutes, change the water, and repeat this process twelve times. Agitate and separate the prints repeatedly during washing.

Drying. Remove excess water by letting the print drip for a few seconds, wipe it on both sides with a viscose cloth or sponge, and then dry it in a photo blotter roll (available for prints up to 16 × 20 inches).

Ferrotyping. For effective ferrotyping of glossy prints (matte and semimatte papers cannot be ferrotyped), an electric print drier and ferrotype plates are needed. Clean the ferrotype plate by wiping it under a stream of water with a soft cloth, place the print face down onto it, then roll it down with a print roller. Place the ferrotype plate in the drier, and be careful not to remove it prematurely, or the emulsion will crack. Prints that are perfectly dry strip off easily. Leaving the prints in the drier too long causes the paper to warp. If sticking occurs, the plate is probably not clean or the print insufficiently fixed. To prevent sticking, clean plates from time to time with Kodak Ferrotype Plate Polish. Yellow stains on a print are a sign of insufficient agitation during fixing or insufficient washing. Matte spots in the glossy finish are caused by air trapped between the ferrotype plate and the paper. They can usually be avoided as follows (at least, this is the theory): Transfer the print dripping wet to the ferrotype plate; stand the print on its short edge; then let it down gradually in such a way that the

water running down from the print forms a cushion between the print and the plate, driving all air ahead of it and preventing the formation of bubbles. Then roll the print down hard with a print roller.

Finishing. The effect of a print depends to a surprisingly high degree on the way in which it is presented. If it is perfectly flat or faultlessly mounted, evenly trimmed, clean, and free from dust specks and stains, then the observer is much more likely to overlook or excuse small faults of composition, sharpness, or contrast. He senses that the photographer did his best—and will give him credit for that.

On the other hand, a picture may be really exciting in subject matter, but, if it is badly dried, warped and curling, spotty from dust specks on the negative, sloppily trimmed, with uneven edges and corners worn from careless storage, then one must conclude that it was made by an untidy person. In criticizing its obvious faults, he will probably overlook its attractive features.

Straightening. Papers that have a tendency to curl (and most do) can be straightened by dampening the back of the photograph with a cloth moistened with a mixture of equal parts or alcohol and water and keeping the print under pressure until it is perfectly dry. Separate prints from each other with sheets of white blotting paper. A still better (and permanent) way to keep a photograph from curling is to mount the print and a sheet of unexposed but fixed and washed photographic paper of the same type and weight together back to back with dry-mounting tissue. As now both sides of the "sandwich" react equally to humidity, they are in equilibrium, and curling can no longer occur. The commercially available print-flattener solutions should be avoided, for they may in time cause yellow stain.

Trimming. Unless you have a paper trimmer, to get a perfectly straight, clean edge, trim the print with a single-edge razor blade and a steel straight-edge on a piece of glass. The glass, of course, dulls the blade within a relatively short time, but no other support produces an equally crisp cut. When the razor blade gets dull, breaking off a small piece (with a pair of flat-nosed pliers) produces a fresh cutting edge. If a narrow white border is left around the print, be sure that it is even. Personally, I prefer to

trim off the white edge, for I feel that its pure white tends to make the near-white tones of the photograph look grayish by comparison. On the other hand, a white border offers a certain amount of protection to prints that must be handled frequently. If corners get ragged, just trim the print a bit, and the photograph will look like new without the need for making the image smaller.

Spotting (retouching). This is the moment when many a photographer becomes annoyed that he neglected to clean his negatives more carefully before placing them into the enlarger. To "spot" a print, first remove the dark spots with a knife—an etching knife or a razor blade that can be kept sharp by breaking off worn corners. Work very lightly. Carefully shave off the emulsion layer by layer until the spot is light enough to blend with the surrounding tone. Be careful not to dig through to the paper base—a common mistake of the beginner. Practice on inferior prints before you start on a good one. If you have overdone the shaving and the spot is now too light, darken it with a pencil or watercolor when you retouch the light spots of the print.

Light spots must be darkened with pencil or watercolor. For glossy papers, special retouching colors are available at photo stores. Apply a shade of watercolor somewhat lighter than the area that surrounds the spot because, as the watercolor dries, it darkens. Mix the proper shade from black and white, and apply it with the tip of a fine watercolor brush. Work as dry as possible, applying the color in very thin layers, gradually blending the spot with the surrounding area. If necessary, apply a slightly darker coat of paint after the first one has dried. If a spot appears too dark after drying, shave it off before you apply a lighter tone.

Mounting. Prints can be mounted on exhibition boards in many different ways—most of which are bad. Water-soluble glues and pastes distort the paper stock, causing prints and mounts to warp. Only a professional bookbinder or paperhanger can do a competent job with glue. Rubber cement is temptingly easy to use but will in time discolor and stain the print, causing irreparable damage. The only "professional" way to mount a photograph is to use dry-mounting tissue. Do not use the rubber wax-base type, which does not last because of early decomposition of the organic

195

component. Use instead the resin-base type, which lasts almost indefinitely and offers the further advantage of protecting the back of the photograph from the deteriorating effects of chemically aggressive glues and other components of the mount, as well as from humidity. Resin-coated dry-mounting tissue is chemically inert, is not affected by humidity and water, does not warp the print or mount, and is applied by heat. The mounting process itself is very simple and, in the absence of a more convenient dry-mounting press, can be done with an ordinary flatiron in accordance with the instructions that accompany the tissue.

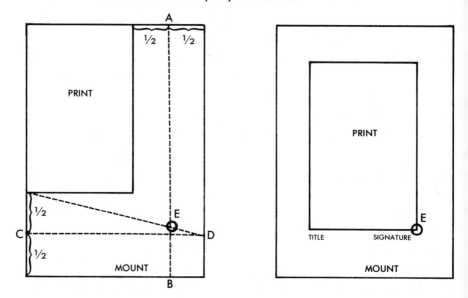

The normal position of a print on its mount is slightly above center with equal side margins. To find this position, place the print in the upper left corner of the mount (see sketch); divide the space to the right of the print in two equal parts and draw the line A–B; divide the space below the print in two equal parts and draw the line C–D; connect the lower left corner of the print with point D; where this last line intersects with line A–B find point E. Place the print on the mount with its lower right corner at E and its sides parallel to the sides of the mount. Finally, write the title of the picture below the lower left corner of the print, and sign your name at the right as shown in the accompanying sketch.

196

PRACTICAL POINTERS FOR ENLARGING

The previous instructions are for the normal processing of contact prints and enlargements. Out of such a routine, most photographers gradually develop methods of their own based on improvements they have made, shortcuts they have discovered, personal preferences they have acquired, and the sum total of such deviations from, and additions to, the customary routine of print making eventually forms a valuable part of their "technique." In this sense, the following suggestions are offered as helpful additions to the ordinary routine of enlarging.

Cleaning. On cold and dry days, removing dust from negatives and the glass plates of the negative carrier becomes quite a problem. The more one brushes and rubs, the more they become charged with static electricity, and the more they attract dust and lint. Under such conditions, brush only once, very slowly. Then use a rubber syringe, and blow off dirt with a series of short, sharp puffs. Wiping negatives and glass plates with an antistatic dust cloth also helps.

Cropping. One of the most valuable advantages of enlarging over contact printing is the possibility of utilizing only the most interesting part of a negative and presenting it in a pictorially effective size. Analyze your contact prints, and decide which parts of the picture are important and which superfluous. With the aid of two L-shaped pieces of cardboard, mask the margins of each contact print, slowly decreasing the rectangle formed by the L masks until you find the most effective section of the photograph. Mark it with a grease pencil whose "writing," if necessary, can easily be wiped off with a piece of tissue moistened with cleaning fluid. Ruthlessly eliminate superfluous subject matter, unsharp foreground, telephone wires cutting through the sky, untidy background, and so on until nothing remains but the subject proper in its most concentrated form. Then enlarge it to a pictorially effective size.

Masking. When only a section of a negative is to be enlarged, the rest of the film must be masked with thin black paper. Otherwise, stray light that

passes through the marginal parts of the negative may fog the sensitized paper, make highlights appear "dirty white," and lower the overall contrast of the print. Neglect of this precaution is a common cause of the "mysterious" and "inexplicable" grayness of many prints.

Reflections. In making enlargements of great magnification, be sure that light from the enlarger does not hit the chromium-plated enlarger column and reflect back onto the sensitized paper. If it does, cover the column temporarily with black paper held in place by adhesive tape. Otherwise, dark parabolic marks will appear in the print (proper masking of the negative would also have prevented this).

Unsharpness. If you use a glassless negative carrier, heat from the enlarger lamp may buckle the negative and snap it out of focus before you are ready to expose the print. This is especially true if the negative is large or if arriving at the best composition takes time. To prevent this, refocus just before you expose the paper.

Focusing can be rather a problem if negatives are very dense or if they do not contain sharply defined detail. If this is the case, focus on a minute blemish, a tiny scratch in the emulsion, a white mark left by a particle of dust, or the grain of the film itself. Personally, I never focus without the aid of a special focusing magnifier (available at any photo store), which I consider essential for critical focusing, especially in cases in which the negative provides nothing specific for the naked eye to focus upon except the film grain.

p. 111 **Dodging.** Local contrast control, as described previously, is one of the most valuable and indispensable techniques for the making of more effective enlargements. It may sound like a paradox—but the more a photographer learns, the more discriminating he becomes; and the more he improves "technically," the more he realizes that there is hardly such a thing as a negative that is "technically perfect" in every respect. Consequently, the more he makes use of the potentialities of "dodging." He hardly ever makes a print in which he does not "burn in" or "hold back" some part of the image, in order to present the subject in the pictorially and graphically most effective form.

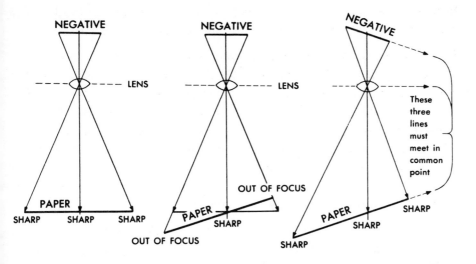

Distortion control. Another great advantage of enlarging over contact printing is the possibility of correcting "converging verticals" in the negative to parallelism in the print. Simply tilt the paper easel in accordance with the accompanying line drawings, then tilt the negative in the opposite direction (if necessary, improvise such a tilt), and stop down the enlarger lens until the entire picture is in focus. Some enlargers have negative carriers, which can be tilted independently from the lens. With their aid, distortion can be corrected and images produced that are sharp in their entirety, even though the diaphragm of the enlarger lens is wide open.

Diaphragm. Stopping down the diaphragm of the enlarger lens serves a triple purpose. *To regulate the time of exposure.* If negatives are very thin, exposures may become too short to be timed accurately, and "dodging" become impossible unless the exposure is increased by decreasing the brightness of the enlarger lamp through stopping down the lens. *To improve the definition of the lens.* Wide open, many enlarger lenses do not cover the entire picture area sharply, for their "speed" is intended not to shorten the exposure but to facilitate focusing and composing by making the image brighter. Most enlarger lenses are sharpest around f/8. *To increase the depth of focus* when working with glassless negative carriers. If the film

buckles under the heat of the lamp, stopping down provides additional sharpness in depth and may prevent unsharpness in the print.

Newton's rings. These beautifully colored rings that appear at times are very annoying. The surest way to avoid them is to use a glassless negative carrier. Sometimes, a piece of clear cellophane between film and glass plates is effective, but it increases the danger of spots from dust. Use of anti-Newton's-ring glass in the negative carrier avoids this darkroom pest. Films that have been rolled for a long time are more likely to produce Newton's rings than films that have been stored flat—a good reason for cutting up rolls of 120 and 35 mm. film into sections and filing them *flat* in glassine envelopes or polyethylene print preservers.

Test-strip data. When making a test strip for exposure determination, pencil the exposure times used on the back of the paper before development. In this way they cannot be forgotten—which happens surprisingly often and forces the photographer to go through the whole rigmarole again.

Check for pure white. A simple way to determine whether highlights and whites in a print are true white or somewhat gray is to bend back a corner of the sensitized paper while it is in the developer and to hold it against the image. As the back of the paper is always pure white (unless a tinted paper is used), even the slightest degree of grayishness in a seemingly white highlight can be detected. Otherwise, surprisingly dark shades of gray can pass unnoticed as "white" under the safelight if the eye has nothing really white for comparison.

Check on darkness. Prints in the fixer or water always look lighter than when they are dry. If a wet print looks just right under the safelight, one can almost be sure that it will look too dark after it has dried. Make allowance for this by developing prints slightly lighter than you want them to look when dry.

5

Learning from Mistakes

SUCCESS—AT A PRICE

Modern photographic materials are generally of such uniform high quality that failure due to faults in manufacturing are extremely rare. Out of the hundreds of technically faulty photographs I have seen in recent years, the failure of only two or three was caused by faulty material. In all other cases, the fault lay with the photographers, and mistakes could have been avoided if they had followed instructions more carefully. While it is human to try to avoid blame, before you blame the manufacturer, retrace your steps carefully under the assumption that there is a possibility that you did something wrong. The chances that you did are overwhelming. However, if you cannot find a likely explanation for a mishap—Kodak maintains a service for just such occasions. Simply send your Kodak films and prints to the Sales Service Division, Eastman Kodak Company, Rochester, New York 14650, and they will provide the answer. There will be no charge—no obligation.

No one is infallible—and mistakes are nothing to be ashamed of as long as one tries his best. There are many times when we do not even suspect a pitfall and avoid it only by sheer luck—until a subsequent time when we happen to fall into it. Actually, a mistake can be a "blessing in disguise." Once made and its cause recognized, the same mistake can in the future be avoided. A photographer who has made "all the mistakes in the book" ought to be a perfect craftsman, provided that he has learned from his mistakes. Regarded in this spirit, each mistake made and understood is a milestone on the hard road to perfection that leads to success.

201

In photography, unfortunately, there are only a few mistakes that can be corrected, and most of these only incompletely. Usually, a mistake means "curtains"—no picture. However, because of their educational value, I have saved every "interesting" mistake I could lay my hands on, with the result that I can give the reader here the benefit of other people's errors. I always advise photographers to save their "mistakes" and to mount them in an album, together with an explanation of their causes, incorporating them into a photographic reference library of things to avoid. They have paid for the mistakes in money, material, time, and disappointment—they may as well reap the reward by never having to make the same mistakes again.

As most photographic mistakes cannot be corrected satisfactorily, I do not even attempt here to give instructions for their correction, with two exceptions: Negatives that are too dense can easily be made more transparent *by reduction*, and some (but not all) negatives that are too thin can be strengthened *by intensification*. Otherwise, all one can do is to salvage what is still usable—which normally means enlarging the undamaged sections from negatives that are spoiled because of stray-light fogging, scratches, spots, or developer streaks and to give up the rest as lost. Or, as they say, "write it off to experience." If the negatives still exist, faulty or damaged prints can, of course, be made over again. If not—there are professional photo restorers, who, with the aid of airbrush and copy negative, can do miraculous things with unspeakable prints and present you with perfect copies or copy negatives from which you then can make perfect prints. However, the methods involved require a degree of skill and knowledge that go beyond the scope of this book.

CORRECTION OF MISTAKES

Successful reduction or intensification of negatives that are too dense or too transparent requires observation of the following rules.

1. The best moment for reduction or intensification is immediately after the final washing of the developed film.

2. Dry negatives must be soaked in water for about ten minutes before they can be subjected to reduction or intensification.

3. Negatives that have not previously been hardened by fixing in a hardening fixing bath must be hardened in the following solution:

Kodak Special Hardener SH-1

water	500 cc.
Kodak Formaldehyde, about 37% solution by weight	10 cc.
Kodak sodium carbonate, mono-hydrated	6 grams
water to make	1 liter

This formula is recommended for the treatment of all negatives that would normally be softened by a chemical treatment like, for example, the removal of stains, reduction, or intensification. Immerse the negatives in this solution for three minutes; then rinse, and fix for five minutes in a fresh acid fixing bath. Wash thoroughly before attempting any further chemical treatment.

4. The best way to reduce or intensify negatives is in a clear glass tray with a weak light underneath. In this way, the process can easily be watched in transmitted light and terminated at the proper moment.

5. Treat only one negative at a time. Some reduction processes are very fast and require constant observation. Accurate control by time is not possible. Agitate constantly, wash thoroughly after treatment, and wipe negatives carefully before hanging them up to dry.

HOW TO REDUCE NEGATIVES

Although *all* negatives that are too dense appear black and therefore similar, they actually may be quite different in gradation. Some may be too dense and too contrasty, others too dense and too contrastless, still others too dense yet have normal contrast. Therefore, since a photographer has the choice among three different types of reducers, a correct evaluation of the contrast of a negative is necessary so that the right type of reducer can be used.

a subtractive reducer if contrast must be increased (as in most cases of overexposure).

a superproportional reducer if contrast must be decreased (as in most cases of overdevelopment).

a proportional reducer if contrast as it exists in the negative should be preserved (as in most cases of overexposure in conjunction with over-development).

As it is sometimes difficult to form a correct opinion about the contrast in a very dense negative, it is advisable first to make a test print on paper of normal gradation and then to judge the contrast of the negative from the appearance of the print: If the correctly exposed and developed print seems too flat (contrastless and gray), the negative lacks contrast; if the print seems too contrasty, the negative is too contrasty; and if the print seems just right, the contrast of the negative is normal in spite of its excessive density.

Dense negatives that lack contrast (usually as a result of overexposure) must be reduced with the following *subtractive reducer*, which *increases contrast* while decreasing density:

<div align="center">

Kodak Farmer's Reducer R-4a

Stock solution A

</div>

Kodak potassium ferricyanide	38 grams
water to make	500 cc.

<div align="center">

Stock solution B

</div>

Kodak sodium thiosulfate (hypo)	480 grams
water to make	2 liters

For use, take 30 cc. of stock solution A and combine with 120 cc. of stock solution B; then add water to make 1 liter. Immerse the negative rapidly and evenly, preferably in a transluminated glass tray for close observation of the reduction process. When reduction is complete, wash the negative thoroughly before hanging it up to dry. For less rapid reducing action, use one-half the quantity of stock solution A with the same quantities of stock

204

solution B and water. Since the two stock solutions do not keep long in combination, they should be combined only immediately before use.

Dense negatives that are too contrasty (usually as a result of over-development) must be reduced with the following *superproportional reducer,* which *decreases contrast* while decreasing density:

<div align="center">

Kodak Persulfate Reducer R-15
Stock solution A

</div>

water	1 liter
potassium persulfate	30 grams

<div align="center">

Stock solution B

</div>

water	250 cc.
*sulfuric acid (dilute solution)	15 cc.
water to make	500 cc.

* To make, take one part of concentrated sulfuric acid, and, carefully to avoid contact with the skin, add it slowly to nine parts of water while stirring. *Never add the water to the acid* because the solution may boil and spatter the acid on the hands or face, causing serious burns.

For use, take two parts of solution A, and add one part of solution B. Only glass, hard-rubber, or impervious and unchipped enamelware should be used to contain the reducer solution during mixing and use. Treat the negative in Kodak Special Hardener SH-1 (the formula has been given **p. 203** already) for three minutes, and wash thoroughly before reduction. Immerse the negative in the reducer. Agitate gently all the time. Keep a close watch on the progress of the reduction (accurate control by time is not possible), and treat until the required reduction is *almost* attained. Then remove from the solution, immerse in an acid fixing bath for a few minutes; wash thoroughly before drying. Used solutions do not keep and must be discarded.

Dense negatives of normal contrast (usually as the result of overexposure in conjunction with overdevelopment) must be reduced with the following *proportional reducer,* which decreases density *without changing contrast*.

Kodak Reducer R-5
Stock solution A

water	1 liter
Kodak potassium permanganate	0.3 gram
*sulfuric acid (dilute solution)	16 cc.

Stock solution B

water	3 liters
Kodak potassium persulfate	90 grams

*To make, take one part of concentrated sulfuric acid, and, carefully to avoid contact with the skin, add it slowly to nine parts of water while stirring. *Never add the water to the acid* because the solution may boil and spatter the acid on the hands or face, causing serious burns.

To use, take one part of solution A, and combine with three parts of solution B. When sufficient reduction is achieved, clear the negative in a 1 percent solution of sodium bisulfite. Wash the negative thoroughly before drying.

How to intensify negatives

Before intensification is attempted, it is well to remember that, first of all, there has to be something in the negative that can be intensified. Normally, negatives are too thin for two reasons: because of underexposure and because of underdevelopment. *Underexposed negatives* are characterized by "shadows" that are as clear as glass—obviously, all that intensification could accomplish in such a case is to build up density in the form of fog, without building up detail. By this, of course, nothing would be gained. On the other hand, provided that they were correctly exposed, *underdeveloped negatives*, though generally too thin and weak, are characterized by the presence of shadow detail, which can be strengthened through intensification. However, before a photographer intensifies a negative, he should consider the following.

All methods of intensification are sensitive processes that are not always reliable. Unless negatives are completely free from hypo and the necessary chemicals are absolutely pure, unevenness and indelible spots and streaks that permanently damage the image may result.

206

Some of the most effective methods of intensification involve the use of deadly cyanides and for this reason should be avoided. No negative is worth risking death from inhaling cyanide fumes.

In my opinion, the most practical way to approach intensification is to make a duplicate negative. This method neither involves the possible loss of a negative through faulty intensification nor requires the photographer to be in contact with dangerous chemicals. If a negative is fairly large, contact-print it, and, if it is small, enlarge it on high-contrast film. Fine-grain develop the film 20 percent longer than normal, fix, wash, and dry as usual. Then contact-print this positive replica of your original negative on the same type of high-contrast film, fine-grain develop, and so on as before. The result should be a duplicate of the original negative, different from it only in that it has much greater contrast and density. Try this method before attempting chemical intensification—if for no other reason than to have a duplicate in case the original gets ruined.

For chemical intensification of a negative, proceed as follows: Harden the emulsion for three minutes in Kodak Special Hardener SH-1. Immerse for five minutes in a *fresh* acid fixing bath. Wash thoroughly for at least half an hour under running water. Then bleach the negative in the following solution. p. 203

Kodak Chromium Intensifier In-4
Stock solution

Kodak potassium dichromate	90 grams
hydrochloric acid (concentrated)	64 cc.
water to make	1 liter

To use, combine one part of stock solution with ten parts of water. Bleach the negative thoroughly at 65° to 70° F.; then wash for five minutes and redevelop in artificial light or daylight (but not in direct sunlight) for ten minutes in Kodak Developer D-72, diluted one to three at 68° F. Then rinse, fix for five minutes, and wash thoroughly. Still greater intensification can be achieved by repeating the process.

Stains and spots in negatives and prints

Most stains and spots are caused by carelessness. Their prevention is as simple as their later correction is difficult. Usually they result from overworking the developer, contamination of the developer by fixer, insufficient fixation, exhaustion of the fixing bath, lack of agitation during processing, inadequate washing. If tongs are not used in developing and fixing prints, manual handling must sooner or later cause brown fingerprints. If negatives or prints are subjected to high humidity or light for a prolonged time, a yellowing or fading of the image is unavoidable.

The removal of spots and stains from negatives and prints, if possible at all, involves techniques that are beyond the scope of this book. Many of these methods are risky and, unless performed by an expert, result in the loss of the negative or print. For this reason, before attempting any of the remedies that are published in photo-magazine articles or photographic books, the photographer should take the precaution of making a duplicate negative or print.

Stained negatives can sometimes be cleaned with a stain remover like Kodak Stain Remover S-6 (see below) followed by redevelopment. Stained prints should be discarded. If such prints are valuable and cannot be replaced because the negatives are not available, make a copy negative of the print through a dark yellow or red filter on panchromatic film. Prints made from such a copy negative usually do not show the stain.

Kodak Stain Remover S-6
Stock solution A

potassium permanganate	5 grams
water to make	1 liter

Stock solution B

cold water	500 cc.
sodium chloride	75 grams
*sulfuric acid (concentrated)	16 cc.
water to make	1 liter

*Caution: Always add the sulfuric acid to the solution, stirring constantly. Never reverse this process, or the solution may boil and spatter the acid on the hands or face, causing serious burns.

For removal of developer or oxidation stains in negatives, first harden the film for three minutes in Kodak Special Hardener SH-1, the formula for which was given before. Wash for five minutes, and bleach the negative in Kodak Stain Remover S-6. To prepare this bath, use equal parts of stock solutions A and B. Because these solutions don't keep long in combination, prepare the bath immediately before use. Make very sure that all permanganate crystals are completely dissolved; otherwise new stains may result. Bleaching should be complete in three or four minutes at 68° F. The brown stain caused by the bleach bath should be removed by treating the negative in a 1 percent solution of sodium bisulfite. Subsequently, rinse well and redevelop the negative in strong light (preferably direct sunlight) in either Kodak Dektol Developer or Kodak Developer D-72 diluted with two parts of water. DO NOT USE any slow-working developer (Kodak Microdol-X, D-76, or DK-20) that might dissolve the bleached image before the developing agents are able to act on it. When redevelopment is completed, wash the negative thoroughly and dry as usual. The following survey lists some of the most flagrant causes of mistakes:

p. 203

Forgetfulness	False economy	Carelessness
Forgetting to wind the film after each exposure (unless, of course, film transport and shutter cocking are coupled)	Expensive camera but no exposure meter	Fingermarks on lens and negatives
	"Nameless" brand of negative material bought cheaply	Sand or dust in camera which has been left "sunbathing" on the beach
Forgetting to turn the slide after the exposure when working with sheet film	Working with insufficient quantities of processing solutions	Bottles not labeled, chemicals in paper bags
Forgetting to draw the slide when using film pack or sheet film	Overworking the developer or fixer in order to save on chemicals	No apron, thermometer, or towel in darkroom
		Fixer solution spilled
Forgetting to consider the filter factor or other factors that influence the exposure	Cheap colored bulb instead of proper safelight in the darkroom	Using the hands instead of print tongs; fingernails too long, negatives scratched
Forgetting to repack sensitized paper in the darkroom before turning on the white light	Neglecting to "bracket" exposures when working under difficult conditions in order to save on film	Neglecting to vacuum-clean the darkroom periodically, dust on negatives

6

Practical Photo Chemistry

A Postgraduate Course in Photo Chemistry

The previous chapters contain in concentrated form *everything* a photographer needs to know in order to make pictures that are "technically perfect." However, while there is a definite lower limit of knowledge—the minimum of know-how, rules, and skill without which photography cannot be practiced successfully—there is no upper limit. A "complete" book on photography would require thousands of pages because it would have to deal with everything from basic to special techniques; discuss the fields of sensitometry, optics, and chemistry; touch upon electronics; go into physics and higher mathematics; and fade out—without ever reaching a definite end—with speculations on the nature of matter, light, and energy. But, although all this is of the highest importance to the future of photography and the development of better photo equipment and materials, it is, with very few exceptions, *absolutely valueless* to the practicing photographer whose interest, aim, and ambition are to make good pictures.

One exception is a certain amount of knowledge pertaining to chemistry, just enough to enable a photographer to understand the workings of developers, fixers, and other photographic solutions, and to help him to compound them in accordance with specific formulas. Such knowledge, though definitely not indispensable, can help the more advanced amateur to achieve better results occasionally and will, for this reason, be dealt with in the following.

211

ADVANTAGES OF USER-MIXED SOLUTIONS

Although it is always *more practical* to buy developers, fixers, and the like in prepared form, especially for the beginner who is concerned with other things that are more important at the start of his career, compounding solutions may eventually become preferable for the following reasons:

Economy. Solutions mixed from chemicals bought in bulk are less expensive than prepared developers, fixers, and so on, especially fixing baths and fine-grain developers.

Versatility. A great number of different formulas can be compounded from only a small number of chemicals simply by varying the number and proportions of their components. Often a slight change in the characteristics of, for example, a developer is desirable for producing a certain result. Formulas mixed at home can easily be modified to fit such special needs because their exact composition is known to the photographer; altering a factory-prepared formula usually ends in disaster.

Availability. A number of particularly useful formulas, especially certain correction baths, are so unstable that they are not available in prepared form. Unless a photographer wants to abstain from using these sometimes "life-saving" formulas, he has to compound them himself.

THE EQUIPMENT FOR MIXING FORMULAS

It is simple and not expensive. Savings made through mixing formulas at home should soon amortize the initial cost. You need

one large and one small graduate; pyrex or plastic is best

one large and one small funnel

a laboratory balance that must be accurate to within 0.1 gram, complete with a set of weights from 1 to 100 grams

a set of spoons for taking chemicals out of their containers; glass or plastic is best; wooden or metal spoons are unsuitable because they are not chemically inert and are difficult to clean

212

two glass rods, large and small, with flat ends, for stirring solutions and crushing the residue of chemicals

beakers of stainless steel or pyrex in three sizes up to one gallon, for dissolving and mixing chemicals

a number of mason jars or wide-necked polyethylene bottles with plastic screw tops, in different sizes, for storing chemicals; some chemicals and all developers are sensitive to light and must be stored either in brown bottles or in the dark

quart and gallon polyethylene bottles for storing stock solutions

HOW TO BUY CHEMICALS

The cost of most chemicals constitutes only a fraction of the expense involved in making a photograph and is completely out of proportion to their importance with regard to the successful outcome of the picture. Chemicals that are not pure enough can unbalance a developer or correction bath so completely that negatives are spoiled beyond repair. Consequently, only chemicals of guaranteed purity, uniformity, and freshness should be used, though actually they are somewhat more expensive than unguaranteed store brands, and they should be bought only through reputable photo supply houses or drugstores. The degree of purity of chemicals is indicated as follows:

TECHNICAL, of comparatively low grade, generally not suitable for photographic work

PURIFIED, of medium quality, suitable only for stop and fixing baths

U.S.P., of high quality, meeting the requirements of the United States Pharmacopoeia, satisfactory for photographic work

A.R., "analytical reagent" of highest purity, intended mainly for analytical purposes, unnecessarily pure and expensive for most types of photographic work

PHOTOGRAPHIC GRADE, complying with the specifications outlined in the standards issued by the United States of America Standards Institute. Suitable for ordinary photographic purposes

The ending "ate" (as in "sulfate") indicates that a chemical contains a relatively high amount of oxygen.

The ending "ite" (as in "sulfite") indicates that a chemical contains a relatively small amount of oxygen.

The ending "ide" (as in "sulfide") indicates that the chemical is a hydracid salt.

HOW TO STORE CHEMICALS

The majority of chemicals used in photographic work are sensitive to either moisture, air, light, heat, or cold. Exposed to these influences, in time they deteriorate and become useless. The best way to store chemicals is in glass containers; the worst is in paper bags. Cardboard containers are unsuitable because they attract and retain moisture. Mason jars are excellent for all dry chemicals. Polyethylene quart bottles with plastic screw tops are best for solutions. Glass stoppers have an annoying tendency to get stuck. To loosen, with one or two matches heat the neck of the bottle slightly from all sides, then gently tap the sides of the neck with a piece of wood, and twist the stopper counterclockwise. When replacing the stopper, do not forget to give it a light coating of vaseline to prevent future trouble.

Chemicals should be stored in a dry, dark, cool (but not cold) place. Do not store undeveloped film and sensitized paper close to chemicals, for some chemicals give off fumes that fog the emulsion. To avoid mixups, attach identifying labels to all bottles and jars. Inch-wide white surgical adhesive tape, which readily takes ballpoint-pen ink, makes excellent labels. Poisonous chemicals must be clearly marked "poison." Do not leave chemicals unnecessarily exposed to air from which many substances attract moisture.

All developers are highly sensitive to oxygen, which they absorb from the air. For this reason, completely fill bottles with stock solution to keep out unnecessary air. If a bottle is not completely filled, fill the empty space by dropping glass pellets (marbles or beads) into the solution until capacity is reached. Large amounts of developer stock solution should be kept in a

number of smaller bottles, rather than in a single large one. Whenever a solution is needed, therefore, only one bottle containing a small amount of liquid has to be opened and exposed to air, and the bulk of the stock remains undisturbed.

Fumes are given off by ammonia water, ammonium sulfide, and formaldehyde, for which reason they must be stored and used apart from all other chemicals, as well as from films and sensitized papers.

Sensitive to moisture to an exceptionally high degree are the following chemicals, which must be stored in a perfectly dry, moisture-proof place: amidol, ammonium persulfate, caustic soda, pyrocatechin, glycin, hydroquinone, metol, potassium carbonate, pyrogallol.

Sensitive to light to an exceptionally high degree are the following chemicals, which must be stored in darkness: ferric oxalate, gold chloride, potassium ferricyanide, potassium iodine, potassium permanganate, silver nitrate.

Unusually sensitive to heat are the following chemicals, which must be dissolved only in cold water and added only to other cold solutions: ferric oxalate, potassium metabisulfite, sodium bisulfate.

Poisonous are the following chemicals, which must never be touched or permitted to come in contact with the skin: caustic soda (developer alkali), potassium bichromate (intensification), sulfuric acid (stain-remover component and cleanser for developer trays; gives off poisonous vapors extremely dangerous if inhaled), hydrochloric acid (intensification), acetic acid (stop bath), uranium nitrate (intensification), potassium ferricyanide (reduction), pyrogallol (developing agent).

HOW TO MIX SOLUTIONS

Prepared developers, fixers, and the like are always accompanied by printed instructions for use, which must be followed implicitly; otherwise failure will probably result. When compounding your own solutions, observe the following rules.

When compounding a printed formula, always dissolve its components in the order in which they are listed.

Vessels of stainless steel or glass are most suitable for dissolving and mixing chemicals. Hard rubber absorbs certain chemicals and leads to contamination of subsequently prepared solutions. Enameled containers chip and rust and sometimes give off alkali (disastrous to fine-grain developers). Glazed stoneware sometimes has flaws through which chemicals can penetrate and subsequently contaminate other solutions.

Never add a new chemical to a solution until the previous component has been *completely* dissolved.

When weighing chemicals, do not pour them directly onto the pan of the balance. Instead, place a piece of paper on each of the pans (to preserve the equilibrium); then pour the chemical onto the paper to avoid contamination with other chemicals. However, the same piece of paper may be used for weighing all the components that go into the same formula.

Minute quantities of chemicals must be measured particularly accurately. When measuring liquids, hold the glass graduate so that the surface of the liquid is level with your eye; then take the reading at the bottom of the curve formed by surface tension at the top of the liquid.

When taking a thermometer reading, keep your eye level with the top of the column of mercury; otherwise your reading may be off by as much as two degrees because of the refraction effect of the cylindrical magnifier built into the thermometer rod.

Dry chemicals must always be poured into water. If you pour water on desiccated (dry) chemicals, they cake into a stony mass and take a very long time to dissolve. This is particularly true of prepared acid fixing salts.

To speed up dissolution, stir vigorously while slowly pouring the chemical into the water or solution. However, be careful not to whip air into the solution when preparing a developer, for the oxygen contained in the air will prematurely corrode the solution. Visible sign: brownish discoloration.

Write the date with a grease pencil on every bottle of stock solution immediately after preparation. This later enables you to estimate its

freshness. If you intend to reuse a developer, with a grease pencil mark on the bottle the number of films developed in it to keep track of the degree of exhaustion. This is important for determination of neccessary increases in subsequent developing times and for replenishment.

Filter previously used developers before reuse by pouring them through a funnel loosely stoppered with a wad of cotton to eliminate sludge and particles of gelatin and dirt, which otherwise might settle on the developing films and cause spots. Before filtering, however, be sure that the developer is warmed to the correct working temperature (68° F.) for the following reason: The solubility of most chemicals decreases with decreasing temperatures. Consequently, if solutions have been stored at relatively low temperatures, some of their components may crystallize and precipitate to the bottom of the vessel. If such a solution is filtered at temperatures lower than 68° F., some of its most important components may be inadvertently filtered out, making the filtered solution useless.

When preparing or using a fixing bath, do not spill hypo crystals or fixer solution. Hypo is "poison" to all developers. Spilled fixing solution dries, and the fine airborne powder subsequently contaminates the entire darkroom, leaving spots wherever it settles on films and sensitized papers. In many cases, tiny dots—supposedly caused by "air bubbles"—are actually caused by spilled hypo.

THE WATER FOR SOLUTIONS

Impurities in water can cause the following effects: Calcium and magnesium can with other chemicals form soluble salts, which precipitate and dry on the negative in the form of fine crystals or white scum, showing as spots in the print, or they can form insoluble salts that settle at the bottom of the tank. These salts must be eliminated by filtration, for otherwise, if stirred up, they settle on the film and adhere, causing spots. Iron increases the rate of oxidation of developers, causes rust spots on negatives and prints, and must be eliminated by filtration. Special water filters are available; they can be attached directly to the faucet. Sulfur, usually in the form of hydrogen sulfide, combines with the silver of the emulsion to form silver sulfide and interferes with proper developing and fixing.

Developer stock solutions can normally be prepared with ordinary tap water. Some photographers insist on boiling the water for stock solutions that they intend to keep for a longer time because boiling eliminates most of the free air contained in water, the oxygen content of which might prematurely oxidize the developing agent. Furthermore, it precipitates most of the suspended impurities and eliminates a large percentage of the calcium and magnesium salts.

Fine-grain developers are sometimes prepared with distilled water, which in addition has been boiled. Distilled water is chemically free from impurities but still contains much free air, which is then eliminated by boiling.

Stop baths and fixers can be prepared with any water that is pure enough for drinking purposes.

Reducers can be prepared with ordinary tap water.

Intensifiers are very sensitive to chemical impurities and should be prepared only with distilled water.

THE TEMPERATURE OF SOLUTIONS

The rate of any chemical reaction increases with increase in temperature. As a result, all chemicals dissolve more readily and in greater amounts in warm than in cold water. However, some chemicals are so sensitive to heat that even moderate temperature changes affect their properties to such a degree that they become useless for photographic purposes. Such chemicals, of course, must be stored, dissolved, and used at correspondingly low temperatures.

Developers can be prepared with water as hot as 125° F. but not hotter. Before use, of course, such a solution must be cooled down to the normal temperature of 68° F.

Hypo crystals can be dissolved in water as hot as it comes out of the hot water faucet. When hypo crystals are poured into water of 140° F., the temperature of the solution is almost instantly lowered to around 50° F.

Before use, of course, the temperature of such a bath must be raised to 68° F., or reticulation of the negative may result.

The acid hardener component of an acid fixing bath is moderately sensitive to heat and decomposes at temperatures above 125° F. It should always be dissolved separately from the hypo in water not hotter than 100° F. Hypo and acid hardener should be mixed only when both solutions have cooled to the working temperature of 68° F.; otherwise the bath may be spoiled by the formation of free sulfur and turn milky.

THE CONCENTRATION OF SOLUTIONS

The strength of a solution can be indicated in two different ways: in terms of "percentage solution," used mostly in reference to solids dissolved in a liquid, and in "parts," used mostly when referring to a mixture of a solution and water.

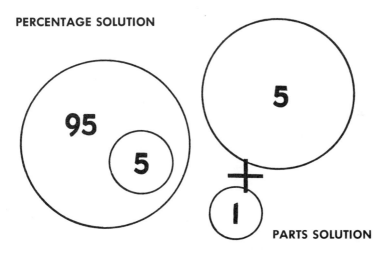

PERCENTAGE SOLUTION

PARTS SOLUTION

A percentage solution is prepared by dissolving the specified quantity (in grams) of a chemical in a small amount of water, then adding sufficient water to make 100 cc. of solution. For example, to make a 5 percent solution, dissolve 5 grams of the chemical in a graduate containing, say, 80 cc. of water; then fill with water to the 100 cc. mark. The result will be 100 cc. of a 5 percent solution.

A parts solution is prepared by mixing one unit of a specified stock solution with a specified number of identical units of water. Such units can be of any weight from grams to tons, provided that all quantities are reckoned in the same units of weight or volume. For example, to make a developer from one part of stock solution and five parts of water, mix one unit of stock solution with five units of water—one ounce of stock solution mixed with five ounces of water or 100 cc. of stock solution mixed with 500 cc. of water—the result will be identical as long as identical units of measurement are used for both stock solution and water. If both liquids and solids are given in "parts," of course, equivalent units of measurement must be used. Thus, grams for solids go with cubic centimeters for liquids; and ounces for solids go with fluid ounces for liquids.

To convert a "parts solution" into a "percentage solution," proceed as follows. The developer mentioned above consisted of one part stock solution and five parts of water, in all six equal parts. In order to convert this ratio into percentage, divide 100 by 6, the result of which is 16.7 percent. In other words, a solution of 1:5 is equivalent to a 16.7 percent solution.

The criss-cross method offers the easiest way of figuring the dilution of a high-percentage stock solution into a lower-percentage working solution. See the diagrams.

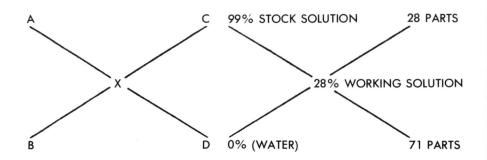

Place the percentage strength of the stock solution at A; place the percentage strength of the solution you dilute with at B (in the case of water, of course, this is 0 percent); place the desired percentage strength at X;

subtract X from A and write the result at D; also subtract B from X and write the result at C. Finally, take C parts of A and mix them with D parts of B, and you will get a solution of X percent.

For example (see sketch): To dilute a stock solution of 99 percent acetic acid to a 28 percent acetic-acid working solution, take 28 parts of the 99 percent stock solution, and mix it with 71 parts of water (0 percent solution).

THE KEEPING PROPERTIES OF SOLUTIONS

To produce consistently high-quality negatives and prints that are uniform and reasonably permanent, it is necessary that solutions be maintained above the point of exhaustion. Exhausted developers act sluggishly. They produce negatives with less and less density and increasingly softer gradation (to the point of useless flatness) and prints with sick-looking brownish tones. Exhausted fixers are even more dangerous because their exhaustion may not be immediately detected. They may still clear a negative and make a print insensitive to light, but such negatives and prints are not permanently fixed and will in time discolor and fade.

To avoid premature exhaustion of negative developers from oxidation, pour solutions back into the bottle immediately after use, and keep the bottle completely filled, if necessary, with the aid of glass pellets as described before. Developers remaining in deep tanks must be protected p. 162 from the air. For this purpose, float a piece of Kodapak Sheet in the form of a shallow boat on the surface of the developer, and keep the tank cover on. Diluted paper developer (working solution) cannot be reused and must be discarded after each printing session. The figures in the accompanying table, which are based on recommendations made by Kodak, give a rough idea how long certain solutions can be expected to last under different conditions.

The following figures are based on experience and intended only as a guide. They apply only if used solutions are stored at temperatures between 65° and 70° F. (18° to 21° C.); storage at higher temperatures shortens the shelf life proportionally. Capacity figures for film developers refer to

221

exhaustion of the solution *without* replenishment. If a slight decrease in quality is acceptable, somewhat larger quantities can be processed.

SOLUTION	KEEPING PROPERTIES WITHOUT USE				USEFUL CAPACITIES	
	Stock solution in stoppered bottle		Working solution		8″ × 10″ sheets per gallon	
	full	half full	Tray	Tank	Tray	Tank
Kodak Film and Plate Developers						
D-8	2 mo.	2 wk.	2 hr. (2:1)	48 hr.	60 (2:1)	60 (2:1)
D-11	6 mo.	1 mo.	24 hr.	1 mo.	30	40
D-72	6 mo.	2 mo.	24 hr. (1:1)	2 wk. (1:1)	30 (1:1)	40 (1:1)
D-76	6 mo.	2 mo.	24 hr.	1 mo.	16	16*†
D-76 (1:1)	Do not store		Discard after use		8	8
Microdol-X	6 mo.	2 mo.	24 hr.	1 mo.	16	16*†
Dektol	6 mo.	2 mo.	24 hr. (1:1)	1 mo. (1:1)	30 (1:1)	40 (1:1)
Kodak Stop Baths						
Indicator Stop Bath	I.O.P.		3 days	1 mo.	Discard when the color	
Ektaflo Stop Bath	I.O.P.		3 days	1 mo.	changes to purplish-blue	
Universal Stop Bath	I.O.P.		Do not store working solution			
SB-1	Indef.		3 days	1 mo.	75	
Kodak Fixing Baths						
Capacity figures apply only if a stop bath is used.						
The capacity of a fixing bath can be increased by use of the two-bath system						
Rapid Fixer (with hardener)	2 mo.		1 wk.	1 mo.	120 negs. (1:3)— 100 prints (1:7)	
F-7	2 mo.		1 wk.	1 mo.	120	
Kodak Intensifiers and Reducers						
Chromium Intensifier	2–3 mo.		24 hr.	–	80	
Farmer's Reducer	2–3 mo.		10–15 min. (Stock sols.)	–	–	
Kodak Washing Aids						
Hypo Clearing Agent	3 mo.		24 hr.	–	Prints—80 without pre-rins 200 with pre-rinse	

* When life of developer is extended by proper replenishment.
† When developing time is increased by about 15 percent after each 4 sheets per gallon.
I.O.P. Indefinite in the original sealed package.

Negs—50–60 without pre-rinse
150–200 with pre-rinse

In this connection, one sheet 8 × 10 inches is the equivalent of

1 roll of 35 mm. film, 36 frames	4 sheets 4 × 5-inch film
1 roll of 120 roll film	11 sheets 2¼ × 3¼-inch film

WEIGHTS AND MEASURES

To convert avoirdupois measures into the metric form and vice versa, use the following table.

Conversion Table for Units of Volume and Weight*

To Convert From	Multiply By								
	To fl. oz.	To pint	To quart	To gallon	To c.c. or g.	To ltr. or kg.	To grain	To oz. av.	To lb. av.
Fluid ounce	1.00000	.062500	.031250	.007813	29.5736	.029573			
Pint	16.0000	1.00000	.500000	.125000	473.177	.473177			
Quart	32.0000	2.00000	1.00000	.250000	946.354	.946354			
Gallon	128.000	8.00000	4.00000	1.00000	3785.42	3.78542			
Cubic centimeter or gram	.033814	.002113	.001057	$.0_32642$	1.00000	.001000	15.4323	.035274	.002205
Liter or kilogram	33.8140	2.11337	1.05669	.264172	1000.00	1.00000	15432.3	35.2739	2.20462
Grain					.064799	$.0_46479$	1.00000	.002286	$.0_31428$
Ounce avoirdupois					28.3495	.028350	437.500	1.00000	.062500
Pound avoirdupois					453.593	.453593	7000.00	16.0000	1.00000

Note: The small subnumeral following a zero indicates that the zero is to be taken that number of times: thus, $.0_31428$ is equivalent to .0001428.

For example: To convert 2½ av. oz. to grams, multiply 2½ by the factor 28.3495 or 70.87 grams.

* Courtesy of E. I. Dupont de Nemours & Co.

To change a formula quickly from avoirdupois into the metric system and vice versa, use the following conversion tables.

Compound Conversion Factors for Solids

grains per 32 oz. multiplied by 0.06847 —grams per liter
ounces per 32 oz. multiplied by 29.96 —grams per liter
pounds per 32 oz. multiplied by 479.3 —grams per liter
grams per liter multiplied by 14.6 —grains per 32 oz.
grams per liter multiplied by 0.03338 —ounces per 32 oz.
grams per liter multiplied by 0.002086—pounds per 32 oz.

Compound Conversion Factors for Liquids

Fluid ounces per 32 oz. multiplied by 31.25 —cubic centimeter per liter
Cubic centimeters per liter multiplied by 0.032—fluid ounces per 32 oz.

For example, if a formula calls for 25 grams of an ingredient per liter of water, multiply 25 by 14.60, and the result is 365.00 grains per 32 ounces. In an emergency, United States coins can be used to weigh small quantities of chemicals. The following list includes their approximate weights.

Silver dollar	400 grains	26 grams
Half-dollar	200 grains	13 grams
Quarter-dollar	100 grains	6½ grams
Nickel	80 grains	5 grams
Cent	50 grains	3¼ grams
Dime	40 grains	2½ grams

To convert degrees Fahrenheit into Centigrade, subtract 32, multiply by 5, also divide the result by 9.

To convert Centigrade into Fahrenheit, multiply by 9, divide by 5, and add 32 to the result.

Developing

THE CHEMISTRY OF A DEVELOPER

Developing a film or a sheet of sensitized paper involves three different operations.

1. Softening and swelling of the gelatin in order to enable the reducing agent to reach the exposed crystals of halide (silver bromide, silver chloride).

2. Dissociation of the silver and the bromide or chloride.

3. Transformation of the exposed crystals of silver halide into metallic silver—the "grain" of the emulsion.

To make these processes possible, a developer must contain among its ingredients the following five components.

1. A solvent—water—without which dry chemicals can neither soften the emulsion nor reach the exposed halides (see discussion of the water for solutions).

p. 217

2. A developing agent (also called a reducing agent). Its purpose is to transform as completely as possible the exposed silver halides into the metallic silver of the negative grain that forms the image, without attacking the unexposed silver salts. If these were also affected, the whole emulsion would turn uniformly gray or black, and no image could be formed. Only very few substances are known to possess the required selective qualities that are neccessary for differentiation between exposed and unexposed silver salts. Most commonly used are amidol, glycin, hydroquinone, metol, orthophenilenediamine, para-aminophenol, paraphenylenediamine, pyrocatechine, and pyrogallol.

3. An activator. Most photographic developing agents function properly only in alkaline solution. For this reason, a developer must include an alkaline activator. The higher the alkali content of a developer is, the more energetic, rapid, and contrasty it will develop. This can occasionally go so far that the overactivated developing agent also begins to attack the unexposed silver salts, producing overall fog in the negative. The most commonly used activators are, in order of increasing action: sodium carbonate, borax, potassium hydroxide, and sodium hydroxide (caustic soda).

4. A preservative. All developing agents have a natural affinity to oxygen. They readily combine with it, "rust" themselves away until they become photographically inactive, and discolor films and papers with brownish oxidation stains. Because water also contains free oxygen resulting from air dissolved in it and because contact with surface air is unavoidable, reducing agents in developer solutions would oxidize rapidly unless a preservative were added to the developer. Such preservatives have the ability to combine with the oxidation by-products of the developing agent, which would otherwise cause excessively rapid oxidation of all the available developing agent. Most commonly used preservatives are sodium sulfite and potassium metabisulfite. Used in large amounts, sulfite dissolves part of the silver halides and produces negatives with a finer grain.

225

5. A restrainer. To prevent the developing agent from attacking the unexposed silver salts (which it might do if overactivated) and to counteract the effects of possible overexposure of the negative, a restraining agent is usually added to the developer solution. It prevents overall fog and also helps speed up development by making it safe to add larger quantities of alkali without the danger of harmful side effects. Too much restrainer, however, slows down the effective speed of a film and necessitates prolongation of the exposure time. Most commonly used restrainer: potassium bromide.

RULES FOR THE PREPARATION OF DEVELOPERS

1. The preservative must be dissolved before the developing agent. Otherwise, the developing agent will oxidize excessively before the preservative takes effect. However, there is one exception: In the case of formulas containing Kodak Elon Developing Agent, the Elon must be dissolved first because it is readily soluble in warm water but only slightly soluble in sulfite solutions without alkali. After the Elon is completely dissolved, the sulfite should be added immediately, then the other developing agents, and finally the alkali.

2. The alkali must be added after the preservative and the developing agent have been completely dissolved. Alkali increases the natural affinity of the developing agent to oxygen and will accelerate its rate of oxidation unless prevented by the preservative.

3. Always dissolve one chemical *completely* before adding the next one. Otherwise, discoloration of the solution and oxidation and precipitation of chemicals can occur.

4. Published formulas commonly list the components in the order in which they must be dissolved. Follow instructions carefully to avoid undesirable reactions.

5. Use only water of a temperature not exceeding 125 degrees F. for the preparation of all developers. A few developers require the use of boiled and even distilled and boiled water.

Kodak Developer D-76

In my experience, this is the best all-purpose film developer. It preserves the full inherent speed of a film, produces maximum shadow detail, and yields negatives with moderately fine grain. I use it exclusively for the development of 2¼ × 2¼-inch negatives and up.

water (about 125° F.)	750 cc.
Kodak Elon developing agent	2 grams
Kodak sodium sulfite, desiccated	100 grams
Kodak hydroquinone	5 grams
Kodak borax, granular	2 grams
water to make	1 liter

Dissolve the chemicals in the order given. A more rapidly working developer can be obtained by increasing the quantity of borax from 2 to 20 grams per liter; the developing time will then be only about half that of regular D-76. The useful life of the developer can be increased considerably by adding 30 cc. of Kodak Replenisher D-76R per roll of 120 or 35 mm. film processed.

Kodak Replenisher D-76R

water (about 125° F.)	750 cc.
Kodak Elon developing agent	3 grams
Kodak sodium sulfite, desiccated	100 grams
Kodak hydroquinone	7.5 grams
Kodak borax, granular	20 grams
water to make	1 liter

Ultrafine-grain developer Sease III

This formula for ultrafine-grain development of 35 mm. films is retained here because it is a "classic." Although it has been, in my opinion, superseded by Kodak Microdol-X, some photographers may still want to experiment with Sease III because of the extremely fine grain that it yields, despite the fact that film exposure time must be increased by a factor of 2 for low-contrast and by 2½ to 3 for high-contrast subjects.

sodium sulfite, desiccated	90 grams
paraphenylenediamine base	10 grams
glycin	6 grams
distilled water to make	1 liter

Dissolve the sulfite and the paraphenylenediamine in water of 125° F.; then add the glycin. Add water to make one liter. When all the chemicals are completely dissolved, filter the solution while it is still warm. Average developing time is twenty-five minutes at 70° F. or thirty minutes at 65° F. Films having genuine fine-grain characteristics require only half this developing time.

Kodak Developer D-8

This is a high-contrast developer intended for any kind of photography where very high contrast and density are required. Since this developer can be used with both continuous-tone and process films, it should be of interest particularly to the experimentally inclined photographer.

water (about 90° F.)	750 cc.
Kodak sodium sulfite, desiccated	90 grams
Kodak hydroquinone	45 grams
Kodak sodium hydroxide (caustic soda)	37.5 grams
Kodak potassium bromide	30 grams
water to make	1 liter

To use, take two parts of stock solution and one part of water. Developing time in a tray is about two minutes at 68° F. For still higher contrast, use without dilution.

High-temperature (tropical) film development

Film development at temperatures ranging from 75° to 110° F. is possible in ordinary developers if the emulsion has been hardened prior to development in the Kodak Prehardener SH-5.

Kodak Prehardener SH-5

Solution A

Kodak formaldehyde, about 37% solution by weight	5 cc.

Solution B

water	900 cc.
*0.5 percent solution of Kodak Anti-Fog No. 2	40 cc.
Kodak sodium sulfate, desiccated	50 grams
Kodak sodium carbonate, monohydrated	12 grams
water to make	1 liter

*To prepare a 0.5 percent solution, dissolve 1 gram of Kodak Anti-Fog No. 2 in 200 cc. of water.

Immediately before use, prepare the working solution by adding 5 cc. of solution A to 1 liter of solution B, stirring vigorously to ensure thorough mixing.

Prior to development, treat the exposed film in the SH-5 working solution for ten minutes, with moderate agitation. Then remove the film from the solution, drain for a few seconds, immerse in water for half a minute, drain thoroughly, and immerse the film in one of the developers mentioned. Duration of development should be as follows:

<div style="text-align:center">

at 80° F., develop 85 percent of normal time.
at 85° F., develop 70 percent of normal time.
at 90° F., develop 60 percent of normal time.
at 95° F., develop 50 percent of normal time.
Above 95° F., double the amount of Kodak Anti-Fog No. 2
at 110° F., develop 25 percent of normal time.

</div>

Should Kodak Prehardener SH-5 be unavailable, good results at temperatures up to 95° F. can also be obtained by adding sodium sulfate to the developer in accordance with the following table:

Kodak developers	Range of Temperatures	Add Kodak sodium sulfate (desiccated) per liter
D-11, D-19, D-61a, D-76	75°–80° F.	50 grams
	80°–85° F.	75 grams
	85°–90° F.	100 grams

Developing times at temperatures up to approximately 90° F. will remain more or less the same as what is normal at 68° F. without the added sodium sulfate. Should it become necessary to develop at temperatures ranging from 90° to 95° F., add 100 grams of sodium sulfate to the developer, but decrease the time of development by about one-third relative to normal. Regardless of the developer temperature, however, the following precautions must be taken.

1. The temperature of all processing solutions including wash water must be within 5° F.

2. Following development, the film must be treated in Kodak Hardening Bath SB-4 (see below); immediately after immersion, agitate for thirty to thirty-four seconds (or streakiness will result); then leave the film in the bath for an additional three minutes.

3. Following hardening, the film must be fixed for about five minutes in a freshly prepared acid hardening fixing bath (or two minutes in Kodak Rapid Fixer).

4. The fixed film should be washed in running water or in several changes of water for not more than ten or fifteen minutes; longer washing may cause trouble.

Kodak Hardening Bath SB-4

water	1 liter
Kodak potassium chrome alum	30 grams
*Kodak sodium sulfate, desiccated	60 grams

*If crystalline sodium sulfate is used instead of the desiccated form, take 135 grams per liter instead of 60 grams.

In tungsten light, a freshly mixed SB-4 hardening bath looks violet-blue in color but gradually turns yellow-green with use. When it begins to assume this color, it ceases to harden and must be replaced with a freshly prepared bath. An unused bath keeps indefinitely, but the hardening power of a partially used solution decreases rapidly on standing for a few days.

Kodak Developer D-72

This is an excellent all-purpose paper developer virtually identical with packaged Kodak Dektol paper developer. It produces prints in neutral to cold tones and can be used with most sensitized papers, regardless of make or type.

water (about 125° F.)	500 cc.
Kodak Elon Developing Agent	3 grams
Kodak sodium sulfite, desiccated	45 grams
Kodak hydroquinone	12 grams
Kodak sodium carbonate, monohydrated	80 grams
Kodak potassium bromide	2 grams
water to make	1 liter

Dissolve the chemicals in the order given. To use, mix one part of stock solution with two parts of water. Developing time at 68° F. should be not less than one and not more than two minutes.

The purpose of a stop bath (acid rinse) is threefold: to interrupt development instantly by neutralizing the developer trapped within the film or sensitized paper; to protect the acid fixing bath from premature exhaustion by neutralizing the alkalinity of the developer, which is unavoidably carried into the fixer with the film or paper; and to prevent prints from staining in the fixer.

Kodak Stop Bath SB-5 for films

water	500 cc.
Kodak acetic acid, 28 percent	32 cc.
Kodak sodium sulfate, desiccated	45 grams
water to make	1 liter

Immediately after development, immerse the films in this bath for about thirty seconds, agitating constantly; then transfer the films to the fixer. Replace the bath after approximately twelve rolls of 35 mm. film or 120 roll film per liter have been processed.

Hardening stop bath for films

This is a good acid hardening stop bath for films that has a greater hardening effect than ordinary hardening solutions.

sulfuric acid, 5 percent solution	30 cc.
potassium chrome alum, granulated	30 grams
water to make	1 liter

Agitate negatives for half a minute after immersion. To achieve maximum hardening, leave them in the bath for an additional three to five minutes.

Stop bath for prints

water	1 liter
acetic acid, 28 percent	50 cc.

To make approximately 28 percent acetic acid from glacial acetic acid, dilute three parts of glacial acetic acid with eight parts of water. Treat the prints for at least five seconds. Capacity of the solution per liter is approximately twenty prints 8 × 10 inches.

THE CHEMISTRY OF A FIXER

After development is completed, the unexposed (undeveloped) silver salts must be removed from the emulsion, for otherwise they would in time darken and obscure the image. These undeveloped silver compounds are readily soluble in a solution of sodium thiosulfate, commonly called *hypo*.

A plain solution of hypo in water would remain efficient for only a short time because it would soon be contaminated with chemicals carried over from the developer. As a result, negatives and prints would stain and fix incompletely or not at all. To prevent this, three additional components are normally needed.

An acid—acetic acid—which neutralizes the alkaline developer carried over into the hypo and prevents undesirable reactions between developer and hypo. However, addition of acetic acid directly to the hypo solution would turn the bath milky and render it useless by decomposing the hypo. This must be prevented by adding a preservative to the solution.

A preservative—sodium sulfite—which prevents the decomposition of the hypo by the acid and makes it possible to maintain a high enough degree of acidity of the fixer to neutralize all the alkali carried over by developer trapped in films and sensitized papers. Furthermore, sodium sulfite combines readily with oxygen in the solution and absorbs it before it can react with the carried-over developer, preventing the developing agents from staining the fixing negatives and prints.

A hardening agent—either white potassium alum or potassium chrome alum—is added to prevent excessive softening and swelling of the gelatin of negatives and prints, particularly during warm weather. These chemicals tan the gelatin and render it less vulnerable to mechanical injuries.

Boric acid is sometimes added to fixers to retard the precipitation of sludge (aluminum sulfite) and to prolong the useful life of the bath.

233

The degree of exhaustion of a fixing bath is best determined with the aid of a test solution (for example, Edwal Hypo-Check): Dip out one or two ounces of fixer, add one or two drops of the test solution, and shake. If no cloudiness results, the bath is still strong. If a white precipitate forms but disappears upon shaking, the fixer is nearing exhaustion; if the precipitate remains, the bath is exhausted and should be replaced by a freshly prepared one.

RULES FOR THE PREPARATION OF FIXING BATHS

1. Dissolve the sodium sulfite first, then the acetic acid.

2. Add the hardener (alum) to the sulfite-acid solution. Do not mix sulfite and alum directly with each other, for they will form aluminum sulfite, which precipitates in the form of a white sludge.

3. Dissolve the hypo by itself in water as hot as it comes out of the hot-water faucet; the melting crystals will lower its temperature almost immediately to somewhere around 50° F.

4. Do not mix hypo and acetic acid directly with each other, because the acid will decompose the hypo, turning the bath milky and useless.

5. Acetic acid is sensitive to heat. Do not add it to solutions that are warmer than 85° F. Mixed with hypo in a solution that is above 85° F., it decomposes the hypo, and the bath is spoiled.

6. After they have cooled below 85° F., mix the sulfite-acid-alum solution with the hypo solution.

7. A fixing bath that has turned milky is spoiled and must be discarded.

RULES FOR THE USE OF FIXING BATHS

Leave negatives in the fixing bath about twice as long as is required to clear the film. Normally, a fixing bath is exhausted when the time required to clear a negative is twice that required when the bath was freshly prepared.

An exhausted fixing bath will still clear a negative, but such a negative is not permanent and fades within a relatively short time. Therefore, the degree of exhaustion of a fixer should be checked periodically with the aid of one of the commercially available hypo-testing solutions; they are inexpensive and available in any photo store.

The safest way to fix negatives and prints is to use two separate fixing baths. First, fix in one for the prescribed time (see instructions that come with the fixer); then fix the negatives or prints for approximately five minutes in the second bath. When the first bath begins to show signs of exhaustion, discard it, replace it with the second bath, and prepare a new bath for the second fixing.

Negatives and prints should not be left in the fixer for more than twice the time that was required for proper fixing. Otherwise, bleaching of the image (particularly in prints) and greater difficulty in removing the fixation by-products from the paper base of prints may result.

Kodak Fixing Bath F-6

water, about 125° F.	600 cc.
Kodak sodium thiosulfate (hypo)	240 grams
Kodak sodium sulfite, desiccated	15 grams
*Kodak acetic acid, 28 percent	48 cc.
Kodak balanced alkali	15 grams
Kodak potassium alum	15 grams
cold water to make	1 liter

* To make approximately 28 percent acetic acid from glacial acetic acid, dilute three parts of glacial acetic acid with eight parts of water.

Kodak Fixing Bath F-6 is recommended for general use with both films and papers. It is a nearly odorless bath and permits somewhat more rapid washing than other fixing baths. Kodak F-6 should be used in conjunction with a stop bath or an acid hardening bath to obtain the full useful hardening life of the fixer. Fix negatives and prints for not less than five and not more than ten minutes.

Prints processed as described in the previous chapters will last for many years without discoloring or fading—provided that they are protected from the influence of light—but they are not "permanent." Actually, of course, nothing is permanent, and, given sufficient time, even the stars will change. However, to make photographic images last as long as the paper they are printed on, they must not only be *made* but also *treated* with special care and protected from all those influences that constantly threaten to decompose both paper stock and emulsion.

Deterioration of photographic prints is most often caused by chemicals remaining in the paper stock and the emulsion, aggressive glues used in mounting, humidity, high temperature, and prolonged exposure to light and polluted air.

p. 192 An exhausted fixing bath cannot completely dissolve the unexposed silver salts, which in time decompose and bleach the print. The best way to prevent this is the two-bath fixing method described before. Subsequently, treat the prints in Kodak Hypo Clearing Agent in accordance with the instructions printed on the package and follow up with a bath in the following solution.

Kodak Hypo Eliminator HE-1

water	500 cc.
hydrogen peroxide (3 percent solution)	125 cc.
ammonia solution (add one part of concentrated 28 percent ammonia to nine parts of water)	100 cc.
water to make	1 liter

Prepare the solution immediately before use, and discard afterward. If the solution is kept in a stoppered bottle, gas developed within may break the glass. Wash the prints for about thirty minutes at 65° to 70° F. in running water that flows rapidly enough to replace the water in the vessel com-

pletely once every five minutes. Then immerse each print for about six minutes at 68° F. in the Hypo Eliminator HE-1 solution. Finally, wash about ten minutes before drying. At lower temperatures, increase the washing times. The capacity of the HE-1 solution is about twelve prints of 8 × 10 inches per liter.

Occasional effects when using the hypo eliminator HE-1:

1. Slight tendency for prints to stick to belt on belt driers. To prevent this effect, treat the print about three minutes in a 1 percent solution of formaldehyde prior to drying.

2. An almost imperceptible change in image tone. To prevent this effect, add 1 gram of potassium bromide to each liter of the HE-1 bath.

3. A very faint yellowing of the whites. To minimize this effect, treat the prints in a 1 percent sodium-sulfite solution for about two minutes immediately after treatment in HE-1 and prior to the final wash.

For ordinary purposes, a good check on the degree to which prints are free from hypo can be made with the aid of the following solution.

Kodak Hypo Test Solution HT-2

water	750 cc.
*Kodak acetic acid, 28 percent	125 cc.
Kodak silver nitrate	7.5 grams
water to make	1 liter

*To make approximately 28 percent acetic acid from glacial acetic acid, dilute three parts of glacial acetic acid with eight parts of water.

Store the HT-2 solution in a screw-cap brown polyethylene bottle in darkness. Avoid contact of the test solution with the hands, clothing, negatives, prints or undeveloped photographic materials; otherwise, black stains will ultimately result.

Test for degree of washing: After washing, cut off a small strip from the white margin of the print, and dip one end of it into a small amount of the test solution for about three minutes. Any discoloration of the treated strip indicates the presence of hypo, and the degree of stain shows the relative

237

amount of hypo. Well-washed prints usually show a slight tint correspond-ing roughly to that of light brown sugar. A darker tint indicates insufficient washing.

When the washing is known to have been fairly thorough, a quick spot test can be made on the back of a print or the back of a small blank piece of paper that has been carried through the processing with the batch of prints. Remove excess water by wiping or blotting the back of the print; apply a drop of the test solution, allow two or three minutes for the solution to react, and judge immediately the depth of the stain as described. Because the excess silver nitrate will darken on exposure to light, even if the test shows adequate washing, return the tested print to the wash water for an additional three to five minutes in order to wash out as much as possible of the test solution.

A note of caution. A negative reaction of prints to the test just described does *not* guarantee that the images will not ultimately fade. It only proves that prints are reasonably free from hypo. To ensure *complete* removal of hypo, the prints must be treated with a hypo-eliminator solution: After a thorough wash, treat the prints for six minutes in Kodak Hypo Eliminator HE-1 (the formula for which we have given); then continue to wash for another ten minutes before drying the prints as usual.

p. 237

To minimize the dangers resulting from exposure to light and air, prints that are expected to last as long as possible must be tightly packed and stored in darkness. For additional protection, they should be treated in Kodak Gold Protective Solution GP-1. This solution covers the silver image with a protective layer of gold, which is much less susceptible to atmospheric influences than silver.

Kodak Gold Protective Solution GP-1

water	750 cc.
Kodak gold chloride (1 percent stock solution; dissolve 1 gram in 100 cc. of water)	10 cc.
Kodak sodium thiocyanate	10 grams
water to make	1 liter

238

Add the gold-chloride stock solution to the volume of water indicated. Dissolve the sodium thiocyanate *separately* in 125 cc. of water. Then add the thiocyanate solution slowly to the gold chloride solution, stirring rapidly. For best results, the Kodak GP-1 solution should be mixed immediately before use.

For use, immerse the well-washed prints (which preferably have received a hypo-elimination treatment) in the GP-1 solution for ten minutes at 68° F. or until change in image tone toward blue-black is just perceptible. Then wash for ten minutes in running water, and dry as usual. The capacity of the GP-1 solution is about eight prints of 8 × 10 inches per liter.

The GP-1 treatment may also be used in conjunction with fine-grain films in cases in which maximum negative permanence is desired.

Negative evaluation

Exposure too short

Development too short

"Normal" negative

Development too long

Exposure too long

To be able to evaluate his negatives, a photographer must learn to distinguish between underexposed and underdeveloped, and overexposed and overdeveloped, negatives. Otherwise, he can neither correct such mistakes satisfactorily nor avoid them. The picture examples above and the table below show him both the appearance of the respective negative and the cause of the mistake.

Appearance of the negative		Cause of the mistake	
Too thin	and too contrasty	= Exposure	too short
	and too contrastless	= Development	
Too dense	and too contrasty	= Development	too long
	and too contrastless	= Exposure	

241

1: Long exposure, short development, low contrast.

2: "Normal" exposure, "normal" development, "normal" contrast.

Print from negative 1 on normal paper. Notice wealth of detail in shadows.

Print from negative 2 on normal paper. Notice balanced rendition of contrast.

These four pairs of pictures illustrate the extent to which subject contrast can be controlled in the negative by controlling exposure and development. Ordinarily, of course, only one such step would be used. However, to be able to produce negatives in which contrast is in accordance with the characteristics of the subject, a photographer must know how to produce any desired contrast—how to decrease, increase, or preserve the contrast of unusually contrasty, contrastless, or "normal" subjects respectively.

I recommend that the reader take a series of pictures of a subject with average contrast and try to produce a series of negatives with contrasts ranging from extremely low to extremely high.

3: Shorter exposure, longer development, higher contrast.

4: Very short exposure, very long development, very high contrast.

Print from negative 3 on normal paper. Notice high contrast, black shadows.

Print from negative 4 on normal paper. Notice absence of intermediate grays.

Subject contrast is preserved if	exposure is according to exposure meter development is according to "standard" rule
Negative contrast decreases if	exposure is longer than normal development is shorter than normal
Negative contrast increases if	exposure is shorter than normal development is longer than normal

The light-accumulating ability of films

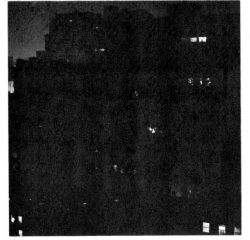

Exposure 1 second

Exposure 10 seconds

Exposure 1 minute Exposure 5 minutes

These four pictures of a night scene were taken under identical conditions within seven minutes of one another. The first picture corresponds approximately to what the eye saw at a glance. The second picture shows all the detail the eye could resolve after prolonged staring. The last two pictures show something the eye could never have seen in reality under the prevailing conditions.

To become familiar with the effects of the light-accumulating ability of films, I recommend that the reader take a similar series of pictures. Such "exercises" are important to successful night photography, in which underexposure results in complete failure and overexposure destroys the mood and mystery of night. The most important application of this phenomenon is in astronomical photography, in which hours and hours of cumulative exposure enables scientists to photograph galaxies and stars that otherwise would be invisible.

Exposure ¹/₁₀₀₀ sec. Bulb is completely underexposed and invisible. Interest is confined to the glowing filament.

Exposure ¹/₂₅₀ sec. Bulb is still somewhat underexposed. Contrast is still high, emphasizing filament's white-hot glow.

Exposure ¹/₁₀₀ sec. Bulb is correctly exposed. Details in darkest as well as brightest areas are well defined.

Exposure ¹/₁₀ sec. Bulb is overexposed. Contrast begins to flatten out. Dark areas are abnormally rich in detail.

Exposure 1 sec. Bulb is enormously overexposed. Contrast is low. Reversal of the negative (solarization) has begun.

Exposure 10 sec. Bulb is overexposed beyond recognition, and detail is wiped out. Solarization of brightest area is complete.

Six versions of an incandescent light bulb

In order to become familiar with the enormous exposure latitude of modern negative emulsions and with the effects of decreases and increases in exposure, I recommend that the reader take a series of pictures of a contrasty subject in which exposures range from total underexposure to total overexposure. In the photographs above, notice how contrast increases as exposure decreases, how shadow rendition improves with increased exposure, and that the first and last pictures seem like positive and negative.

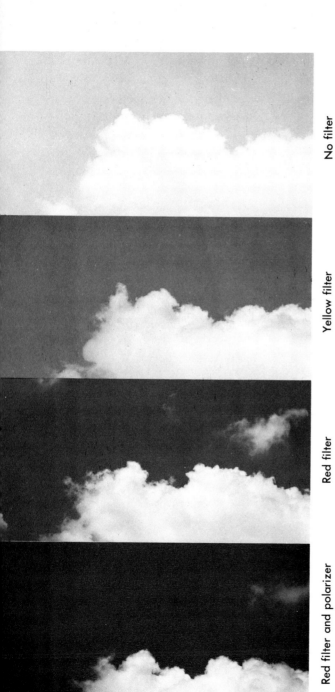

Blue filter

No filter

Yellow filter

Red filter

Red filter and polarizer

In the majority of outdoor photographs the sky is an important picture element. In order to make objects stand out in contrast against a blue sky or to capture the beauty of clouds, it is necessary to control the gray-tone rendition of the blue sky. For this reason, I recommend that the reader take a series of sky-and-cloud photographs through different filters in accordance with the instructions given in this table.

	Filter	Tone of the blue sky
	blue	white
	none	lighter than it appeared to the eye
Panchromatic film	medium yellow	as it appeared to the eye
	dark yellow	slightly darker than it appeared to the eye
	light red	dark gray
	dark red	very dark gray
	red and polarizer	black

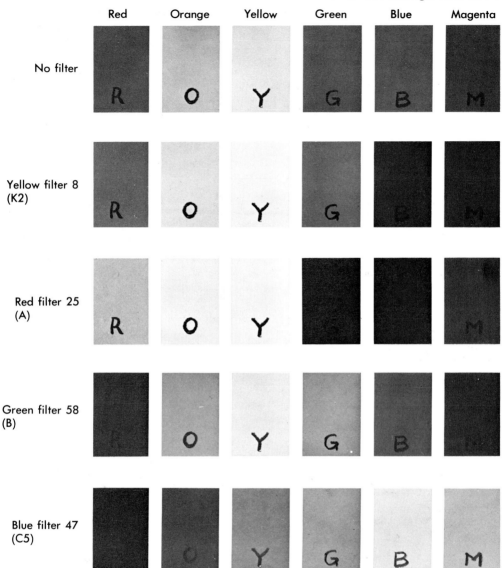

Translation of color into shades of gray can be controlled by means of color filters. To make a color appear darker in the photograph than it appears to the eye, a filter of a complementary color must be used. To make a color appear lighter, a filter of the same color must be used.

To become familiar with the effect of different color filters on different colors, I recommend that the reader make a color chart containing red, orange, yellow, green, blue, and magenta—by cutting swatches of colored paper and pasting them side by side—and photograph the chart through different color filters.

The demonstration pictures above are photographs of such an arrangement taken on panchromatic film through the four basic color filters, yellow, red, green, and blue. They were printed on the same grade of paper (no. 2) for fair comparison of color translation.

Color control through color filters

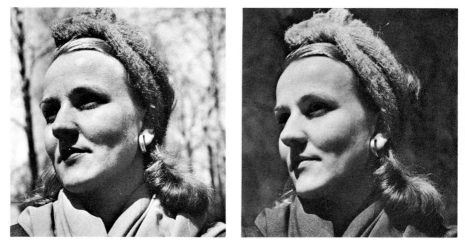

Left: Panchromatic film, blue filter. *Right:* Panchromatic film, red filter. Sky and scarf were blue, hat red, hair blonde, and suit gray. Notice the difference in translation of color and subsequent change in "mood" produced by these filters.

Practical examples of the use of color filters. The differences in color rendition between the components of each pair of pictures are almost as great as the differences between positive and negative. But only photographers who have done their "finger exercises" and know which filter produces which results achieve the desired effect.

Top: Panchromatic film, blue filter. *Bottom:* Panchromatic film, red filter. Sky was bluish gray, upper front part of the locomotive orange, rear part of the roof dark blue, and lower part of the engine gray. Pictures taken under identical light conditions.

248

Left: "Ordinary" photograph. *Right:* Picture taken through a polarizer. Notice how unwanted reflections can be eliminated and the "hidden" subject brought out.

Polarizers and lens shades are valuable aids in combating glare and reflections. However, they are not infallible, and there are things they cannot do. To become familiar with their potentialities and limitations I recommend that the reader shoot comparison pictures of different subjects with and without these aids.

Left: Picture taken without a lens shade. *Right:* Picture taken with a lens shade. Notice how ugly flare—so common when one shoots against the light—can often be avoided by the use of a lens shade.

Control of perspective distortion

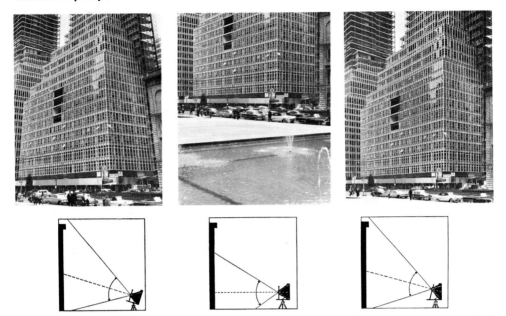

Distortion control by means of camera swings. *Left:* Tilting camera to include top of tall building produces "converging verticals." *Center:* Leveling camera so that film is parallel with building renders verticals parallel but cuts off top of building. *Right:* Keeping camera level but raising lens until all of building appears on groundglass produces "normal" distortion-free photograph. For this purpose, a lens with sufficient "covering power" is needed.

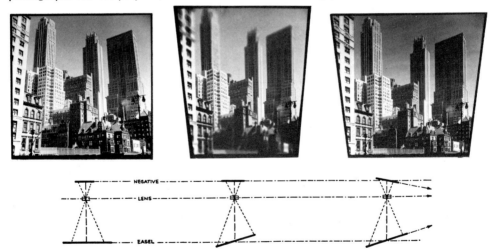

Distortion control by means of an enlarger. *Left:* Straight print from a "distorted" negative; vertical lines converge. *Center:* Tilting the easel restores verticals to parallelism; unsharpness must be corrected by stopping down the enlarger lens. *Right:* Tilting the negative and the easel in opposite directions by means of a tilting negative carrier produces distortion-free image that is sharp throughout, even though the enlarger lens is wide open.

Left: **Wide-angle shot** from close-up. *Right:* **Telephoto shot** from far away. Use of lenses of different focal lengths enables a photographer to adapt the space impression of his picture to the demands of the subject. Here, photograph on left emphasizes "endless" length; picture on right stresses the narrowness of the individual buildings.

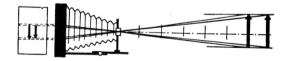

Wide-angle shot, camera close to subject. Depth appears exaggerated, proportions between subjects seem distorted, objects in foreground appear too big, objects in background appear too small. Notice great difference in size of images of arrows on groundglass in sketch.

Telephoto shot, camera far away from subject. Depth appears shallow, proportions between subjects are well preserved, distortion is avoided. Notice small difference in size of images of arrows on groundglass in sketch.

Subject, setup, and distance between boxes are the same in both pictures (notice the four horizontal film boxes); only the camera position and focal length of the lenses are different.

Seven renderings of a cube—"finger exercises" in perspective control. To become familiar with the use of camera swings, I recommend that the reader take a similar series of pictures. Carefully note the following: (1) To give the most convincing impression of a cube or any three-dimensional form, a photograph must show three of its sides (lower row). Pictures showing only two sides of the cube suggest a "hinged screen." Picture showing only one side (top, left) suggests a flat surface without "body" or depth. (2) Converging of parallels can be made to suggest either "height" (top row, right) or "depth" (bottom row, left and right). (3) To avoid "distortion," the film must be parallel with the surface that has to be rendered distortion-free. To achieve this, the photographer must adjust the swing back of the camera accordingly. (4) If the swing back is correctly adjusted, the image on the groundglass will appear undistorted. If the image is partially out of focus, this unsharpness can be corrected to some extent by tilting the lens slightly. Remaining unsharpness must be corrected by stopping down the diaphragm. This type of work requires the use of a groundglass-equipped view camera with swings.

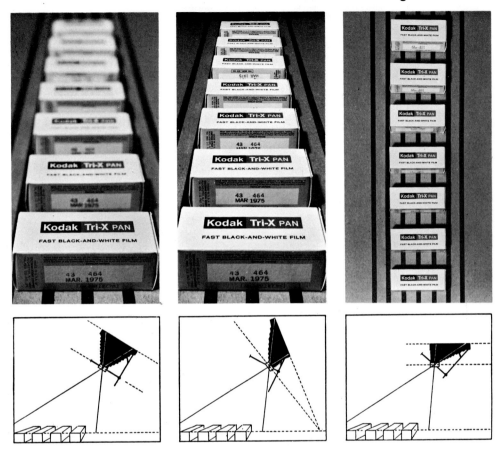

The extent to which perspective and extension of sharpness in depth can be controlled by using a swing-back and front is illustrated by these three pictures which were taken *from the same camera position with an identical diaphragm stop—f/4.5.*

Left: "Ordinary" photograph; notice limited extent of sharpness in depth.

Center: Adjusting camera front and back in such a way that imaginary lines drawn through the planes of subject, lens, and film meet in a common point produces a picture that is sharp throughout, even though the diaphragm is wide open. Notice, however, the slight degree of distortion: Parallel lines converge more sharply toward depth than in the undistorted but unsharp picture at the left.

Right: Readjusting camera front and back in such a way that imaginary lines drawn through the planes of subject, lens, and film are parallel produces a picture in which "inverted perspective" completely eliminates diminution toward depth: Film box farthest away is rendered exactly as wide as the nearest one; parallels are rendered parallel and do not converge toward depth.

Practical application of these principles is particularly useful in advertising and industrial photography, in which undistorted rendition of objects is often necessary in order to create a correct impression of a product or a piece of machinery.

253

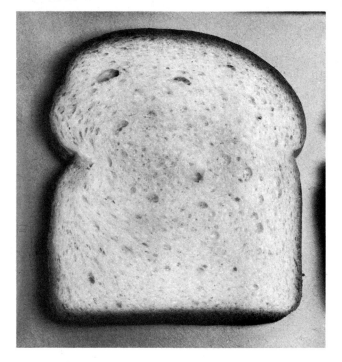

Direct front light produces "shadowless" illumination, which obliterates "texture." This type of illumination must be avoided whenever texture rendition is important, for without shadows texture rendition is not possible.

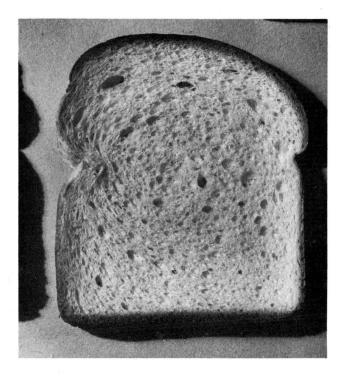

Low-skimming, shadow-producing illumination brings out texture. Picture taken with a single floodlight. The diffused character of its illumination, however, produces shadows that are too weak for first-class texture rendition.

The concentrated beam of a low-skimming spotlight renders texture crisp and clean. Exaggerated contrast "dramatizes" the subject but at the same time makes it appear too "harsh," unsuitable to the softness of bread.

texture-lighting

Combination of texture-producing, low-skimming spotlight and shadow-softening floodlight "fill-in" renders texture crisp but not harsh. In most cases, this setup gives the best illumination for "documentary" texture rendition.

Symbolizing the radiance of light

Halo (non-antihalo glass plate)

Out of focus rendition

Halo (Duto diffusion disk)

Small diaphragm stop

Single layer of fly screen

Two screens crossed at 45° angle

In a photograph 'light" and "white" are of necessity the same. Actually, however, "light" is radiant and active, whereas "white" is merely reflected light and passive. To render "light" in a photograph in the most effective form, its radiance must be "symbolized." Some of the forms in which this can be done are illustrated above. To become familiar with the creation and use of such symbols I recommend that the reader experiment in this direction, studying and analyzing the emotional effects of the different symbols and learning how to use them for the creation of predetermined impressions.

7

Learning from Experience

Experimenting with Materials and Techniques

Many amateurs erroneously believe that anyone can become an accomplished photographer in a relatively short time. This view may be so prevalent because it is so easy to produce recognizable pictures. And since this view is fortified by the "you push the buttom; we do the rest" kind of advertising, it is no wonder. What most people overlook is the fact that there is a world of difference between "recognizable pictures" and "good pictures." It is true that almost anyone can quickly master the rudiments of photography and turn out "recognizable pictures." Out of the thousands of pictures entered in every photographic contest, most are "technically good"; some are excellent. But—and any contest judge or editor will confirm this—despite their high technical standard, the overwhelming majority of these pictures are pointless, boring, and trite; in short, anything but "good." Why? For two reasons: First, lack of originality and imagination on the part of the photographer, who mainly imitates what others have done before (I'll have more to say about this in Chapter 8), and, second, because the majority of photographers are satisfied with elementary techniques. As soon as they know how to focus, expose, develop, and print, they start out to make "finished pictures"—they are freshmen trying to do postgraduate work. Considering this, it is no surprise that so many photographs are meaningless and immature.

Photography is not quite as simple as that. If it were, it would be difficult to explain the fact that the work of some photographers is good and the output of others is poor. All of them obviously use the same equipment,

257

materials, and techniques; the same makes of cameras; and identical brands of film. Why, then, are some pictures so much better than others? Very simple: Their originators knew how to "see in terms of photography"; in other words, they recognized an interesting subject when they saw it. And they knew how to render their subjects in a photographically exciting form. To use an analogy from music: "Run-of-the-mill photographers" use only one finger to play a tune, whereas "good photographers" use all ten. The piano and the tune may be the same, but the effect is different.

Having mastered the fundamentals of his craft, a photographer should then broaden his techniques. Learn to play "with both hands." This applies both in practice and in theory. In practice—by attempting increasingly difficult subjects like photographs at night, candid indoor shots, extreme close-ups, wide-angle, and telephoto pictures. In theory—by studying the various methods by which things can be achieved in photography: how lenses of different focal lengths affect perspective, how different filters translate colors into different shades of gray, the interdependence of exposure and development times and their influence upon the contrast of the negative, the characteristics of papers of different gradation and their effects upon the impression of the picture, the use of camera "swings" for controlling perspective and avoiding distortion, the use of high key and low key as a method for creating specific "moods," dodging, burning-in, and holding back for contrast control on a local scale in prints, and so on.

What the student photographer must realize as soon as possible is the fact that there are always *many* ways of photographing a given subject. First, of course, there is what we may call the "obvious way." It is the simple and easy way, never very original and seldom the best. It usually is an imitative and unimaginative way. Then there are other approaches, which, being creative, make common subjects appear exciting and new. By selecting an unusual point of view—literally, as well as figuratively speaking—through use of a telephoto or wide-angle lens instead of a standard lens, by utilizing the close-up, a "dramatizing" filter, or backlight and silhouette, a photographer can produce pictures that intensely express an idea, a feeling, or a mood, pictures that make other photographers exclaim: "Why didn't I think of this! Where did I have my eyes!"

The pictures that precede this section are intended to stimulate the reader to perform experiments of his own. They should arouse his curiosity and make him eager to know more. They are photographic "finger exercises," designed to help him to explore the potentialities of his medium. They testify to the breadth of its scope. They are as "abstract" as the "scales" a music student must play in order to become a good musician. Normally no one, of course, would photograph the same subject through filters of every color from red to blue. But to be able to select *the right type of filter*, a photographer must be familiar with the effects of all filters upon every color. The same reasoning also applies to other "exercises"—in exposure, perspective, contrast control, and the like. In practice, of course, only one of the many different possibilities would be used to depict a given subject. But to be able to select the most effective one, a photographer must know them all. And the only way of knowing is to have studied each in practice. This must be taken quite literally: Take your camera, lenses, filters and so on, and find some suitable test objects; then actually repeat all the examples shown here. Merely to read about them and to look at the pictures is not enough. Remember, there is no shortcut to success, unless it is by way of experiment and test. The hours spent on such "finger exercises" will save you incalculable time later.

THE GREAT CONFUSION

The fledgling photographer who goes out into the world to try his wings immediately lands in the middle of a gigantic confusion, both literally and figuratively speaking.

Literally—because the moment he shyly enters a photo store to buy some equipment, he finds himself confronted with an overwhelming array of what at first seems like thousands of different cameras and lenses and hundreds of different types of film and paper, not to mention the ten thousands of different accessories, from photoelectric exposure meters and speedlights to viewfinders that look around corners and filters in all the colors of the rainbow.

Figuratively—because one day he hears that photography is nothing but a mechanical means of reproduction and the photographer just another technician: "The sooner you get off your high horse, the better off you are." The next day he reads in a photo magazine that photography is Art, that a photographer must be an Artist, and that photography is his "medium of expression." He reads about the "documentary photographers" and Roy Stryker, the "Pictorialists," and the members of "Group f/64" and Edward Weston, and he is confused by extreme differences in technique and approach to a subject. He is bewildered by an aggregate of pictures by amateurs and professionals representing all fields and phases of photography. Where does that leave our young photographer? Which should he choose? What should he do?

He can do one of two things. He can listen indiscriminately to anyone who "advises" him; toy with one camera, lens, and film after another; copy the work of other photographers whom he admires; identify with a "group" or "school"; and thus forgo his individuality and limit his development. Or he can make up his own mind, critically sifting the advice given; resorting to experiments and tests to verify or disprove specific claims, to expand his own knowledge, and to perfect his facility and technique; *learning* from others, *not* by imitating them; and striking out on a path of his own to contribute the individuality and talent he possesses to express his aims.

In short, he can do what every man or woman who ever accomplished anything worth while in this world has done: go his own way in his own manner and "be himself." And maybe—some day—he will become a great photographer.

How to Select Your Photographic Equipment

In my opinion, the only intelligent way to select one's equipment is on the basis of two factors:

suitability
quality

Suitability

Suitable equipment is a prime requisite for success, in photography no less than in any other field of human endeavour. Many photographers overlook the fact that *their* equipment has to fit *their* needs, *their* temperaments, and *their* ways of working. Too often a photographer buys the type of camera that someone whose work he admires uses successfully, completely disregarding the fact that his own temperament, subject preference, and photographic goals may be very different. To use an analogy: A heavy turret lathe is a wonderful precision-made tool for the production of heavy engine parts, but it is completely unsuited to a watchmaker who needs an equally precision-made but otherwise entirely different kind of lathe.

> Conclusion: The better suited the equipment is to your *personal* needs, subject preferences, habits, and temperament, the more it will facilitate your work, and the happier you will be with it. And the less you have to worry about "technicalities," the better you can concentrate upon the more important *creative* problems of picture making.

Quality

Without good quality tools, no craftsman—not even the best—can do a technically first-class job. A photographer is no exception. A cheaply made camera—equipped with a flashy-looking but unsharp lens, film guides not truly aligned, inaccurate shutter speeds—simply cannot produce the sharp and sparkling pictures that anyone with a feeling for graphic quality demands.

> Conclusion: The higher the quality of the equipment, the easier it is to produce "technically perfect photographs."

Your own contribution

Even the finest and most suitable camera, lens, accessory, and so on holds nothing but a promise. You, the photographer, are responsible; you alone can give your camera "life," make it work, express your ideas, and create your photographs!

WHICH CAMERA IS "BEST"?

Photographers constantly ask me which camera, lens, film, developer, or the like is "best." This, of course, is a question that has to be qualified before it can be answered: Best for what purpose? For what kind of subject? For what demands? But even then it is very hard to give a definite answer because there are always several brands of camera that are equally well suited to specific types of work. Which of them he should buy depends then entirely upon the preference and solvency of the photographer.

The more objectively a photographer approaches the problem of selecting a camera, the less he allows himself to be influenced by the glamor of brand names and the glitter of chromium trimmings (or "professional" black finishes); the more coolly he analyzes the impressive "records" of certain makes of camera relative to his own contemplated type of work, the better off he will be. Do not start by collecting catalogues and pamphlets describing sundry types of cameras. Instead, start by asking yourself what kind of subject you mainly want to photograph (people, landscapes, architecture, insects, and so on), what kind of pictures you want to take (documentary, pictorial, snapshots, and the like), why you want to take them (hobby, record, sale, self-expression, and so on), and what type of worker you are (slow and careful, impulsive, temperamental, perfectionist, and so on). Read the following pages, which deal with these considerations. Then make your decision, handle the camera of your choice to get its "feel," take it out on actual jobs, put it through its paces, use it, test it, see whether you like how it performs, and—if you are really satisfied—buy it.

The three "P"s

Selection of a camera should always be governed by three factors: the *purpose* for which the camera will be used, the *personality* of the photographer, and his *purse*.

262

The purpose of *any* camera, of course, is to make good pictures. However, because potential subjects exist not only in immense numbers but also in very different types, no single camera design is equally suited to photograph *all* of them—never mind the claims of manufacturers of "system cameras." Therefore, experienced photographers distinguish between two main types of subject, each requiring a different camera design for best rendition:

Dynamic subjects—subjects characterized by movement require a "fast," that is, mobile, relatively light, and small camera with a large film capacity and equipped with a viewing and focusing system suitable to hand-held operation.

Static subjects—subjects that hold still indefinitely can, of course, be photographed with any kind of camera. However, because of technical limitations, a large-format camera will invariably yield better results than a camera that takes a smaller film format.

In regard to design, we must distinguish among three types of cameras, each of which is available in different sizes for different negative formats.

1. The reflex-type camera. Available in two subtypes—the single-lens and twin-lens reflex cameras—this type is most suitable for photographing dynamic subjects. Because lenses of more different types, designs, and focal lengths are available for single-lens reflex cameras than for any other camera design, SLRs, as they are called for short, are adaptable to virtually any kind of photography, *except* that which requires provisions for perspective control, which cannot be incorporated into an SLR design. A twin-lens reflex camera (TLR for short), though more limited than an SLR, in addition to being an excellent camera for general photography, represents, in my opinion, the camera design best suited for the beginner.

2. The rangefinder camera shares with the reflex cameras the distinction

of being extremely well suited to the photography of dynamic subjects. But, unlike reflex cameras, it is not particularly suitable for photographing static subjects because, in this field, both reflex and especially view cameras yield better results. Furthermore, rangefinder cameras (or RFs, as they are called) have certain shortcomings not shared by other camera designs: They are useless for close-up photography and in conjunction with the more extreme telephoto lenses (unless equipped with clumsy and expensive auxiliary reflex housings). Only lenses provided by the respective camera manufacturers can be used (SLRs take a very large number of various lenses made by different manufacturers, if necessary by means of special adapters, in addition to those specifically made for them); the extent in depth of the sharply covered zone cannot be checked visually; the view-finder image is relatively small, which makes composing difficult; and the rangefinder may go out of synchronization with the lens without the photographer's being immediately aware of it, resulting in unsharp pictures. For these reasons, rangefinder cameras are rapidly losing popularity.

3. The view camera, because it cannot be equipped with a special viewfinder (the groundglass panel serves for both viewing and focusing), cannot be used hand-held but must always be mounted on a tripod. As a result, this camera design is totally unfit for photographing dynamic subjects. On the other hand, it is unsurpassed for making photographs of static subjects and should therefore be the first choice of anyone specializing in landscape, architectural, industrial, interior, or commercial product photography, in copy work, or in reproductions of works of art.

View cameras represent the only design type that can be equipped with an individually adjustable front and back—the so-called "swings"—indispensable in all cases in which perspective must be controlled or corrected or in which sharpness in depth must be extended beyond the capability of the diaphragm. If any one of these requirements is important, only a view camera will be able to do the job.

The most advanced view cameras are constructed according to the module or building-block principle with virtually all their components—front and rear standard, bellows, track, lens shade, and so on—detachable and

interchangeable with other parts of similar function but of different size or design in accordance with different photographic requirements. As a result, a photographer can not only "custom tailor" his view camera to fit his purpose exactly but, if necessary, also "grow with it," including adapting it to a larger or smaller negative format.

Specialized cameras are specifically designed for single limited purposes, to which they are better suited than any other camera designs; but they are almost or totally useless for all others. These are the "second cameras" that ambitious photographers acquire to broaden their fields of work and to get ahead of their less enterprising competitors. Here is a brief summary of the most important ones.

Super wide-angle cameras encompass angles of view ranging from 90 to 220 degrees, depending on the design of the lens. The perspective that they deliver is either rectilinear or, if the lens is of the fish-eye type, spherical. They are suitable only for extreme wide-angle photography—in cases in which "ordinary" wide-angle lenses are not wide enough to include the required angle of view—or for the typical "wide-angle perspective" characterized by extremes of "distortion."

Panoramic cameras are extreme wide-angle cameras covering an angle of view of 140 degrees. They are equipped with lenses that describe an arc during the exposure, as a result of which the perspective that they deliver is cylindrical; that is, all straight lines not parallel with the axis of the "swing" are rendered curved, increasingly so the closer they are to the long edges of the picture. This unusual form of perspective manifests itself, of course, only if the subject contains straight lines; panoramic cameras are thus basically unsuitable to architectural photography, but the cylindrical perspective is not noticeable in ordinary outdoor scenes.

Aerial cameras, because their lenses are permanently focused at infinity and they lack bellows (which would collapse in the slipstream of an aircraft), are unsurpassed for aerial photography but useless for any other purpose. As a result, photographers should beware of buying the so-called "surplus" aerial cameras often advertised at fantastic bargain prices in the hope of converting them to some other use; it simply cannot be done, except, perhaps, at an exorbitant price.

265

Polaroid Land cameras—The well-known "picture in a minute" cameras are specialized in so far as they can be used only in conjunction with Polaroid Land films, most of which don't yield usable negatives. They are valued by amateurs for obvious reasons and by professionals for making on-the-spot exposure and composition checks and for producing instant give-away pictures as rewards for cooperation. Special Polaroid Land backs are also available for use in conjunction with 4 × 5-inch and a few other cameras.

Subminiature cameras are often precision instruments equipped with the most sophisticated refinements. They are almost irresistible to gadget-oriented amateurs but, as a rule, disappointing in regard to performance. In my opinion, they are invaluable in cases in which smallness and lightness are prime requirements but virtually useless in all others.

Box and simple roll-film cameras are little more than toys designed to satisfy the purpose of the occasional snapshooter who wishes to take pictures with a minimum expenditure of money, mental effort, and mechanical know-how. Their potential is, of course, almost nil.

> The **personality** of the photographer determines the **negative size.**

Today, two main trends can be distinguished in photography. One is characterized by a demand for highest technical quality and precision of rendition, the other by a quest for spontaneity, action, and life. The first has been publicized by the work of photographers like Edward Weston, Ansel Adams, and members of the West Coast Group f/64. Typical of the second trend is the documentary kind of photography that was the trade mark of picture magazines like *Life* and *Look*.

Parallel with the evolution of these two trends, two camera formats have been developed and perfected: comparatively large cameras, which take 4 × 5-inch sheet film and produce photographs of unsurpassed technical quality and perfection, and comparatively small 35 mm. roll-film cameras, which combine maximum mobility and "speed" with minimum size and

weight. Cameras of both formats are available in various designs: There are 4 × 5-inch sheet-film cameras of the single-lens reflex, rangefinder, and view-camera design; 35 mm. cameras are available in single-lens reflex and rangefinder forms. Each format has specific advantages and shortcomings. The most important ones are listed here:

35 mm. characteristics, potentials, and limitations

1. Smallness, compactness, and lightness make for easy portability, an invaluable requirement on hikes, canoe trips, and mountain-climbing expeditions and in war. They also make for relative inconspicuousness—a prerequisite for all candid photo reporting. A 35 mm. outfit with three different lenses, filters, and film for hundreds of exposures takes less space and weighs less than the average 4 × 5-inch press camera without accessories, film holders, or film.

2. In maneuverability and speed of operation, small cameras are vastly superior to large cameras. This advantage alone should be sufficient to make a small camera the choice of any photographer who specializes in documentary photography of people.

3. An enormous variety of lenses of different types, designs, and speeds for the most varied and specialized purposes, ranging from super wide-angle and fish-eye lenses to super telephoto, high-speed, and zoom lenses, are at the disposal of the 35 mm. photographer, whereas the range of lenses for 4 × 5-inch cameras is quite limited, including neither fish-eye, high-speed, zoom, nor extreme telephoto lenses.

4. Rapid-fire operation made possible by capacious film magazines, if necessary augmented by a motor drive, is available to the 35 mm. photographer but beyond the scope of those who work with cameras of larger formats.

5. The cost per exposure is ever so much lower per 35 mm. shot than per 4 × 5-inch shot. The immediate consequence is that 35 mm. photographers tend to cover their subjects much more thoroughly than photographers working with larger film formats.

6. Simple and easy loading of the camera with film in daylight can be fully appreciated only by those who have had to load sheet film individually into holders in darkness.

Shortcomings of 35 mm. cameras in comparison to 4 × 5-inch cameras include the following.

Pictures are generally less sharp and more grainy than those made with larger cameras because, to yield an 8 × 10-inch enlargement, a 35 mm. negative must be enlarged eight times linear, a 4 × 5-inch negative only twice. The higher the degree of enlargement, the lower the image quality.

All the shots on one roll of 35 mm. film must be processed together, no matter how different the subject or the shooting conditions, which may range from low-contrast front light to high-contrast backlight; the exposures may also vary from too long to too short. In contrast, 4 × 5-inch negatives can be developed individually with proper regard to specific requirements resulting from abnormalities of either subject or exposure.

All the "frames" (individual exposures) on a roll of film must be used up before the photographer can switch film, say, from fine-grain to high-speed or from color to black-and-white. By contrast, 4 × 5-inch sheet-film cameras permit changing to a different kind of film after each shot.

Small films must be processed much more carefully than larger formats because defects like scratches, spots, streaks, dust, and fingermarks will be enlarged approximately four times as much (and become four times as objectionable) as if 4 × 5-inch film were used. Obviously, 35 mm. photography is not for sloppy people.

The ease and speed of operation in conjunction with the low cost per exposure makes working with 35 mm. cameras a constant temptation to overshooting and wasting time and film on meaningless subjects. Self-discipline is therefore an indispensable ingredient of any successful 35 mm. photographer.

4 × 5-inch characteristics, potentials, and limitations

1. Superior sharpness, definition of rendition, and tonal quality of the print: To make an 8 × 10-inch enlargement, the negative has to be magnified only twice linear; to make an 11 × 14-inch print, less than three times linear.

2. Simpler processing allows more control: Individual shots can be developed individually with proper consideration of special requirements; ordinary rapid developers utilizing the full inherent speed of the film can be used without danger of producing objectionable graininess in the negative, which normally does not require a high degree of enlargement; and for the same reason, small specks of dust, minor scratches, and other blemishes don't show up nearly as much in prints made from 4 × 5-inch negatives as in those made from 35 mm. negatives—and those that show, because they show up smaller, are easier to "spot" (retouch).

3. Films of higher speed (which normally are grainier than slower films) can be used without the danger of incurring excessive graininess because the degree of enlargement of the negative is probably comparatively low.

4. Switching from one film type to another—say, from black-and-white to color—at any time in a shooting session without loss of a single "frame" (individual negative or exposure) is possible only if sheet film is used. With roll film, this can be done only if the camera permits the use of interchangeable light-tight film backs or special magazines—which at the time of writing is not the case with 35 mm. cameras.

5. Compositional advantages: The comparatively enormous 4 × 5-inch groundglass panel of a large camera makes it much easier to visualize and evaluate the final picture than the tiny viewfinder of a 35 mm. camera, compose the subject, detect undesirable influences before it is too late (in the print), accurately check visually the extent in depth of the sharply covered zone, and critically evaluate the distribution of light and shadow.

6. Individually adjustable front and back "swings"—indispensable for perspective control and, in certain cases, virtually unlimited extension of

the sharply covered zone in depth—can be incorporated only into view-type camera designs, thereby giving large cameras an exclusive advantage over 35 mm. and roll-film cameras in the fields of architectural, industrial, interior, and commercial-product photography.

Shortcomings of 4 × 5-inch cameras in comparison to 35 mm. cameras include the following.

Size, weight, and bulk make working with large cameras more cumbersome, reduce the speed of operation, and make the photographer conspicuous, especially if he has to use a tripod.

No high-speed, fish-eye, or zoom lenses are available for 4 × 5-inch cameras, and the few extreme telephoto lenses are big, monstrously heavy, and expensive.

Sheet film must be loaded individually sheet by sheet into special film holders, an operation that has to be performed in total darkness.

Each sheet-film holder holds only two sheets—film for only two exposures—yet in the 4 × 5-inch size takes as much space and weighs more than 35 mm. cartridges containing film for several hundred exposures.

Film cost is considerably higher per shot than for 35 mm. film.

CONCLUSIONS

Consideration and evaluation of the characteristics of 35 mm. and 4 × 5-inch cameras should make it obvious that, next to the purpose for which the camera is intended, the personality of the photographer is the most decisive of the factors that determine whether he should choose a small or a large format: If graphic quality and technical perfection are important to him; if he is a relatively slow and careful worker; if he realizes the importance of good composition and likes to arrange his subjects with care; if he is a perfectionist who would rather forgo a picture than lower his standards; and if he is willing to pay the

price for this in the form of inconveniences, weight, bulk, slower speed, and higher cost of operation, then only a 4 × 5-inch camera will ever really satisfy him.

On the other hand, if he is more interested in movement, action, drama, and life than in texture and definition; if he wants to travel light with a maximum of equipment taking up a minimum of space; if he is impulsive, reacts quickly, and likes to shoot fast, catching his subjects "on the fly"; if he intends to use his camera as a "photographic sketchbook"; and if he is satisfied with prints of less than maximum sharpness and definition, can face the problem of emulsion grain with equanimity, can forgo smoothness of gray shades and accept the fact that he must take great care in processing his films (or having them processed), then only a 35 mm. camera will ever make him happy.

And if he belongs to that very large group of photographers whose interests are not particularly specialized, if he intends to photograph both static and dynamic subjects, if he is neither a stickler for perfection nor a casual worker, if his photographic standards are high but not inordinate, then a camera in an intermediate size—2¼ × 2¼ inches or 2¼ × 2¾ inches—will probably serve him best. It will serve best because these intermediate formats combine relative smallness, lightness, maneuverability, and speed of operation with a relatively large negative size and consequent high, although not spectacular, print quality—characteristics that represent a good compromise because they include, to some extent, the most desirable qualities of both large and small cameras.

> The **purse** of the buyer determines the **quality** of the camera.

Always buy the best camera that you can afford, but do not make the mistake of confusing the "most expensive" with "the best." The "best" camera is always the one that is best suited to *your* particular needs. For

example, the "best" camera for a photographer who specializes in architectural photography is a comparatively inexpensive, simple 4 × 5-inch view camera with "swings," whereas for the candid night-club and theater photographer a 35 mm. camera with f/1.4 lens is "best"—an instrument that can cost several times as much as the relatively simple although much bigger 4 × 5-inch camera.

Personally, I would rather spend a given sum of money for a top-quality camera with only a standard lens than for a camera of the same design but of lower quality that, complete with standard, wide-angle, and telephoto lens, costs the same. Rather than buying my entire outfit at once and living with equipment of questionable quality, regretting my choice each time a print does not measure up to my expectations, I'd postpone acquiring additional lenses, filters, and the like until I can afford those that have the quality that I demand. How high this quality is, of course, is a decision that each photographer must make himself.

A good way to acquire a fine camera at a reasonable price is to buy it second-hand. Thanks to that common amateur "disease" of constantly trading the "old" camera in for the latest model after only a brief period of use, the photo market is flooded with equipment classified "like new"—and such equipment sells for only one-half or two-thirds of its original cost. In other words, last year's top-of-the-line model may sell for no more than today's economy version; is there any question which of the two would be the "bargain"?

Whenever you buy a used camera or lens, try not to close the deal until you have had a chance to test the equipment under field conditions to find out whether you like its performance. Some dealers allow a three-day trial period for this purpose and will refund your money if you are not satisfied with your purchase. This procedure is especially recommended when buying equipment that is no longer covered by the manufacturer's guarantee. The following section tells you what to look out for, particularly in buying a used camera.

Checks to be made in the photo store. Thoroughly examine the camera visually, paying particular attention to the following: The degree of wear manifested in edges and corners that show the camera body metal through the chrome or lacquer finish is direct evidence of the amount of use the camera has had and the degree of care that the previous owner lavished on it; a much-used camera, despite the greatest care, is often worn out internally and should be rejected, no matter how attractive the price. Check all visible screws for burr—a sure sign that the camera has been repaired by an incompetent person; a good camera repairman does not cause burr and if he accidentally damages a screw replaces it with a new one. Any dent in the camera body or the lens mount is cause for suspicion: The camera or lens has probably been dropped and may have been damaged internally too. The best way of determining whether or not such damage occurred and how serious it is is by making test shots.

Operate all the camera controls—focusing, shutter, film transport—and make sure that they function smoothly and are neither too tight nor too loose. Listen to the shutter: It should sound sharp and clean. Hesitation, irregularity, or scratchiness is evidence of dirt or damage and means that such a shutter must be cleaned or repaired before it can perform satisfactorily; it does not have to be cause for rejecting the camera, though it should affect the price.

If the camera is equipped with a built-in exposure meter, check its performance against two separate, high-quality hand instruments borrowed from the store. Variations of half a stop are probably unavoidable; larger variations are cause for concern. Repairing a built-in exposure meter is a delicate and expensive operation.

If the camera is equipped with a lens-coupled rangefinder, check its performance: Step out of the store and focus on a building several hundred feet away (which, photographically speaking, is equivalent to "infinity"); the lens and the rangefinder should simultaneously indicate an infinity

setting. Back in the store, focus on a test object at a measured distance of six feet from the camera, and set the lens for six feet, using the engraved distance scale on its mount; the two images inside the rangefinder should now coincide, or the two half-images should match. If they do not, something is wrong and must be adjusted before the camera can yield sharp pictures.

Checks to be made at home. To test whether or not the lens and the focusing control (mirror-projected or rangefinder image) are in synchronization (the first requirement for sharp pictures), proceed as follows: Take a printed page from a "slick" magazine; more or less in the middle of the page, mark one line of type by underlining it with a ballpoint pen and drawing a second line above it; tape the page to a wall in such a way that the printed lines run *vertically*; mount your camera on a tripod, with the lens at the same height as the center of the printed page, *not* facing the page "head on"; but "looking" at it at an angle of approximately 45 degrees between the optical axis and the wall. Then focus critically on the marked line; with the diaphragm *wide open*, make an exposure, process the film, and examine the negative with a good magnifier. If the line on which you focused is sharp while all the others are more or less blurred, the focusing mechanism of the camera is in sync with the lens. But if a line of type on either side of the marked line is sharper than the (marked) line on which you had focused, something is out of adjustment and has to be aligned by a competent repairman before the camera can yield sharp pictures.

Very few of even the best shutters are accurate at all speeds. Most quality shutters are reasonably accurate at medium settings from $^1/_{30}$ to $^1/_{125}$ second, whereas the slower and higher speeds are "off," sometimes by a factor of 2 and more. This is one of the facts of photographic life and does not matter as long as such aberrations are constant and the photographer knows the *actual* (in contrast to the *engraved*) shutter speeds. Professional photographers are aware of this and have their shutters tested at least once a year by a competent repairman, who, with the aid of an electronic shutter-testing machine, prepares a little chart listing the actual shutter

speeds next to the engraved ones. I can only recommend that the reader emulate their example.

One of the most highly stressed parts of a focal-plane shutter-equipped camera is the shutter curtain. If this curtain consists of rubberized cloth, it will eventually develop pinholes, with the result that the film will become light-struck. To check for this defect, remove the lens and open the back of the camera; with the shutter cocked and closed, hold the camera against a bright light source; cover your head and the camera with a black cloth (perhaps a focusing cloth) to keep out extraneous light, but leave the front of the camera exposed to the light: if the shutter has pinholes, they will appear as tiny, bright points of light. Repeat this test with the shutter released.

In a bellows-equipped camera, the part that becomes defective first will probably be the bellows, which tends to develop light leaks in the corners of the folds. To check for this defect, extend the bellows fully; close the lens by means of the shutter (if the camera is equipped with a focal-plane shutter, open the shutter, but close the lens with a lens cap); remove or open the camera back; take the whole thing into the darkroom, and extinguish all lights; insert an unshielded 40-watt light bulb at the end of a cable into the camera (a bulb of higher wattage might scorch the bellows), and look for light leaks, which, if present, should now stand out glaringly if you move the bulb back and forth inside the camera. At the same time, check whether or not the connections between bellows and camera front and back are still light-tight. Individual small holes in the bellows can easily be repaired with black adhesive tape. More extensive damage requires replacing the defective bellows with new ones.

Some focal-plane shutters "wedge"; that is, they expose one side of the film more than the other, a defect that occurs most often at the highest speeds. To test for this fault, take an outdoor photograph of a sheet of white paper, either in full sunlight or on an evenly overcast day (indoors it is virtually impossible to illuminate a surface *perfectly* evenly with photo lamps, as spot checks with an exposure meter will reveal). Determine the exposure by taking a reading off the white paper with an exposure meter, but expose only $1/10$ as long as the meter indicates (you want a relatively thin negative

of medium gray, *not* an evenly black one, which would not show the effect of "wedging"). Increase the normal time of development by 25 percent to increase contrast. If the shutter wedges, one side of the negative will be lighter than the other. This fault is very difficult and sometimes impossible to cure, but if the photographer is aware of it he can avoid the relevant shutter speed or at least avoid shooting subjects of even, medium-light tones, which show this defect particularly clearly, especially when color film is used; in black and white, this unevenness can be corrected by appropriate dodging during enlarging.

A common source of trouble in used (particularly wooden) view cameras are lens boards that fit too loosely and move when the shutter goes off. To correct this fault, tape the edges of the lens board until a good tight fit is achieved. Some lens boards may at one time have been fitted with solenoids for flash photography, which were later removed, leaving screw holes that, if they penetrate the lens board, act as "pinhole lenses" and cause ghost images in the negative. Such holes must, of course, be plugged or taped shut.

CONCLUSIONS

Cameras should be treated with the same care and respect as other precision instruments. But proper treatment should never approach fetishism—an attitude often found among certain amateurs who get more pleasure from owning and fondling a fine camera than from using it. As a matter of fact, many amateurs own more and better equipment than some well-known professional photographers. Such amateurs pay high prices solely for the pleasure of owning and displaying such equipment; they also pay a high price—for as long as they persist in attributing so much importance to their equipment, their interest naturally centers around the technical aspects of photography instead of being concentrated on the photographs they might produce. When a beginner leaves this gadgeteer stage behind him, it is a sign that he has started to grow up as a photographer.

HOW TO SELECT YOUR LENS

Most cameras are sold complete with lenses (exception: view cameras, in which the lens is always sold separately). This fact may seem to make a special chapter on lenses and their selection superfluous. However, because many of these cameras are available in different models equipped with different kinds of lenses, a choice still remains to the photographer. In addition, a constantly increasing number of cameras provide for interchangeability of lenses, and sooner or later the owners of such cameras may wish to acquire other lenses for particular types of work that are beyond the scope of the original lens.

SUITABILITY

The most important quality of any lens is *suitability*. Neither "speed," name, price, nor appearance is of the slightest significance if a lens is not suited to the particular kind of work required from it. A typical example of this is the mistake constantly made by amateurs who buy lenses that are too fast for their needs. They are motivated either by pure snobbishness, or they believe that "speed" is a valuable "reserve." But fast lenses do have serious disadvantages: Aside from being heavier, bigger, and ever so much more expensive than slower lenses, they are also generally less sharp (a few exceptions exist), even when stopped down. In order to have sufficient sharpness in depth, the overwhelming majority of photographs are taken anyway with the lens stopped down to at least f/5.6. And, because this is so, why not use slower, sharper lenses to produce sharper pictures with more detail, rather than cope with the inferior sharpness of high-speed lenses merely because one occasionally expects to need their higher speed? This seems to me as impractical as driving around in a moving van merely on the chance that someday one might need its capacity for moving to a new house.

277

The standard lens is the photographer's work horse—the lens that does a little bit of everything. As a result, it is the best lens for the average type of picture. A standard lens has a focal length approximately equal to the diagonal of the negative it must cover, and a relative aperture from f/1.8 (for 35 mm. cameras) to f/5.6 (for 4 × 5-inch and larger cameras). Most faster lenses are unsuitable as standard lenses because they are not sharp enough even when stopped down, and their superior speed is too rarely needed by the average photographer to compensate for this shortcoming, which would manifest itself daily. Furthermore, standard lenses are less expensive than high-speed lenses, and the difference in price can be invested more advantageously in a better camera, useful accessories, or simply more film.

High-speed lenses with relative apertures that range from f/0.95 to f/1.5 are indispensable under two conditions: when the light is too weak to permit correct exposure with a lens of slower speed and when the zone of sharpness in depth must be extremely shallow. Such lenses are computed with only one aim: speed. Consequently, other qualities had to be sacrificed to a greater or lesser extent. As a result, high-speed lenses are generally less sharp, less "contrasty," more prone to flare and halation, considerably bigger and heavier, and much more expensive than slower lenses of equal focal length. In my opinion, they are *not* suitable as standard lenses but are highly specialized "special-purpose lenses," which should be used only when really needed.

Wide-angle lenses save the situation when the distance between subject and camera is so short that a standard lens can render only part of the subject. Wide-angle lenses have more covering power than standard lenses, which means that a given negative format can be covered with a lens of shorter than standard focal length, and that the resulting picture will include a wider than standard angle of view (from 65 to 110 degrees, compared to the 45- to 55-degree angle covered by a lens of standard focal length).

Because of their shorter than standard focal length, wide-angle lenses

produce (from the same camera position) images in smaller than standard scale. As a result, photographers working with wide-angle lenses are often tempted to increase the image size of their subject by moving the camera closer. This, of course, not only increases the size of the image, but also simultaneously produces the well-known wide-angle perspective, which makes nearby objects appear unnaturally large and distant ones abnormally small.

Wide-angle lenses come in two types: Those computed to produce pictures in which perspective is rectilinear and those that produce pictures in which perspective is spherical. The first type renders actually straight lines straight in the picture; the second type—the so-called fish-eye lenses —renders actually straight lines curved, increasingly so the farther they are from the center of the picture. Rectilinear wide-angle lenses can cover angles up to 130 degrees (the Goerz Hypergon lenses for 5×7-inch and 8 by 10-inch view cameras), fish-eye type lenses up to 220 degrees, which means in effect that such lenses can "see backward."

At present, it is fashionable among young documentary photographers to substitute a moderate wide-angle lens for a standard lens because, equality of f-stop provided, "a wide-angle lens produces a more extended zone of sharpness in depth than a lens of standard (or longer) focal length." They forget that this is true only as long as comparison pictures are made at the same subject distance. In that case, however, the wide-angle lens, because of its shorter focal length, produces an image in smaller scale than the lens of standard focal length. In other words, a gain on one side (a deeper zone of sharpness in depth) is offset by a loss on the other side (a decrease in image size), a loss for which the photographer usually tries to compensate by approaching his subject more closely. Unfortunately, this practice, although it increases the image size, invariably also causes the subject to be rendered in more or less "distorted" form—the well-known "wide-angle perspective." At the same time, because now the subject is rendered in more or less the same size as it would have been if the picture had been taken with a lens of standard focal length from farther away, the initial gain in sharpness in depth is lost. Because one of the laws of optics decrees that, provided that there is *equality of image size on the groundglass or film, all*

279

lenses, regardless of focal length, no matter whether they are wide-angle, standard, telephoto, zoom, or what-have-you lenses, *produce equal amounts of sharpness in depth at equal f-stops.* It is for this reason that I urge the reader to use wide-angle lenses only under two conditions: when circumstances make it impossible to include in the picture a sufficiently large angle of view with a lens of standard focal length and when the typical "wide-angle perspective" is required for emphasis.

Telephoto lenses have longer focal lengths than standard lenses and therefore produce pictures in which the subjects are rendered in larger scale when comparison pictures are made from the same subject-to-camera distance. The gain in image size is proportional to the ratio of the focal lengths of the two lenses: A telephoto (or long-focus) lens of twice the focal length of another lens (standard or otherwise) will produce an image twice as large on the film.

Telephoto lenses are used for two reasons: to produce pictures in sufficiently large scale when the distance between subject and camera is so great that a lens of shorter focal length would show the subjects too small and to minimize "perspective distortion," rendering a nearby subject matter in more natural proportions relative to more distant subject matter. This effect, the typical *telephoto perspective* characterized by an apparent "compression of depth and space," is the exact opposite of the typical "wide-angle perspective," which seems to exaggerate depth and space; it invariably creates particularly monumental space effects.

All telephoto lenses magnify not only the subject but also accidental camera movement during the exposure, in direct proportion to their focal lengths, which makes it imperative to hold a camera equipped with a telephoto lens particularly steady when taking the picture—the more so the longer the focal length of the telephoto lens.

Teleconverters (or focal-length extenders) are negative supplementary lenses, which, mounted between the camera body and a standard or telephoto lens (other lens types are unsuitable), increase the focal length of the primary lens by a factor that ranges from 1.85 to 3, depending on the converter's design. At present, they are available only for use in conjunction with 35 mm. SLR cameras with interchangeable lenses.

Unfortunately, while increasing the focal length of the primary lens, tele-converters cause a corresponding loss in speed. For example, a 135 mm. telephoto lens in conjunction with a 2x converter acquires an effective focal length of 135 × 2 = 270 mm. At the same time, its f-stop number must also be multiplied by the converter's factor; if its relative aperture is, say, f/5.6, it will become 5.6 × 2 = 11.2. That is, the *effective* relative aperture of the lens system will now be f/11.2, a value that, in terms of exposure, amounts to only *one-quarter of the original "speed" of the primary lens*. In addition to this speed loss (which, of course, remains the same regardless of the f-stop with which the picture is made), the image quality of the photograph will probably be somewhat lower than that of a picture made with a telephoto lens of equal (270 mm.) focal length.

If greater focal lengths are required, two teleconverters can be used simultaneously in tandem arrangement. But image quality will deteriorate even farther, and exposure times will increase accordingly. If, for example, two 2x teleconverters are used together, the corresponding exposure factor will be (2 × 2) × (2 × 2) = 16. If a 2x and a 3x teleconverter are used simultaneously, the factor will be (2 × 2) × (3 × 3) = 36; and so on.

Now, figuring out the applicable f-stop values for a number of shots taken under different light conditions can be rather bothersome. Instead, an experienced photographer will simply set his exposure meter in accordance with a correspondingly lower film speed, a method that will enable him to apply the exposure data indicated by the meter directly to the diaphragm and shutter-speed dial of his camera. For example, if he uses a film with an ASA speed number of 160, all he will have to do is to divide this number by the converter factor, which, as we have seen, in the case of two 2x converters is 16. Now, 160 divided by 16 equals 10—the new *effective* speed of his film under the present circumstances. Setting the film-speed dial of his exposure meter at 10 instead of 160, he can now apply all exposure data directly, and if the meter indicates an exposure of, say, $^1/_{30}$ sec. at f/5.6, $^1/_{30}$ sec. at f/5.6 it is, notwithstanding the fact that *without* the two teleconverters he would have to expose $^1/_{500}$ sec. at f/5.6.

However, such losses in lens (or film) speed, large as they are, may well be worth the effort, for the attainable degrees of image magnification are

truly staggering: in conjunction with two 2x converters, a 200 mm. tele-photo lens acquires an effective focal length of 800 mm.; if one 2x and one 3x converter are used together, they become the equivalent of a 1200 mm. lens and, if two 3x converters are used, of an 1800 mm. lens. Whether or not the resulting picture degradation will be tolerable depends on the following factors: the quality of the primary lens, the quality of the teleconverters, how well lens and converter work in combination (this varies between lenses of different makes and designs), how still the camera is held during the exposure (remember, the degree of unsharpness due to camera motion is proportional to the focal length of the lens), and how good the "seeing conditions" are, that is, whether or not thermal disturbances in the atmosphere make it impossible to produce sharp pictures, no matter how favorable all the other conditions may be.

Zoom lenses, which, at present, are available only for 35 mm. SLR (and movie) cameras, are complex optical systems with variable focal lengths. Within the limits of their minimum and maximum focal lengths, they provide an infinite number of intermediary focal lengths. Depending on the design, the longest focal length is two, three, or, for movie cameras, even four times as long as the shortest. As a result, a zoom lens provides within one unit the equivalent of many lenses, thereby saving the photographer weight, space, money, and the time otherwise required to change from one lens to another. In addition, it enables him to study his subject from the same camera position in many different scales and forms of cropping simply by sliding a collar or turning a ring. The price for these amenities, however, is high: Zoom lenses are heavy, long, and clumsy; almost invariably some-what less sharp than individual lenses of comparable focal lengths; and sometimes subject to distortion; that is, they may render straight lines very slightly curved.

Close-up lenses are specially computed to produce maximum sharpness at subject distances that are measured in centimeters or inches, rather than meters or feet. Also known as *macro lenses*, they sometimes feature lens mounts that permit focusing all the way down to rendition in natural size (1:1) on the film without the aid of extension tubes or auxiliary bellows. Their focal lengths are always short and their speeds relatively slow. Typical representatives are the Macro Kilars and the Zeiss Luminars.

Process lenses are another type of close-up lenses, this time computed for maximum sharpness at subject distances from approximately one to several feet. They are the typical *engraver's lenses* used in photomechanical reproduction and are characterized by the possession of an extremely flat field, resulting in uniform distribution of critical sharpness over the entire film area even at full aperture. If such lenses are corrected not for two (achromate) but for three colors, they are called *apochromates* and represent the ultimate in lens design as far as sharpness is concerned.

Process lenses, which are made primarily for use on view cameras, have relatively long focal lengths to compensate for their limited covering power and lower than average speeds with maximum relative apertures around f/9. They are unsurpassed for making reproductions of two-dimensional objects and also superbly suited for commercial-product photography.

Catadioptric, or mirror, lenses are mixed lens-mirror systems, available so far only for small SLR and movie cameras constructed according to the principle of the reflecting telescope; the parabolic mirror is the main component of their design. "Cat systems," as they are also called, are practicable only in focal lengths of 500 mm. (20 inches) and longer and have the advantage over regular telephoto lenses of comparable focal lengths that they are much shorter, lighter, often cheaper, and almost completely color-corrected. These advantages, however, are partly offset by two serious shortcomings: Cat systems preclude the use of a diaphragm, and the out-of-focus images of point sources of light, sharp reflections, street lights at night, glitter on water, and the like will be rendered not as circular, more or less blurred disks (as with ordinary lenses) but as bright rings that look like miniature doughnuts; the effect can be rather disturbing.

As a result of the lack of a diaphragm, catadioptric lenses cannot be stopped down but must always be used at full aperture. The consequences, of course, are that the sharply covered zone in depth is always extremely shallow, and exposures can be regulated only by changing the shutter speed. In cases in which even the highest available shutter speed is still too slow to prevent overexposure, the light transmission of the system can be reduced accordingly, with the aid of appropriate neutral-density filters provided by the manufacturer.

Aerial lenses are computed to yield maximum sharpness when focused at infinity and usually perform badly at shorter subject distances. Many suffer from severe chromatic aberration and are therefore unfit for color photography. Others are designed for use in conjunction with a deep red filter and corrected accordingly, which means that without such a filter they are not very sharp. And most are too heavy to be truly "portable" and too big to fit into conventional leaf-type shutters; they can therefore be used only on cameras equipped with focal-plane shutters. As a result, though unsurpassed for aerial photography, they are virtually useless for any other purpose.

Soft-focus lenses produce images that are neither critically sharp nor outright fuzzy—subject detail seems to consist of a relatively sharp nucleus surrounded by a halo of unsharpness, an effect that becomes increasingly pronounced with increasing subject contrast and can be quite effective in high-contrast and backlighted shots, where it strongly suggests the radiance of brilliant light.

This is an "old-fashioned," highly specialized type of lens of very limited usefulness, although it still ranks high with some pictorialists and photographers of women. In the hands of the tyro it is an invitation to disaster.

Slip-on lenses, which are used in front of ordinary lenses somewhat as filters are used, are designed to change the characteristics of the primary lens in conjunction with which they are used. They are intended primarily for use with cameras that do not provide for lens interchangeability. They are available in different types to increase or decrease, respectively, the focal length of the primary lens, to convert it into a fish-eye lens, and to turn it temporarily into a soft-focus lens. Their most common use is for close-up photography with cameras the focusing mechanism of which otherwise would not permit this kind of work. For twin-lens reflex cameras, matched sets of positive slip-on lenses are available for close-up photography, which provide for parallax compensation by means of a wedge built into the supplementary lens that goes on the camera's viewfinder lens.

HOW TO TEST A LENS FOR SHARPNESS

The simplest and most practical way to test a lens for sharpness is to take pictures with it, enlarge the negatives, and check the prints for sharpness. However, in order to produce conclusive results, such tests must be conducted according to strict procedural rules, for there are causes of unsharpness that are not related to the performance of the lens. Observation of the following recommendations will eliminate these factors.

1. **The lens must be perfectly clean.** A greasy film or fingermarks on the glass cause a slight degree of unsharpness. A lens must be cleaned very carefully to avoid scratching the antireflection coating. First, with a soft camel's hair brush, remove all traces of dust or grit from the lens. Then put a drop of lens cleaner on the glass and with a piece of lens tissue gently and lightly wipe it clean. Never touch the glass surfaces of a lens with your fingers, and never use ordinary household cleaning fluid because it may penetrate into the lens and attack the cement that holds the elements together.

2. **The camera must be supported** by a rigid tripod to positively eliminate movement during the exposure.

3. **A well-illuminated, flat, contrasty test object** that is rich in fine, sharp detail must be used. A square consisting of four pages of type from a "slick" magazine will do very nicely. Test objects lacking in contrast and well-defined detail (like people or a face) are unsuitable because in such subjects distinction between sharp and unsharp is almost impossible.

4. **The film inside the camera and the test object must be parallel to each other;** otherwise, one side of the image will be out of focus through no fault of the lens. If the camera is equipped with "swings" (the view-type camera), they must be in a neutral position. In a large camera, a heavy lens may pull the camera front down slightly and throw the whole system out of alignment, particularly if a long focal length requires a long bellows extension; this, of course, will cause unsharpness even though the lens may be capable of producing perfectly sharp pictures.

To ensure that test chart and film are parallel, proceed as follows. Tape a small pocket mirror to the center of your test chart, flat against the wall. Adjust the height of the tripod in such a way that, with the camera in level position, the center of the lens is at the same height from the floor as the center of the mirror. Now, by trial and error, moving the tripod from side to side, find the position in which the image of the lens reflected in the mirror appears exactly in the center of the viewfinder or groundglass of your camera. In this position, test chart and film are parallel and the conditions for a valid sharpness test fulfilled.

5. **Focusing has to be done extra carefully.** If a rangefinder is used, check first that it is in synchronization with the lens. If it is "out of sync," the picture will be unsharp, no matter how good the lens. Try to focus as fast as possible to avoid tiring your eye. If you use a reflex camera, use the focusing magnifier built into its hood; if working with a view-type camera, check the sharpness of the groundglass image with the aid of a special five- or eight-power focusing magnifier.

6. **To avoid possible confusion later on,** write on a piece of paper the name, serial number, and focal length of the lens you are testing, together with the diaphragm stop used for the respective exposure; then tape this data sheet to the test chart so that it will appear in the test negative and thus become a permanent part of the record. But don't forget to make the appropriate change in these data each time you change the f-stop number in consecutive shots.

7. **To avoid accidental camera movement,** which would invalidate the test, make the exposure with the aid of a cable release. Still stricter are the rules under which the U.S. Air Force tests its lenses. Completely darken the test room; open the shutter in darkness; wait half a minute until the camera has quieted down; expose the film by turning on the lights for the required time (very weak bulbs are used to achieve exposure times long enough to time accurately without overexposing the film); turn off the lights; close the shutter in darkness. Only in this way can accidental camera motion be avoided with certainty—provided that the floor on which the tripod stands is not shaken by people moving around or passing trucks that shake the entire building.

8. **Choose an exposure time** that will result in a relatively thin negative. The more overexposure, the more light is scattered within the film emulsion, and the less sharp is the negative. This kind of unsharpness, of course, is not the fault of the lens.

9. **Make a series of test shots** with all the different diaphragm stops engraved on the lens. Adjust each exposure accordingly by making the appropriate change in the shutter speed. Don't forget to change the f-stop data on the little record sheet that you photograph together with your test chart.

10. **Develop the film** in a fine-grain developer if you use roll film, in a standard or rapid developer if you use sheet film. Slightly increase the developing time beyond normal in order to produce relatively contrasty negatives.

11. **Examine the test negatives** on a light table with a magnifier, and compare the differences in sharpness caused by different diaphragm stops. Then make 11 × 14-inch enlargements, but make very sure that these are "grain sharp" from edge to edge (the film grain must be visible over the *entire* area of the print); otherwise possible unsharpness (particularly toward the corners of the paper) could be partly or entirely the fault of the enlarger lens or your own inadequate enlarging technique. Personally, I enlarge *all* my test negatives between glass plates because glassless negative carriers simply cannot hold a negative *perfectly* flat.

The evaluation of any lens test is to a greater or lesser degree a matter of opinion. Except for certain apochromates ("flat-field" lenses especially computed for copy work), no lens produces negatives that are critically sharp from corner to corner unless it is more or less stopped down. What must be judged is the degree and extent of the central sharpness of the negative shot at full aperture and how far the lens has to be stopped down before it produces a negative that is acceptably sharp all over. As a matter of fact, it is extremely difficult to make a fair evaluation of a lens without a suitable comparison object—a negative of the same test chart made under identical conditions by another lens: Is this one better than that, and if so, by how much? But the final judgment should always be made with reference

to the intended purpose of the lens because, obviously, a lens intended exclusively for portraiture does not have to be as sharp as a lens intended for architectural photography; the "field" of a lens intended mainly for landscape photography (where depth is great) does not have to be as "flat" as that of a lens intended for copy work where the subject has no depth at all.

Consequently, even a lens that doesn't check out too well in conjunction with a test chart—a flat two-dimensional object—may produce completely satisfactory pictures if used on three-dimensional subjects because, in that case, a slight degree of curvature of field present in the lens will not show up as glaringly or not at all, and, in order to yield sufficient sharpness in depth, the lens will probably have to be stopped down anyway, which automatically improves its sharpness. It is for these reasons that many experienced photographers disdain the use of test charts, judging a new lens instead by the way it renders the kind of subject that they intend to photograph with it. Which, after all, makes sense.

Now that you know "how to do it"—what are you going to do with it? The most important chapter in any photographic textbook—and the one most often neglected. Photography is a means to an end—the picture with purpose and meaning. The following chapter will show you one approach—the rest is up to you.

8

How to Use Photography

A Matter of Opinion

Photography is such a varied medium of visual communication that trying to establish rules for making "good" photographs would be as ridiculous —and as pointless—as telling a painter how to conceive and execute a "good" painting. Who is so infallible that he can decide whether Rubens is a "better" painter than Renoir or whether Cézanne is "superior" to Van Gogh? Similarly, in photography, is Hiro better than Mili? Is Weston "superior" to Haas?

Anyone can easily see that creative and "original" photographers— photographers who possess styles of their own—are different from one another. But no one can say authoritatively whether or not one of these photographers is "better" than another. If a photograph conveys something to the observer, if it is imaginative and original, filled with meaning, intent, and feeling, then it is automatically a "good" photograph and its creator a "good" photographer. If not, the photographer who made it will just as automatically be considered a "poor" photographer, notwithstanding the "group" or "school" to which he belongs.

From this we may safely conclude that *the first requisite for a good photograph is that it have meaning*. It must be the logical result of interest in a particular subject, a personal feeling or opinion concerning it, and a sincere desire to express this feeling in photographic form—coupled, of course, with the technical ability to do so and a form of rendition that is sufficiently imaginative to capture the interest of the observer. If a photog-

289

rapher fails in this last respect—if he cannot "get his ideas across"—all his efforts are in vain; for then his picture has no meaning, at least as far as the observer is concerned.

Thus we can formulate a second prerequisite for a "good" photograph: Not only must it have a meaning, but this meaning must also be *expressed in such a form that it becomes apparent to the observer*. As long as this is the case, it does *not* matter what final form the picture takes—whether it is sharp or fuzzy, "pictorial" or "documentary"—or whether the subject is a landscape, a face, or a nude.

As far as form and technique are concerned, they should be determined by the mood or idea that is to be expressed in the picture. This presupposes complete freedom of action on the part of the photographer. Realization of the importance of this freedom makes me an opponent of any kind of photographic "group" or "school" concept, for I believe that adherence to the principles or aims of any "group" or "school" is limiting. Narrowness in any form stifles creative ability and promotes stagnation of the mind. Most adherents of "groups" or "schools" are too zealous. They unthinkingly condemn anybody who does not conform to *their* opinions. Young, inexperienced photographers are naturally eager to learn and are therefore likely to be easily impressed, particularly by opinions expressed with conviction. If the reader is aware of this, listening to such set opinions can do him no real harm. As a matter of fact, listening to other people is often a good and sometimes even a stimulating way to learn—as long as the listener does not forget that he has a mind of his own and a right to his own opinion.

MY OWN OPINIONS ON PHOTOGRAPHY

And now I am going to stick my neck out by voicing my own opinions on photography. I am well aware that I thus invite criticism and may even be accused of the very things to which I object in others. I take this calculated risk for the following reasons.

I firmly believe that anyone is entitled to express his opinion and should have

the courage of his conviction. I have no quarrel with followers of "groups" and "schools" because their approach to photography is different from my own. I respect their opinions, even though I often disagree with them. What I object to is their narrow-mindedness and intolerance—their "conform or be condemned" dicta.

I am not opposed to argument. I believe that any spirited discussion is stimulating, no matter how wide the disagreement. As a matter of fact, discussion without disagreement seems pointless to me because there is no possibility for constructive criticism. And this is another argument against belonging to a "group" or "school": Members tend to share the same opinions, principles, and goals. As a result, criticism within the group is usually limited to small-scale bickering since agreement on the larger issues is ensured by the fact of membership. The unavoidable result is an inbred attitude that cannot help but lead to stagnation.

Finally, I am stating in the following my own opinions because I believe that what I have to say may contribute to the reader's becoming a better photographer.

A PHILOSOPHY OF PHOTOGRAPHY

According to my experience, most photographers go through three stages of development. Some photographers gradually pass from the first stage through the second stage to the third. Others never get that far in their development. And still others skip stage one. Only the "naturals"—the "born photographers"—start at stage three.

The first stage. At this stage the photographer is merely a collector, a *gadgeteer* whose prime interest is in cameras and lenses, in the mechanics of photography. He often possesses the finest equipment, the latest gadgets, and a full line of accessories. His ideal is the "system camera." He is the delight of the owner of any photo store because he never keeps a camera for any length of time. He always comes back and "trades." He constantly "tests" his cameras and lenses, but he never gets around to taking "real" photographs.

The second stage. At this stage the photographer's prime interest is in "print quality." He also owns a lot of fine equipment, but at least he takes pictures with it. However, he photographs purely for the purpose of taking pictures—photography for photography's sake. The subject is strictly incidental—provided, of course, that "it makes a good picture." His ambition is to make "perfect prints." He talks lovingly (and knowledgeably) about film grain and negative gradation, gamma and inertia, threshold value, opacity, and reciprocity failure. He religiously buys each new brand of fine-grain developer as soon as it appears on the market, always hoping for perfection—the developer that will enable him to make "grainless" 16 × 20-inch enlargements from 35 mm. negatives (often with a contact print pasted in the lower left-hand corner).

The third stage. At this stage the photographer is akin to the painter or the novelist who is motivated by some inner compulsion. He does not care what kind of camera he uses as long as it takes the kind of picture he wants. You may see him toting a battered Nikon—but his photographs are exhibited at the Museum of Modern Art. His "technique" is often questionable, but his sincerity is not. If a photographer definitely knows what he wants to accomplish, even though he may not know *how* to accomplish it, he will eventually learn—through application, tenacity, and resourcefulness —ways to express better and more clearly on film and sensitized paper the experience he wants to share with other people.

THE MISSION OF THE CAMERA

To me, photography is a means to an end—the picture with purpose and meaning.

The purpose. Any photograph is a means of communication. A photographer takes pictures for other people to see. Every photograph is a message from photographer to observer. The purpose of such a message is to tell, in visual form, something that the photographer feels worth communicating to others. A picture that does not "say" anything is pointless. Of course, sometimes the "message" may not be of interest to others, or may

not be "understood." This is particularly true of "experimental" photographs—the usually grainy, blurred, distorted, or zoomed pictures that seem to be in vogue today. In this respect, photographers share the fate of many other artists whose work is too "advanced" for their time, whose public is not "ready" for what they have to say. Such artists are ridiculed by their contemporaries, yet their work, once labeled "radical" and worse, sets the style one generation later. It would be well for those who automatically condemn anything they don't understand, anything they consider too "modern" and too "far out," to remember this. Even if such pictures don't always "come off"—a hazard that, incidentally, they share with any kind of pioneer work—to me they are still more stimulating than most "conventional" photographs. Of course, photographers who merely imitate the work of others, who indulge in "fads" for the sake of "being different," and who have nothing worthwhile to say produce pictures that serve no purpose and justly invite criticism. But a photographer who is sincere in his work should always be respected. Sincerity and purpose go hand in hand, and a sincere photograph is always a purposeful and valid one.

The meaning. Any message has content. This content is its "meaning." The content of a photograph can be almost anything; it can be educational, informative, satirical, entertaining. Even a picture taken merely for record's sake has a meaning—to provide a record for future reference. The majority of amateur pictures fall into this category—all the photographs of babies, children, and sweethearts; of birthdays and picnics; of happy vacation times and strange lands—they are "records for future reference," to be taken out, looked at, and enjoyed in times to come. Compare those photographs, which many a "serious" amateur derides as "snapshots," to the types of pictures so often seen in photographic salons. The snapshots at least mean something to the photographer and his family; the "salon pictures" are often completely meaningless.

Any meaningful photograph begins with an idea. The more original the idea, the more likely it is that the picture will convey something new to the observer, and the new and original are always stimulating. This automatically makes an *original* photograph an *interesting* photograph. And vice

versa: A photograph based on a trite idea can never be anything but trite. All pictures that are imitations of other photographs are trite because they are repetitious. To me, imitating is equivalent to duplicating, repeating something that somebody else has already done, a pointless waste of time and energy; but many photographers still seem to disagree. Otherwise, how can we explain the continuous production of such photographic clichés as pattern shots of rows of empty chairs, coils of heavy rope, bums with beards and battered hats, spectacles on open books, gnarled hands folded in simulated prayer, and nude girls toying with rubber balloons? Aside from the hope of winning a prize at the local photo-club contest, what is the purpose of such pictures? What do they mean?

With interesting subject matter everywhere, it is hard to understand why so many photographers still waste their time on hackneyed trivia. Perhaps it is lack of imagination. Or that they don't know how to "see." Perhaps they want to "play safe" by sticking to subjects that have been "done" successfully before. Possibly they feel they must compete with other photographers by making better pictures of the same subjects. But whatever their motivation, unless they cease to imitate and begin to do original work, they will never make good pictures.

The first step on the road to original work is the realization that a camera is no more than an instrument for making pictures. Forget its glamor and value as a status symbol, its precision workmanship, its chromium trim, its shiny lens; look at it in the way you would look, for example, at a typewriter. What a typewriter is to the novelist, a camera is to the photographer—a machine for recording ideas. And as anyone can learn to type, so anyone can learn to photograph. Nobody cares what make of typewriter a novelist uses. Similarly, why should anybody care what brand of camera a photographer uses in making his pictures? The only thing that matters is whether his work is interesting and good or pointless and bad.

A camera is an instrument potentially as versatile in the realm of exploration as a microscope or a telescope. Similar to these, it can be used to present in picture form far more than merely images of things seen before. Imaginatively used, a camera becomes an instrument for making discoveries in the realm of vision. Many of us have seen such photographs. But

294

few amateurs seem to realize how many such opportunities are within the scope of their cameras. Here are a few suggestions.

Extreme close-ups. This type of photograph, particularly of small objects of nature in more than natural size, discloses a whole new world: faces of insects, grotesque as some of the masks of primitive tribes; tiny seeds of plants revealing their ingenious arrangements for transportation, wings and featherlike devices, hooks, and spikes. Nothing seems more stationary than a weed or a tree. But in their earliest stages, many plants, in the form of seeds, wing their way with the wind as free as birds or travel for miles attached to the fur of animals. Isn't it more exciting to photograph such aspects of nature than to dress your uncle in burlap, make him pretend to write with a "quill," and photograph him as a "monk?"

Telephotographs. Not only do they bring distance within your reach, but they also show objects in more natural proportions. They minimize "distortion." They make everything appear monumental and create the feeling of being in the midst of things. Telephotograph your home town from a nearby hill and watch how impressive it becomes. Photographed with a telephoto lens, people in street scenes appear as they "really" are, without the tense, frightened, or "posed" expression that is almost unavoidable when they are directly confronted with a camera. Use a telephoto lens if you want a photograph of traffic to seem as congested as it is when you try to squeeze through it in your car. Photograph animals in nature or captivity with a telephoto lens. Use it for any kind of subject—not only those that are too far away for your standard lens, but also those that you never thought of telephotographing before. Step back until you get the necessary distance—and watch your pictures improve!

Infrared sensitized film. Have you ever thought of using it? Explore its potential; see how it "dramatizes" landscapes, penetrates dust and haze, unveils distance, makes familiar objects appear exciting and new. No special equipment is needed—even a "box" will do.

Pictures at night. The modern photographer's day has twenty-four hours. Part of your life is lived at night—so why not record some of it on film? Time exposures can be made with any camera, even with a "box." For instance, the pattern of traffic at night traced by the headlights of approaching cars

produces diagrams in space and time that can be seen only with the aid of the camera. Time exposures show the stars wheeling in the night sky as a profound cosmic spectacle. A lonely street lamp, a rectangle of light high up in a dark house, evoke the mystery of night. And modern high-speed lenses in conjunction with modern high-speed films enable you to take instantaneous night photographs of people and life on any well-lit street.

Speedlights are ideal for portraits. Their light is modulating and soft, their flash too short to blind the eye. The days of "hold it!" are over. There is no excuse now for posing and frozen smiles, no need for a tripod, blown fuses, or for pictures that are blurred because the subject or the photographer moved at the moment of exposure. You can "forget" your equipment and concentrate on what you want to photograph: the characteristic gesture, the fleeting expression, the natural, spontaneous smile.

To use the camera as a means for widening man's horizon, to explore the realm of the factual as well as the emotional, to show how people live and feel, seems to me one of the most exciting tasks a photographer can set himself. Henri Cartier-Bresson's pictures of people, David Douglas Duncan's photographs of marines in the Korean war, Ed van der Elsken's deeply moving essay on life in Paris's Latin Quarter, Sam Haskins' lovely and provocative pictures of young girls and the African scene, Lewis W. Hine's documentation of the New York labor scene at the turn of the century, Gjon Mili's motion studies with the aid of stroboscopic light, Erich Salomon's pictures of post-World War I diplomats, W. Eugene Smith's *Life* essays, Edward Weston's nature studies—these are only a very few of the great classics of photography that immediately come to mind. These are photographs that should be seen and studied by anyone seriously interested in photography. To the highest degree, they have those qualities that characterize great pictures: They have purpose and meaning; they are interesting and informative; and they are sincere, moving, and deeply felt.

A camera is a responsibility—particularly in the hands of a man who makes pictures intended for publication. Photography has rightly been called a "picture language." But if it misrepresents the truth, if it falsifies facts and, by so doing, wrongly influences people's opinions, then "shooting" with a camera becomes, in a sense, as dangerous and irresponsible as shooting

wildly with a gun. Anyone knows the potential danger of a gun. But few photographers are aware of the damage that an irresponsibly used camera can do. This applies particularly to irresponsible photo journalism. To a lesser degree, it also applies to the pointless pictures inflicted upon the public via photo magazines and exhibitions. Many a young photographer believes that such pictures must be "good" because they have been chosen to be printed or exhibited; consequently they take them as a standard for their own work. Pictures of this kind have retarded the development of many amateurs and prevented them from recognizing the tremendous potential of their medium. Caught in the vicious circle of that society for mutual admiration called the "photo club," they never bother to look elsewhere for stimulation, for examples of good photography. And they never become responsible photographers.

THE TRUE VALUE OF EQUIPMENT AND TECHNIQUE

Photographers constantly justify the mediocrity of their pictures with remarks like "If only I had this camera and that lens, I could take pictures like such and such a photographer. . . ." To them, it may come as a shock to hear that, for example, Henri Cartier-Bresson never uses anything but a simple Leica—exactly the same type of Leica that countless amateurs use. At a guess, 90 percent of all the photographs printed in *Life* were taken with ordinary 35 mm. cameras. Obviously, it is not *what* camera a photographer uses but *how* he uses it that accounts for the merit of his pictures.

Photographers who believe that possession of a thousand dollars' worth of equipment automatically guarantees the production of "thousand-dollar pictures" are in for a disappointment. The basic operations of exposing, developing, and printing are the same for "thousand-dollar cameras" as they are for Instamatics. The same kind of film is used in both. Negatives produced by both are printed on the same kind of paper. And, apart from possible differences in size, the only difference between a "thousand-dollar camera" and a "box" is the optical and mechanical quality that manifests itself mainly in the degree of sharpness of the negatives. However, only a

very good technician can practically exploit the superior quality of, say, an $800 camera as contrasted to an $80 camera. And even so, he would, at best, only get a slightly sharper negative—a fact that, of course, does not exclude the possibility that the photographer using the $80 camera will produce a better *picture*.

Expensive "special" equipment is needed only for "special" jobs. Such jobs are exceptional and rare even among professional photographers. No amateur can convince me that he has exhausted all the possible sources for taking interesting pictures with his own camera and thus must "step up" to a more sophisticated type. If he is unimaginative enough not to be able to find worthwhile motifs for his "ordinary" camera, I'd bet him any amount he will not find them for "sophisticated" equipment either.

In itself, a camera is no more creative than a lump of clay. But, like a lump of clay, in inspired hands it can become a means for creation. "Prize-winning cameras" and "system cameras that can do everything" exist only in the imaginations of copywriters who are trying to promote their products. There are no prize-winning cameras, there are only prize-winning photographers. Any camera, regardless of size, design, or cost can produce inspiring pictures. As a matter of fact, great pictures have been taken even with a "lowly box"! In this respect, a camera that is in working condition is analogous to a car: Any car that is in working condition will take you to your destination. Some, of course, will do so faster and in greater comfort than others. But it is still the driver who must steer the car and decide where he wants to go.

Preoccupation with technicalities is one of the greatest obstacles to the making of good pictures. This may seem contradictory in view of the fact that I recommended the development of additional techniques as a means of producing better photographs. However, I only consider such techniques necessary for the making of good photographs in the same sense as it is considered necessary for a writer to be able to spell correctly, have command of the language, and know how to choose his words effectively. What must be avoided is that photographers, while developing their techniques, become so absorbed in technicalities per se that they forget that "technique" is only a means to an end. To these photographers, the

technical aspects of photography become "the end"—and thereby also the end to their development as creative workers.

Preoccupation with superficial technicalities is particularly evident in the importance most amateurs attribute to "technical data"—the make of camera and lens, the f-stop, shutter speed, and so on with which specific pictures were made. Editors of photo magazines and annuals print them religiously below each picture or in collected form in the back of the book, supposedly as an aid to photographers who wish to make similar pictures. Save for a few special cases, such data are not only worthless but also misleading. For one thing, because information like, for instance, the settings for diaphragm and shutter can be furnished much more accurately and conveniently, if needed, by any exposure meter right at the scene of shooting. Moreover, statements referring to the brand of camera, lens, film, and the like are of no practical value to anyone. They serve only as free publicity to the manufacturers of these items (who, incidentally, usually are advertisers in the magazine). The pains that some photo editors take in order to present their readers with "complete information" are really touching. For example, one reads again and again that a certain picture was "taken with a Rolleiflex 2¼ by 2¼ inch equipped with a Carl Zeiss Tessar lens f/2.8." Anyone who knows what a Rolleiflex is also knows that its size is 2¼ × 2¼ inches, that it comes equipped with either a Tessar or a Xenar, that all Tessar lenses are made by Carl Zeiss, and that the speed of this particular lens is normally f/2.8 (there are only very few old f/3.5 Rolleis left). But can anyone tell me what difference it makes, as far as the picture is concerned, whether it was taken with a Rolleiflex or any other "ordinary" camera, with a Tessar or a Xenar lens? Or whether or not the lens had a speed of f/2.8 instead of f/3.5, especially as it probably was stopped down anyway? Upon being questioned, such editors always maintain "that their readers request this kind of information," even though the editors themselves realize that it is of no practical value. Should not the editors then inform their readers to this effect? After all, aren't these magazines supposed to "educate" the amateur? What makes such "data" not only valueless but also actually misleading is the fact that they never tell the whole story. They do *not* tell whether the listed exposure was right or wrong and, if the exposure was wrong, whether the negative was underex-

posed or overexposed. Neither do they say anything about the illumination at the moment of exposure, which should have been indicated in the form of a meter reading (without these data, most of the other information is, of course, totally useless). Nor do they mention the time of negative development, the type of developer (some, as will be remembered, require additional exposure), the density and gradation of the negative, or the contrast grade of the paper. Furthermore, analysis of such data often reveals that they are obviously "fabricated." In many outdoor pictures of people, for example, closer inspection reveals a shadow within a shadow, proof that fill-in illumination was used. No such thing, however, is mentioned in the "data," the purpose of which supposedly is to tell the amateur "how to do it." Or examination of the zone of sharpness in depth gives the lie to the indicated f-stop. But what else can we expect? How many photographers actually make notes on the "data" of every picture that they take? How many photographers can later remember precisely how they took particular shots? As long as amateurs insist upon "data" with each picture that is printed, they must run the risk of being misinformed. I hope that from now on at least the readers of this book will rely upon their exposure meters and common sense and will leave spurious "data" to others.

"Technique" is valuable only insofar as it can be put to practical use. "Know how" must always be complemented by "know what" and "know why." Sometimes, however, knowing too much may cause a photographer to risk too little. If you are in doubt whether or not a shot will come off "technically," take it anyway, for what can you lose? Only "safe" pictures always come off. However, they are often very dull. Taking chances, as, for example, shooting against the light or even directly into the sun, often leads to the most exciting photographs. Of course, the resulting halation may be terrific—but, then, so is the brilliance of the sun!

HOW TO SEE IN TERMS OF PICTURES

I stated before that part of any "good" photographer's success is due to his ability to "see" more, and "better," than his less fortunate colleagues. This faculty for discovering picture possibilities that others overlook is the combined result of three factors: an eye for *interesting* subject matter; a feeling for the *photogenic*; and knowledge based upon experience of the *subjects that should be avoided* because they rarely make good pictures.

Interesting subject matter. As a rule, something that is alive, unusual, or a combination of both is more interesting and makes for better pictures than subjects that are static, commonplace, or inanimate. Among the most interesting photographs are always those pictures of people that show their true emotions. At the other extreme—characterized by the dullest and most pointless pictures—are still lifes and the childish exercises known as "table-top photographs." Phony setups, no matter how "artistically conceived," can never result in anything but phony photographs.

Photogenic qualities. Every photograph is an abstraction in the same sense that words and letters are abstractions. A letter, for example, is a symbol for a sound. A combination of letters is a symbol for a more complex sound—a word. And a word is a symbol for an object, a quality, an event. Everyone who speaks English knows the meaning of the symbols G-I-R-L. Without such symbols, we could not convey to others in written form the meaning of the concept "girl." The same principle applies in photography. The black-and-white picture of a girl, for example, is an abstraction in that it lacks color, depth, and motion—three of the most important qualities of any living subject. In black-and-white photography, color is "symbolized" by shades of gray; depth is symbolized by perspective and diminution; and motion is symbolized by blur. Without these symbols (and others not mentioned here), photography would be impossible. The degree to which a photographer is aware of them, how well he knows them, and how he uses them are important factors for the outcome of his pictures.

The most elementary qualification of a writer is that he knows the meaning of words and how to use them. In other words, he has to know his symbols.

But few photographers realize that they also work with symbols—gray shades, perspectives, and blur, to name only the three most important. They take these symbols for granted because they appear "automatically" on the film. But they forget that these symbols, like words, can be *controlled*, changed, used, or combined in many different ways. However, whereas any literate person will spot a mistake in grammar or spelling right away, few people are "photographically literate" enough to detect in a photograph a symbol that is used wrongly (and I do *not* mean a technical mistake, which is much easier to spot). For example, most photographers like their pictures sharp. However, the *sharp* photograph of, say, an automobile in motion differs in no way from the *sharp* photograph of a car that is standing still. In order to indicate motion, the photographer has to use a symbol, for obviously motion can never be rendered directly in a "still." The most effective symbol for motion is blur. The more blurred a car appears in a picture, the faster it seems to go. Anyone can "freeze" the motion of a car by taking the picture at a sufficiently high shutter speed. However, such *faulty* use of a photographic symbol results in a picture that creates a *faulty* impression: the impression of a car standing still.

To give another example: A photographer has to take a fashion shot in black and white of a green dress trimmed with red. Although the colors themselves are complementary (as different from one another as possible), their brightness value is practically the same. Consequently, an *uncontrolled* or "ordinary" photograph will render the red and green as more or less identical shades of gray—contrast will be lost. Because the particular attraction of the dress lies in the vivid contrast between the red and the green, such a picture would obviously create a faulty impression —the dress would appear monochrome and dull. Although such a photo-graph will be *factually correct* (that is, as far as monochromatically correct translation of color into shades of gray is concerned), it will nevertheless be *emotionally wrong*. In order to appear *emotionally correct*, the colors red and green have to be separated adequately in the black-and-white rendi-tion and symbolized (represented) by gray shades that are indicative of their character. Red is aggressive and warm, green receding and neutral. Given equality of brilliance (as in our example), a warm and aggressive color appears lighter than a passive and receding color. To create this

impression, the picture of the dress would have to be taken through a light-red filter. This would make the red appear as a light shade of gray and the green as a darker shade of gray. Contrast would be created, and the black-and-white "translation" of the dress would be emotionally true—as a result of the correct use of photographic symbols.

Subjects that have qualities that lend themselves well to photographic symbolization are called *photogenic*. Subjects that lack such qualities, or have them only to a small degree, are called *unphotogenic*. Photogenic subjects are characterized by bold and simple forms, contrast, roundness, depth, interesting outlines, life. Unphotogenic subjects are flat, mono-chromatic, contrastless, disorganized, excessively complex, static, or just plain dull.

Unphotogenic subjects, however, are not always obviously so. As a matter of fact, a subject may have great eye appeal and still be extremely unphotogenic. This is particularly true of scenic views from high vantage points and of wide-open, "scaleless" landscapes. These may be magnificent to behold but will turn out disappointing in reproduction unless the feeling of grandeur is *symbolized* through introduction of *scale*—a human figure, a man on horseback far off in the distance, whose smallness makes the landscape appear wide and deep by contrast.

All subjects that are too cluttered, that have several centers of interest or an unsuitable background, are basically unphotogenic. Green meadows under cloudless summer skies appeal to almost everyone, but they make some of the dullest pictures. This is also true of lush vegetation, which has too much green against green, too little contrast, and too little outline and form.

A photographer does not enjoy the same advantage as a painter, who can change and invent in order to improve his painting. However, *the photographer can always select and reject*. By *discriminately* choosing his subjects in accordance with their photogenic qualifications he can enormously increase his chances of success.

Thinking in terms of photography is different from thinking in terms of literature. A subject might be extremely interesting, and we might write a

fascinating story about it, yet the same subject might be exceedingly boring as a photograph. For example, let us consider a battle monument. A book could be written about that stage of history to which it belongs, with all its color, drama, life, and significance. But in picture form it probably would appear, like countless other battle monuments, uninteresting and dull.

The reason for this discrepancy between interest and appearance lies in the fact that the camera "sees" objectively, whereas the eye sees through the screen of the imagination. To the camera, a battle monument is only one more general on a horse. To the eye, it is a symbol of a cause, lost or won, for which men died. The mind wanders—and history comes alive. Sherman and Grant and Lee . . . the memory of these names stirs the imagination. But how can such intangibles be expressed in a photograph? They usually cannot—which is the reason why this type of "literary" picture usually disappoints. It requires imagination to symbolize an idea: a stark silhouette, black against an emblazoned sky, rays of light breaking through stormy clouds, lightning streaking the horizon—and the war memorial comes to "life"; the drama, might, and terror of battle are signified.

Similar considerations apply throughout photography. Let us suppose you have to photograph a certain man—a man you know. He is married, has children, lives in a comfortable home. You know him to be a successful businessman, a driver of hard bargains, yet he is well liked by his friends for his genial ways. He smokes cigars, plays bridge, and likes to tell jokes. How can such knowledge help you to make a good portrait of him?

If photographed by someone who does not know anything about him, this man, being obviously wealthy and important, would very likely be photographed in a conventional pose with standard lighting against an opulent, somber background. It would be a "standard portrait"—very likely pompous, probably stiff and posed, and impersonal. Since you have some knowledge of this man, you might evaluate this knowledge "in terms of pictures," reasoning as follows: Because he seems happily married, has children and a nice, comfortable home, he must be content and quite pleased with himself. Because he lives in a wealthy neighborhood, he must be prosperous and successful. Because he is known to drive hard bargains, he must be strong and clever, perhaps ruthless. But since his friends speak

well of him and he likes to joke, he must be basically nice and have a sense of humor. Knowing these facts, your problem then is to incorporate them into the picture. Since he smokes cigars, photograph him with a cigar, and he will feel at ease. Arrange your lights to emphasize the line of the jaw to create a feeling of strength. Talk to him, and tell him jokes to bring forth expressions characteristic of his own humor and friendliness. Get him to talk to you, watch his gestures, and take shot after shot of him, trying to capture those moments when he looks "himself": relaxed, successful, happy, and strong.

Let me repeat for emphasis: The "technical" requirements are usually simple and few. Not the number of lights or the quality of camera and lens determines the outcome of your portrait, but your ability to "see" and "think in terms of pictures."

COMPOSITION

A painter can make changes, additions, and deletions to improve his composition. He can paint a tree where there is none in reality, change the color of the sky, paint over whole sections and begin again, and keep this up until he is satisfied with his work. But a photographer is not given this latitude. Once he has released the shutter, the composition is set. In this respect, every photograph is final, unalterable. Before this crucial moment, a photographer is in command of his picture. He has the power to arrange, select, and reject. After that moment, there is little he can do to influence his composition. For this reason, a good photographer "edits" his photographs before he releases the shutter. This editing is what is meant when we speak of "composing."

Composing means arranging. Its purpose is to organize the different components of a photograph in such a way that the picture becomes a self-contained unit. To do this, it is necessary to direct and concentrate interest where it belongs, to arrange lines and forms in harmonious patterns, to balance the distribution of light and dark in graphic equilibrium, and to create organic boundaries—an unobtrusive natural frame which holds the picture together. To do this, a photographer has four choices.

1. He can arrange and direct the subject until he is satisfied that the requirements of good composition are fulfilled. This is the ideal solution, but it presupposes, of course, that the photographer has as much command of the situation as a movie director has of his cast.

2. He can change his point of view (camera position) until the subject is composed satisfactorily. This applies particularly to immobile subjects like landscapes, buildings, trees, and so on. Whenever possible, he will use a lens of longer than standard focal length because he knows that this can materially improve his composition by pulling the subject together (the typical telephoto effect of "compressed space").

3. He can wait for the right moment, then quickly snap the picture. This applies particularly to documentary and action photographs in which changes are sudden and unexpected. It also applies to many street scenes and pictures in which it is desirable to have a figure or group of people in just the right place to provide scale or "human interest."

4. He can improve the composition during enlarging by blowing up only that section of a negative that contains the essence of his picture and cropping off distracting marginal detail. In this way, he can even produce telephoto effects with a standard lens. Aside from this, however, composing during enlarging hardly affords more than the possibility of making minor adjustments of a compositional nature, and when taking a picture it must *not* be relied upon as a remedy for hasty or poor composition.

Contrary to popular belief, there are no definite "rules of composition." All those "rules" about S-curves, L-shapes, triangular composition, pyramidal arrangements, leading lines, positioning the horizon within the frame of the picture in accordance with the Golden Section, and so on, are at best half-truths that sometimes apply but for which examples proving the contrary can easily be found among any number of excellent photographs. Only judges on photographic juries rate pictures according to such preestablished rigid rules. Ordinary people—the people that matter and for whom we make our photographs—neither know of nor care for such rules and judge photographs only by the ways in which they affect them. They judge by the heart instead of the head. But even though they may not be able to appreciate the beauty of an S-curve or a pyramidal arrangement

complete with "leading lines," they can distinguish between phony and sincere pictures. And this is what counts.

As an aid to the student photographer, here are some aspects to consider when composing.

Simplicity is never wrong. As a rule, the more simply conceived and executed, the stronger the picture. Principally, this means that each picture should contain no more than one single subject. Multiple subjects produce multiple centers of interest and splinter the attention of the observer. If confronted with a complex subject, simply take several pictures instead of trying to show everything in one.

Graphic black and white is often more effective than a long scale of subtle shades of gray. Don't be afraid of using it in your pictures, no matter what you have been told concerning "blocked" highlights and "empty" shadows. A highlight that is not pure white appears fogged and dirty, whereas a black, detailless shadow can hold the entire composition together, giving it power and strength.

The background is one of the most important—and most often neglected—picture elements. An unsuitable, objectionable, dominating, or ugly background ruins any photograph, no matter how important or beautiful the subject. One of the best of all possible backgrounds is the sky.

The horizon—if present—divides a picture into two parts, earth and sky. A low horizon suggests distance, space, and a sense of elation. A high horizon emphasizes the foreground and the earth, suggesting more materialistic qualities. As long as you are aware of these effects and use them, you may place the horizon anywhere in the picture—even directly across the middle (for example, if you intend to indicate monotony).

Framing the subject with interestingly silhouetted, dark foreground matter leads the eye toward the center of the picture and increases the illusion of depth.

A close-up usually creates a stronger impression than a view from farther away. It produces a feeling of intimacy, brings out surface texture ("one can almost feel it . . ."), and presents the very essence of a subject. Keep

307

this in mind when enlarging, and trim your picture to the limit. "Cropping" is one of the most effective ways to heighten the impact of a photograph.

Light and shadow play a double role: *Modulating* light and shadow creates illusions of three-dimensionality, roundness, and depth; *graphic* light and shadow—black and white—set the key of a picture and determine its pattern. Light tones and white are aggressive. They suggest joy, youth, ease, and pleasant sensations. Dark shades and black are passive. They furthermore suggest somber moods, power, strength, drama, and death. Light areas in a picture usually attract the attention of the observer first (exception: black silhouettes). Dark areas allow the eye to rest and give a picture strength.

Motion can best be symbolized by blur—the more blurred the image, the more convincing the illusion of speed. As far as subjects in motion are concerned, the sharpest picture is usually the least representative. Motion can furthermore be suggested by means of a diagonal composition. This applies particularly if the moving subject for reasons of clarity must be rendered sharp. By placing the subject on one of the diagonals of the picture and by arranging the main elements of composition so that they run diagonally, instead of horizontally or vertically, a static arrangement can be transformed into a dynamic composition, suggesting movement, action, and speed.

The proportions of the print should reflect the character of the subject. Many photographers consistently compose their pictures to fit the proportions of the viewfinder or groundglass. This fault is particularly noticeable in cases in which the negative is square. As adherence to such proportions creates monotony and handicaps the effective presentation of many subjects, they should be changed during enlarging. The number of possible proportions of the print is infinite—from extremely narrow horizontal through square to extremely narrow vertical. Effective use of these possibilities is an important means of composing.

Cropping during enlarging takes care of small last-minute adjustments. Main forms of the picture should normally not touch the margins of the print. Either place them well inside its boundaries, or boldly cut them partly off. Symmetry is boring; try to avoid it—unless there is a reason for it. Lines that

run directly into a corner seem to split it. Trim the picture so that this does not occur. Small white forms along the edges of a print make the picture look as if mice had gnawed its margins. Trim them off. If this is not possible, darken such areas by "burning in" when enlarging.

And to those photographers who are seriously interested in photographic composition and wish to know more about this fascinating subject, the author recommends his book *Principles of Composition in Photography* (Amphoto), which, he hopes, will answer most of their questions.

Photography can be taught only in part—mainly that part that deals with technique. Everything else has to come from within the photographer himself. All that any teacher—or textbook—can do is to guide potentially creative photographers in the right direction by showing them what can be accomplished in photography when it is approached with competence and imagination.

From here on it is up to you—where you go and how you get there. Rules and instructions are for technicians—the creative worker must chart his own course. Discrimination, selection, and the limitations of the medium are his starting points. Condensation and symbolization are the means by which he turns his subject material into art. No one cares what tools he uses. Few know the kind of person he is. But millions may participate in his work. This is the essential. If his work is honest and sincere, if it has something to say, if it provides an element of that which helps people to better understand themselves, their neighbors, their surroundings, their world—what difference does it make whether such work is created with brush and paint on canvas, with chisel and mallet in stone, with typewriter and words, or with camera and film?

Glossary

Like any other in-group, photographers have their own jargon, special expressions which often sound like gibberish to the uninitiated. Memorizing the following terms and their meanings should facilitate your acceptance by the fraternity.

Blowup = a photograph that is larger than the negative from which it was made; to *blow up a negative* means to make an enlargement.

Bracket = a series of negatives (usually three to five) identical in all respects except exposure, from which the photographer afterwards picks the best one for printing. *Bracketing his shots* means making such a series.

Burning in = giving additional exposure during enlarging to negative areas that are undesirably dense (black) in order to improve differentiation in the print.

Contact print = a photograph made in direct contact with the negative and therefore always of the same size as the negative.

Contact sheet = a contact print of all the negatives from one roll of film printed together on the same sheet of 8" x 10" or 8½" x 11" paper.

Crop = cut. *Cropping a negative* means enlarging only a certain area of it, cutting off, so to speak (actually, omitting) unwanted parts in the print.

Density = degree of blackness in a negative or print.

Developer = any one of many chemical solutions used for transforming the invisible (latent) image on an exposed film into a visible one.

Diapositive = a black-and-white transparency—a "positive negative"—intended either for viewing in transmitted light (projection) or for producing a negative print. Diapositives are made by printing negatives on film (or glass plates) instead of printing them on paper.

Dodger = a device for density control used during enlarging, usually made of cardboard or red celluloid. To *dodge a print* means to affect its density on a local scale and thereby control its contrast range and distribution.

Emulsion = the light-sensitive layer of a film or photographic paper.

Enlargement = a photographic print that is larger than the negative from which it was made.

Enlarger = a projection printer, an instrument indispensable for making a negative yield an enlarged print.

Exposure = the act of admitting light to the film inside the camera by means of the shutter; to *make an exposure* means to take a photograph.

Ferrotyping = giving glossy photographic paper a mirror-like finish by drying it in contact with a ferrotype plate.

Fixer = the chemical solution that renders a developed film (or print on sensitized paper) insensitive to further action by light, clears the film, and makes it printable and permanent.

Flare = the effect on the film of unwanted light, caused by internal reflections in the lens. It can usually be prevented by use of a proper lens shade.

Flat = lacking in contrast; a *flat print* is a photograph that appears too gray. *Flat light* is low in contrast and more or less shadowless.

Flush mounting = mounting a print on a board in such a way that the photograph extends all the way to the edges, with no part of the mount showing.

Fog = a more or less uniform layer of density in a film or print, usually the result of exposure to extraneous light or a harmful chemical reaction during processing. *Fogging a negative or print* means accidentally or occasionally deliberately producing such a layer of overall density.

Forcing = trying to increase insufficient density in an underexposed negative or print during development, usually by extending the duration of development beyond what is considered normal.

Frame = any individual negative on a roll of developed film. Also, foreground subject matter (usually dark) which, like the frame of a painting, partly or entirely encloses the main subject of the picture. *Framing the subject* means surrounding the subject with foreground material in such a way that, in the picture, it appears to be framed.

Gradation = contrast range, the span between the highest and lowest densities in a negative or print.

Grain sharp = an enlargement that is critically sharp over its entire area; sharp enough to distinguish the film grain, the light-blackened silver particles of a developed photographic emulsion which produce the image.

Halation = light spilling over into the darker areas of the negative or print, usually the result of shooting toward a strong source of light or considerable overexposure of the film. Also, certain manifestations of unwanted light.

Hard = high contrast; a hard negative or a hard paper yields prints of greater-than-average contrast.

High-key = a low-contrast print in primarily light shades of gray dominated by white, making a light and joyous impression.

Highlights = the densest (blackest) areas in a negative or, conversely, the lightest areas in a print.

Holding back = giving less-than-average exposure during enlarging to those areas of a negative which otherwise would appear too dark in the print.

Hypo = *sodium thiosulfate*, a salt used in the form of a watery solution for the removal of the unexposed silver salts from the developed negatives or prints.

Intensifier = any one of several chemical solutions used to increase inadequate density in underexposed negatives or prints.

Latent image = the invisible image produced within a photographic emulsion by the action of light; development transforms a latent image into a visible one and an exposed film into a negative.

Low-key = a low-contrast print in primarily dark shades of gray dominated by black, making a dark and somber impression.

Mask = (1) a frame cut out of thin, black paper placed in contact with the film during enlargement of only part of the negative; its rectangular opening corresponds to the area of the negative that is to be shown in the print and its borders prevent harmful stray light from reaching and possibly fogging the sensitized paper. (2) A low-contrast, low-density, positive contact print of the negative made on film; taped to the negative in register, its purpose is to reduce the contrast of an overly contrasty negative to a printable level. *Masking a negative* can mean either framing it with a paper mask, or lowering its contrast with a density mask.

Negative = a developed film showing the image of the depicted subject in reversed tonal gradation, *i.e.*, light areas of the subject appear dark and dark areas light.

Oyster shell marks = irregular, more or less concentric cracks in the glossy surface of a ferrotyped print caused by its premature removal from the ferrotype plate.

Photomural = a large photographic print, usually larger than 30″ x 40″.

Print = professional photographers call *any photograph on paper* a print, regardless of whether it was made by contact printing or with the aid of an enlarger; *printing*, therefore, can mean making either a contact print or an enlargement.

Processing = performing the complete operation of transforming an exposed film or sheet of photographic paper into the finished negative or print.

Proof sheet = a contact print or enlargement displaying all the negatives from one roll of film (or a number of different sheet-film negatives) on the same sheet of paper.

Reducer = any one of several chemical solutions used to decrease excessive density in overexposed or overdeveloped negatives or prints.

Safelight = a light (or lamp) used to illuminate a photographic darkroom

which, because of its particular color (spectral composition), does not affect sensitized photographic material. Differently sensitized materials require safelights of different colors.

Shadows = the thin (transparent) areas of a negative and, conversely, the dense (black) areas of a print.

Shoot = to take a picture; professionals don't photograph; they shoot. A *good shot* means a good picture.

Slide = a positive photograph on film (rarely on glass) intended for projection, usually (but not necessarily) made on 35mm color film and mounted in a cardboard frame or between two cover glasses in a plastic or metal frame.

Soft = low in contrast; a soft negative or a soft paper yields prints of lower-than-average contrast.

Solarization = partial or total reversal of the image in a negative or print as a result of enormous overexposure. True solarization—the Sabattier effect—occurs only rarely and then mostly in negatives. The process of solarization described in Volume II involves a phenomenon that actually should be called "pseudo-solarization."

Soup = a common professional slang expression meaning developer. *Souping a film* means developing a film.

Straight print = a print all the areas of which received identical exposure, *i.e.,* a print that was not contrast-controlled by means of dodging, holding back, or burning in.

Stray light = harmful, unwanted light in the darkroom that fogs film and sensitized paper.

Take = all the photographs made or films exposed at one time, of one subject, during one day, or on one assignment.

Toning = changing the color of the image of a print by chemical means, for example, from the ordinary shades of gray to shades of brown or blue. A *toner* is a chemical solution used for this purpose.

Transparency = a positive photograph on film, usually (but not necessarily) in color, made on film larger than 35mm, and intended either for projection or reproduction with photomechanical means. A 35mm transparency is usually called *a slide.*

Index

318